THE
CODEX BORGIA

THE CODEX BORGIA

A Full~Color Restoration of the
Ancient Mexican Manuscript

GISELE DÍAZ AND ALAN RODGERS

With an Introduction and Commentary
by Bruce E. Byland

DOVER PUBLICATIONS, INC.
New York

Bibliographical Note

The Codex Borgia: A Full-Color Restoration of the Ancient Mexican Manuscript is a new work, first published by Dover Publications, Inc., in 1993.

Library of Congress Cataloging-in-Publication Data

Codex Borgianus.
 The Codex Borgia : a full-color restoration of the ancient Mexican manuscript / Gisele Díaz and Alan Rodgers : with an introduction and captions by Bruce E. Byland
 p. : ; cm.
 Includes bibliographical references (p.).
 ISBN 0-486-27569-8
 1. Codex Borgianus. 2. Aztecs—Religion and mythology. 3. Aztecs—Calendar. 4. Aztecs—History. I. Díaz, Gisele. II. Rodgers, Alan. III. Title.
F1219.56.B65C63 1993
299'.792—dc20
 93-6714
 CIP

Manufactured in the United States of America
Dover Publications, Inc., 31 East 2nd Street, Mineola, N.Y. 11501

"The mission of man is to remember. To remember to remember. To taste everything in eternity as once in time. All happens only once but that is forever."
HENRY MILLER
Remember to Remember

To Richard Gutherie, artist, and Tomás Díaz—each, in his own way, proving that when enough pressure is applied a diamond appears from within.
G. D., 1993

Thanks to Alberto and Gualberta Trejo, papermaker, San Pablito, Mexico; Armando Arriaga, woodcarver, Puebla, Mexico; Beckey Reisberg, conservator and bookmaker; Jeff Baker, photographer; Carl and Terrie Huff, whose door was always open; Patricia Morris, Lenny Lamm and Henry Miller, for showing the way.
A. R., 1993

My thanks go to John Pohl, Betsy Smith and Nancy Troike, inspiring students of pre-Columbian writing; to Cara Tannenbaum for almost everything; and to Leah Madeline for giving reason to being.
B. B., 1993

CONTENTS

ARTISTS' PREFACE

The aim of the Díaz-Rodgers version of the Codex Borgia was to reproduce the codex using traditional methods and materials, and to restore as accurately as possible all damaged sections of the book; in short, to see the book in the pristine condition it had existed in during the time of the Aztecs.

Of course, the idea of codex restoration is not new. This project was heavily influenced by the restoration work done on the Codex Dresden and, most importantly of all, the work on the Codex Nuttall, which has been reprinted by Dover Publications.

Work on this project began with drawings made from photographs of the Codex Borgia. The first set of drawings was made to become familiar with the symbols and characters within the manuscript. The object at this point was to copy the original artwork as closely as possible. After the first drawings were completed, the entire book was redrawn again using pen and ink on Herculene film. In these final drawings, the restoration of the codex was conducted. First, each character (separate image) was centered within its defined space. For example, if the original artist(s) implied a division of one-half page in the original text, exactly one-half page was used to reproduce that portion of the codex. With regard to the characters, no changes were made. If a temple leaned in one direction or another, it was left as it was. Here, the process of extrapolated restoration occurred. The easiest restoration was the connecting of the lines based on other undamaged parts of the manuscript. This was relatively easy in some parts, as the figures were easily identifiable with just small parts of the figure worn away.

Of course, other sections were not so easily reproduced and some value judgments were called for. It is here, in the more difficult restoration parts, that some criticism is possible. An example is Plate 2. According to Alexander von Humboldt, the first and last pages of the original codex were partially burned by servant children of the Giustiniani family. In one of the burned areas (upper right), a scorpion is partially visible. Therefore, in the final series of drawings it was reproduced as a whole scorpion using other scorpions in the codex as guidelines. For example, Plates 13, 18, 59 and 69 each contain stylized versions of the scorpion. What may be wrong or lacking is the direction or curve of the scorpion's stinger on Plate 2. In order to fill and balance the given area, the scorpion was drawn with the straight extended stinger as found on Plate 59. The stylistic traits of the partial scorpion on Plate 2 served as the foundation of the new scorpion. In the final drawings, implied symmetry was formalized. All red dividing lines were made straight in the horizontal and vertical directions.

In the section of the book comprising Plates 61 through 70, the day signs, or symbols, are accurate. What may be lacking are certain characteristics unique to that particular day according to its place within the sacred order of 260 days. For instance, it should be noted that each half of these pages has 13 day signs associated with it. This order was noted by Sahagún in his monumental work *Historia de las Cosas de Nueva España*. What will be found lacking are certain aspects of characteristics of the day signs which would have borne specific significance for that specific time period. For example, "Ollin," or Movement, can take several forms. In all the different forms, Movement is still Movement but it has several ways of being represented in this manuscript. On Plate 65 (upper half) it is seen upright and entwined with a red side dominating the right half of the symbol. On this same plate, in the bottom row of day signs, Movement is found again entwined, but this time it is lying down with the red half of the symbol on the bottom side. Plate 70 again shows Movement in the top row of the day signs. Here it is exactly as found on the bottom row of Plate 65, except the blue half is found on a totally different form. It is no longer entwined, but rather a star or flower form. That is by no means all of the possible forms of "Ollin." Sometimes the color and the shape of the center point varies. Each aspect that "Ollin" assumes has an important symbolic meaning and something distinct to say about that particular moment in time and space.

The bottom parts of Plates 28, 57, 58, 61 through 64 and 66 through 70 were especially difficult to reproduce. In all of these plates, the day signs were entirely missing, which called for quite a few judgment calls during the restoration process.

Concurrent with the drawing process was the investigation of different types of traditional *ámatl* bark paper. This investigation led to San Pablito, Mexico, and to Alberto and Berta Trejo. The Trejos were traditional makers of the paper that was used in this project. The process for this handmade paper has been well documented in many papers and several books; however, because of the special size requirement of the paper and the fact that the paintings were to be mounted onto an accordion-like book, several new methods of producing oversize pieces of paper were investigated. The new process for large-format paper quickly became the standard for the entire village.

After the final drawings were completed and the *ámatl* paper selected, the drawings made on the transparent film were transferred to the *ámatl* paper using a blackline undercoating. Because of the variation in the paper's color and quality, approximately 20 copies of each plate were transferred. The best copy of each plate was then carefully selected, based on paper characteristics and accuracy of line reproduction.

The next phase was the application of color. First, two coats of titanium-white watercolor were applied as a base. This served to stretch the paper and fill the porous surface of the paper. Colors were then applied by hand starting with yellow. Red was the final color to be applied. Experiments were conducted using natural dyes; however, it quickly became apparent that this was beyond the

scope of this project. Instead, watercolors were used. To insure uniformity in paint color, some portions of the plates required as many as four or five separate coats of paint. Although the plates were produced over several years, every effort was made to insure uniformity and consistency in color from Plate 1 through Plate 76. Finally, after all the colors were applied, the black lines were hand painted with tiny brushes, thereby encasing the characters of the manuscript. Two coats of acrylic fixative were finally applied to protect the colors. The plates were produced in order.

After the paintings were completed, they were photographed by Dallas photographer Jeff Baker. The plates were then taken to Beckey Reisberg, who assembled them into a unique accordion-style book using proper conservation techniques and methods. Two 40-foot *ámatl* sheets were produced. Each painting was then mounted on one of these long sheets, which then folded into an accordion-style book. Plates 1 through 38 are in one of these original books and Plates 39 through 76 are in the other. The books are stored in a hand-carved cedar box produced by Armando Arriaga, one of Mexico's finest woodcarvers.

Total time to complete the project was seven years.

G. D.
A. R.

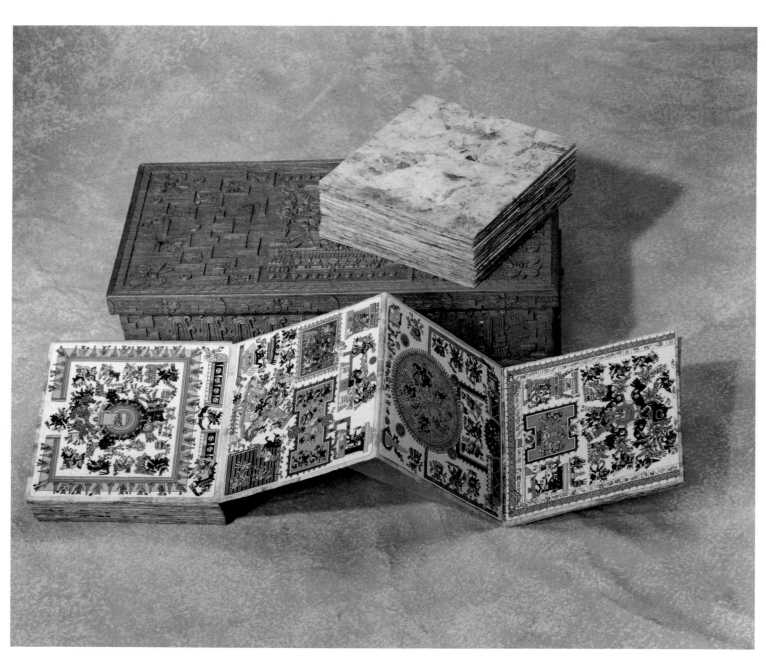

The original painted Díaz and Rodgers restoration of the Codex Borgia, showing its screenfold (accordion-fold) nature, its *ámatl* paper and the handsome box crafted for it.

INTRODUCTION AND COMMENTARY

BY BRUCE E. BYLAND

The Present Edition of the Codex Borgia

The present edition is a new hand-painted restoration of the Codex Borgia designed to recreate the sense of awe and wonder that the original manuscript must have inspired before the depredations of time and ill treatment took their toll. Over the five or more centuries since the original was painted by some unknown Mexican scribe or scribes, much has happened to it. It has been opened and closed countless times. Its fragile pages have been touched and manipulated, folded and rubbed, photographed and drawn. It has been exposed to heat and humidity. It has survived the abuse of children, who folded some of its pages and burned others. It has lost its original wooden end pieces. The result of all this activity is that the images painted so carefully by the original artist or artists have been damaged. In many places flakes of pigment have been rubbed off and lost, thus obscuring the original images to varying extents. Most seriously, parts of three leaves have been damaged by fire.

This has left a document which, though still recognized as one of the finest and most important original sources for the study of pre-Columbian religion, has been seriously compromised. Ms. Gisele Díaz and Mr. Alan Rodgers are to be commended for their efforts to recover the grandeur of the original manuscript. The Dover edition will, for the first time, make a reproduction of the manuscript accessible to the general public. That it is not a photographic or precise facsimile may possibly trouble some among the corps of professional codex scholars, though they are among the few who have access to the costly photographic facsimiles already published (Kingsborough 1831–48, Ehrle 1898, Seler 1904–09 [Spanish translation as Seler 1963], Nowotny 1976). Although these rare, expensive editions remain preferable for serious scholarship, that does not lessen the inspirational and broad educational value of this restoration.

Just as Dover's edition of Zelia Nuttall's copy of the Codex Zouche-Nuttall is not an exact rendition of the original, the reproduction published here is not an exact copy of the Codex Borgia, even in its current state. It is, rather, an informed attempt at a restoration, a careful reimagining of the original beauty of the manuscript. Even though the restoration has omitted the glosses added to the manuscript by a European hand after the conquest, it is not intended to be a definitive reconstruction of the original as it was painted before the arrival of the Spanish. It is not a precise copy of the extant portions but rather a redrawing that includes tiny differences of detail throughout. (Any significant differences will be pointed out in the commentary later in this introduction.) Colors are rendered close to their appearance in the original as it exists today, not as they were when the Codex Borgia was new; for example, some original greens are now a shade of tan, and it is the tan that appears here.

Because of its very availability and because of the care that Díaz and Rodgers have put into this faithful restoration of the manuscript, students can learn much from it. Those who want to study the original in fine detail should first use this edition as a guide but should also seek out a copy of the fine photographic facsimile published by ADEVA (Nowotny 1976). They should also look for the outstanding commentaries on the codex published by Nowotny (1961a) and Seler (1963). In addition, the serious student should not neglect the important studies of the Codex Borgia and the other members of the Borgia Group of codices published by Humboldt (1810), Caso (1927), Noguera (1927), Robertson (1963), Spranz (1964), Glass (1975), Sisson (1983), Biedermann (1989) and others. The present edition will become a starting point for study of the religious codices of highland Mexico just as the Dover publication of the Codex Zouche-Nuttall (Miller 1975) has become the principal introduction to the Mixtec historical codices for so many modern students.

The original codex was painted on a long strip of folded animal skin as a screenfold book. Fourteen strips of skin were attached end to end, trimmed to a standard height of 27 cm, folded into a screenfold and prepared for painting with a white lime-plaster ground. The artist or scribe then painted the manuscript with an extraordinarily artistic hand, using both mineral and vegetable pigments. The book was intended to be read in continuous fashion from one end to the other, from right to left, on one side and then turned over so that the reading could continue on the other side. Even though the current binding does not reproduce that screenfold format, the reading order in this edition does recreate the linear form of the original by binding the pages in reverse order so that the text begins at the back and is read from right to left and from back to front, in much the same way as the Dover edition of the Codex Zouche-Nuttall.

The History of the Codex Borgia

The Codex Borgia has long been recognized as one of the most elegant and beautiful of the few surviving pre-Columbian painted manuscripts. Its special significance has been seen in its detailed depiction of highland Mesoamerican gods and the ritual and divination associated with them. Substantial portions of the codex convey various aspects and attributes of the 260-day ritual calender. The more detailed ceremonial aspects of the images have been harder to understand.

The Codex Borgia is today housed in the Apostolic Library of the Vatican in Rome, Italy. It was originally painted somewhere in the central highlands of Mexico as a unique manuscript. The exact

place at which it was painted is not now known and is the subject of much discussion. During the summer of 1982, the Pre-Columbian Studies Program at Dumbarton Oaks in Washington, D.C., sponsored a summer research seminar on the codices of the Borgia Group at which much attention was paid to this problem (Sisson 1983). While no final conclusion could be drawn, the opinion of most of the participants in the seminar was that the Codex Borgia was probably originally painted somewhere in central or southern Puebla, the area around Tepeaca and Cuauhtinchan or the Tehuacán Valley. Others would expand this potential area of origin to include nearby areas of the Mixteca Alta in Oaxaca. Since various aspects of the manuscript seem to point with equal validity to each of these areas, we cannot choose one over the others. Perhaps we should conclude, rather, that central and southern Puebla and northern Oaxaca shared a religious and iconographic scheme and that the pronouncements of the Codex Borgia would have had equal validity in all of these nearby regions (Pohl and Byland n.d.). Seen in that light, the precise point of origin is not so important as the information that can be gained from careful study of the codex.

It is generally believed that the Codex Borgia was originally painted in the decades immediately before the arrival of the Spanish. This presumption is based on the observation that its style shows no hint of European influence. In addition its religious content was more apt to have been repressed rather than encouraged after the arrival of Catholic priests. It is not possible now to determine exactly how long before the beginning of the Colonial period it was painted, though it probably dates to the late fifteenth or very early sixteenth century.

The Codex Borgia was sent back to Europe at some point in the early Colonial period, though when, by whom and to whom is not known. Its early movements in Europe are also obscure. It has been argued that at some time in the sixteenth century the manuscript was sent to Italy either directly from Mexico or from an intermediate stop in Spain (Ehrle 1898). This supposition is based on the paleography of a gloss on page 68 of the manuscript that appears to have been written in poor Italian (presumably in the hand of a sixteenth-century Mexican or Spaniard not fully fluent in Italian). At any rate, from then until very late in the eighteenth century nothing is known of the whereabouts of the codex.

It first came to the attention of scholarship when in 1805 Alexander von Humboldt saw it in Rome among the effects of Cardinal Stefano Borgia, who had died the previous year. Humboldt wrote, with some authority, that Cardinal Borgia had acquired the codex from the Giustiniani family, neighbors who had entrusted the document to some servants, who in turn had given it to their children as a plaything. As a result, before Humboldt ever saw it the manuscript had been burned and mistreated. When Cardinal Borgia died he left almost all of his possessions to the branch of the Vatican which he had directed for many years, the Congregatio de Propaganda Fide; his brother was to inherit the family museum. Although the codex was not located in the family museum at the time of the Cardinal's death, his brother sued for its possession. After a few years of legal wrangling the Congregatio was awarded the codex and housed it in its library. Late in the nineteenth century it was transferred to the Apostolic Library of the Vatican, where it remains today.

Pre-Columbian Manuscripts

The painted books of Mesoamerica represent an amazing legacy of the religious and historical knowledge acquired by the pre-Columbian people of Mexico and northern Central America. A scant few of these documents survive to this day. The vast majority of them were destroyed in the misguided efforts of early Spanish priests to stamp out all vestiges of the heathen religions of the native peoples. Accounts of the burning and destruction of hundreds and thousands of native books can bring tears to the eyes. We can only wonder today at the range and depth of information lost through the destruction of so vast a cultural resource. Despite this tragedy, much can be said about the manuscript-painting traditions of Mesoamerica. We have perhaps fifteen or so surviving books and manuscripts that were produced either before the Conquest or in a native style in the years directly after the arrival of the Spanish (Glass 1975:11–12). In addition to these works, there are about two dozen pictorial documents made by indigenously trained native scribes and artists for the Spanish conquerors as illustrations of native history, religion, custom and practice. Finally, there are literally hundreds of pictorial manuscripts produced by native artists during the early Colonial period in many ordinary contexts: maps to go with geographic descriptions, genealogies or histories to support claims to titles and tribute, lists of tribute actually paid or due, evidence for cases tried in Spanish courts, calendrical documents and many others.

The surviving pre-Conquest–style screenfolds include three classes or groups of books: Mixtec histories, Maya religious books and highland religious books. The histories include the seven Mixtec historical manuscripts, which deal with local history and royal genealogies from various communities in the Mixteca Alta and surrounding regions (Smith 1973, Byland and Pohl in press). A second group comprises the three or four surviving Maya screenfolds, all of which are painted on paper rather than animal skin (Glass 1975:77). These codices are substantially divinatory and calendrical in content and are written in a distinctively Mayan style incorporating much Maya hieroglyphic text. A third group of pre-Conquest books is known as the Borgia Group, named after their most prominent member, the Codex Borgia (Nowotny 1961a). These are all screenfolds on animal skin that are concerned with religious and ritual matters. They are painted in styles very similar, though not identical, to those of the Mixtec historical codices.

The Mixtec historical manuscripts include the Codex Zouche-Nuttall (Miller 1975, Troike 1987); the Codex Colombino-Becker I, composed of two rejoined parts (Troike 1980, Smith 1963, Caso and Smith 1966); the Codex Becker II (Nowotny 1961b); the Codex Bodley (Caso 1960); the Codex Selden (Smith 1983, Caso 1964); the Codex Vindobonensis (Furst 1978, Adelhofer 1963); and the Codex Egerton (Burland 1965).

The three widely accepted Maya codices are the Codex Paris (Anders 1968), the Codex Dresden (Anders and Dekkert 1975) and the Codex Madrid (Anders 1967). Each appears to be dedicated to the calendar, the deities of the Maya pantheon and the supernatural aspects of the calendar associated with ritual divination. A fourth codex, the Grolier Codex, may also be a member of this group though it is not yet universally accepted.

The Codex Borgia is the leading member of a small group of pre-Columbian manuscripts known collectively as the Borgia Group. The Borgia Group is particularly significant because of its pre-Conquest date and its religious content. The many manuscripts treating religious subjects that must have existed before the sixteenth century were particularly sought out for destruction by zealous Spanish priests and friars who were charged with ending idolatrous practices. The manuscripts of the Borgia Group seem to have been spared this fate by the happy accident of their having been sent to Europe, probably to Spain, early in the Conquest period.

In addition to the Codex Borgia, the principal screenfold members of the Borgia Group are the Codex Cospi (Nowotny 1968),

which is a ritual calendar with some ritual information on its reverse side; the Codex Fejérváry-Mayer (Burland 1971), which is a ritual calendar; the Codex Laud (Burland 1966), which is a ritual calendar with several other kinds of ritual information included; and the Codex Vaticanus B (Anders 1972), which is also a ritual calendar. The other related documents sometimes included in the group as minor members are the Fonds Mexicains no. 20, a single page of deerskin, and the Codex Porfirio Díaz, a screenfold that includes a section with similar ritual and religious content.

From these extant native-tradition books we may discern several characteristics of Mesoamerican written records. We know, for example, that books were not published in a European sense. That is to say, they were all handmade in single copies without the use of any type of impression-making device: no movable type, no stamps or rollers. It is arguable that every book was unique, made in one place by one patron and for one set of purposes. Information is shared among several of the codices but its form is never identical. Of course, the very small sample size of surviving manuscripts makes this generalization difficult to prove. It is certainly possible that books were exactly copied in a scribal tradition similar to that of the European monastic tradition, though no proof of this possibility exists.

It can be argued that the written literature of the pre-Columbian peoples was divided into categories in their minds as well as ours. Historical books deal with people, places, politics and genealogy. Religious documents deal with the calendar, ceremonialism and divination. Overlap between them is found in areas where historically important people participate in divination or other ceremonies and where politically significant places have sacred significance.

The content of the post-Conquest documents suggests the possibility of other written genres that have not survived. The codices do not contain two-dimensional maps of the landscape in forms familiar as such to European eyes. Despite this observation, the fact that space is represented in the codices in various ways (Pohl and Byland 1990) and the existence of many post-Conquest maps (see Glass 1975) suggest that space had been graphically represented in pre-Columbian times. In addition, the lists of tribute obligations of towns prepared for the Spanish tax collectors suggests the likelihood of similar record keeping before the European arrival. We can imagine the rulers of native communities making a sincere effort to keep such documents, if they ever existed, out of the hands of the new oppressors.

Pre-Columbian Religion

The religious beliefs of pre-Columbian peoples in Mesoamerica were vastly complex. There was a shared religious system over much of Mexico and northern Central America with regard to the calendar, the major deities, the structure of the world and the hierarchy of the supernatural world. Nevertheless, each town and region had its own nuances of belief that set it apart from its neighbors. Different deities were held in esteem in different places and many gods, even major ones, had differing characteristics of dress and behavior. Much of this complexity is not now discernible but some has been preserved. We know, for example, the patron deities of many communities whose particular charge was the protection of the local people and land.

The behavioral range covered by religion in ancient Mesoamerica was like that of any complex religious system. The gods were organized in a hierarchy reflecting that of the people. They came equipped with family ties, affections and jealousies, indeed with all the complexities of human life. They had potential influence over the very existence of the world, having caused its destruction and re-creation as many as five times, according to Aztec chroniclers. On a smaller scale they were thought to have the capacity to affect the forces of nature and the success of human endeavor. Rain would come only if the rain deity was properly propitiated. Wind would blow too strongly or too weakly unless the wind deity was correctly worshiped. Spirits inhabited the night air and the wild animals of the hills. Auguries and oracles could predict the success or failure of any activity. Patterns in nature were explained by the interaction of the forces of the supernatural world with those of the physical one. In all these ways and more, the supernatural was present in the daily lives of the people of Mesoamerica.

The people of the various towns and cities of ancient Mesoamerica had to be able to deal with the potent forces of the transcendent world above, below and around them. These interactions were often made on a personal level, at a family shrine, or by repetition of a special prayer or incantation in the fields or while doing some task. At other times connection to the power of the supernatural required a trained specialist, a priest. For this task a wide variety of specialized priests was available. There were priests dedicated to each of the many gods and other supernatural forces. There were bureaucratic priests dedicated to the ancestral deities of each town or region. There were priests who performed autosacrifice and human sacrifice. There were those who prophesied the future of natural phenomena and those who prophesied the future of human activity. There were priests who preached and others who taught.

For priests to be able to fulfill all these complex roles they had to have immense knowledge. Part of that knowledge was acquired in formal schools called *calmecac*. More was learned on the job as junior priests working with older, more experienced priests. Among the things required of priests was the ability to read books and interpret the information contained in them. That was nowhere more evident than in the case of the religious books, which served as densely packed compendia of vital information about the nature of the supernatural world and its relationships with the physical one. The Codex Borgia was just such a book.

Much of the capacity to interpret the codex was based on intimate knowledge of the gods and their many characteristics. The pantheon of ancient Mesoamerica was amazingly complex. The many deities often had multiple identities, different names and characteristics apparently being associated with a single deity. Similarly, the iconographic representations of deities often seem to display substantial overlap. Attributes associated with two or more individual deities could be represented on the person of a single god in a particular context. All this makes the study of pre-Columbian religion a daunting task. The most encyclopedic analysis of which I am aware is the masterly work of H. B. Nicholson (1971). A very strong, and more accessible, recent study is by Davíd Carrasco (1990).

It is not possible in any brief treatment to expound fully the intricacies of pre-Columbian religion and its extraordinarily complex deities. A few characteristics of a handful of the deities will have to suffice as an introduction here.

Quetzalcóatl is the Feathered Serpent. He is a god of rebirth and renewal. In one of his most important capacities he is known as Ehécatl, the god of the wind. He is at one and the same time the god of the wind, the four winds of the four directions and the 400 little winds that blow everywhere. In another identity he is known as Tlahuizcalpantecuhtli, the embodiment of the planet Venus as the morning or evening star. Quetzalcóatl was one of the creators of the sun and the world.

Tezcatlipoca is the Dark Smoking Mirror. He is an all-knowing, ever-present and all-powerful god. He, too, is a god of several capacities or personalities. Tezcatlipoca is sometimes represented as

the Red Tezcatlipoca (Tlatlauhqui Tezcatlipoca) and sometimes as the Black Tezcatlipoca (Yayauhqui Tezcatlipoca). He is the sower of discord and conflict, a god of darkness and warfare.

Tláloc is the god of rain and storm. He is the god of waters in the sky. Tláloc is a creator of life; his rain brings regrowth in the spring. He also carries the lightning and is responsible for destructive storms.

Chalchiuhtlicue is the consort of Tláloc. She is the goddess of running water, waters on the earth like lakes, rivers and springs. Her name literally means "Precious Green Stone Skirt."

Tlazoltéotl was a very basic and very complex deity. She was a goddess of the earth. She had a role as the goddess of the moon. She was sometimes known as Tlaelcuani and in that capacity was known as the eater of filth and excrement. In this role she was also a sensual goddess of enticement and sexuality. Other names for Tlazoltéotl included Teteoinnan, "mother of the gods," and Toci, "our grandmother."

There were, of course, dozens of other deities both high and low, some of whom will be identified briefly in the commentary below.

The Nature of the Codex Borgia

Purpose or Function

The Codex Borgia is a native-tradition religious manuscript from an unidentified part of the southern central highlands of Mexico, perhaps from somewhere in what is now the states of Puebla and Oaxaca. Though we do not know from what indigenous context it was first extracted by the Spaniards, it is not hard to surmise that it was a ritual document taken from a sacred place—perhaps a temple, a priest's residence or a sacred shrine of some sort. Its content suggests that it was used for several purposes. It seems to have been a prognostication tool for divining the future in various ways. Parts of the codex are ritual 260-day calendars. These are augmented by substantial sections delineating the signs of the days and the deities of the days and the nights. Other pages characterize various portions of the ritual calendar and still others relate the ritual calendar to the solar year. Another part of the manuscript presents a sort of numerological prognostication of the lives of wedded couples. Other sections concern the cardinal directions of the world and the supernatural characters and attributes of these regions. Other portions describe the characteristics of various deities, forming a sort of catalog of supernatural beings who can influence the world. Still other passages may contain a pattern for ceremonies for the installation of rulers in certain pre-Columbian kingdoms. These aspects will all be discussed below in an abbreviated commentary based largely on the work of Seler (1963) and Nowotny (1961a).

An underlying level of meaning within the Codex Borgia is found in its frequent depictions of the various deities and other supernatural beings. The interpretation of auguries depended on the priest's reading of the images and his knowledge of the characteristics of the various powerful creatures represented.

Approaches to Reading the Codex

The Codex Borgia is composed of 39 equally sized leaves. The first and last of these, the outside surfaces of the stack of folded pages, were affixed to end pieces, presumably fashioned of wood. Every exposed side of the manuscript was painted with information by the artist or artists who created the document. We thus have 37 leaves that are painted on both sides and two end leaves painted on only one side, for a total of 76 painted pages.

The wonderful character of a screenfold manuscript, in comparison with a modern binding, that the reader is not restricted to seeing only two pages at once. When a screenfold book is opened two, four, six or more pages can be seen at a time. Indeed, the pages being consulted simultaneously do not need to be consecutive or even on the same side of the manuscript. This structure allows for easy transgression of a simple linear reading order. Flashbacks, flashforwards and cross references can be found entirely out of the simple flow of time.

As a result of this versatile format, reading order for a learned scribe could be very diverse. He could read a book from beginning to end in a linear form similar to ours, or else read several pages at once, referring back and forth as needed through many images to follow different aspects of the information being studied. Clearly the skill required to read these books was not easily obtained.

The Content of the Codex

Though the content of the Codex Borgia is only partially understood, we can say with assurance that it is a ritual book. Substantial parts seem to be a text of standard ritual information, to be used like a reference book. Other parts seem to be mnemonic devices encoding more arcane ritual information. Yet another part seems to have been a prescriptive set of directions for the performance of a particular series of ceremonies. The best and most detailed commentaries on the manuscript are those written by Eduard Seler (1904–09) and K. A. Nowotny (1961a). Their work notwithstanding, much of the interpretation offered to date is limited. While codex scholars have been able to work out much of the calendrical order and to recognize some of the deities, creatures and objects depicted in the manuscript, the contexts in which they have been portrayed are still not fully understood. It is still necessary to identify the more obscure images and to divine the relationships between the deities and activities depicted and the calendar to which they are attached. Efforts to do so are ongoing. Similarly, it is still necessary to pinpoint the language spoken by the original authors of the Borgia Group codices; many separate languages were spoken in the likely regions of origin. Recent work on these manuscripts has been conducted by a handful of scholars from around the world, among them Peter van der Loo, John M. D. Pohl, Maarten Jansen, Eduardo Matos Moctezuma, Mark King and Edward B. Sisson.

What follows here is a very brief redaction of the commentaries of Seler and Nowotney, informed by the more recent work of Pohl (Pohl and Byland n.d., 1991) and van der Loo (1982, 1987 and personal communication) and with a few ideas of the present writer. It is intended to help the novice reader begin the search for understanding. All readers of this introduction are encouraged to pursue the study of ancient Mexican religion by referring to more extensive commentaries on the codex and to other more general studies of pre-Columbian religion (Carrasco 1990, León-Portilla 1963, Lopez Austin 1973, Nicholson 1971) and writing (Benson 1973, Marcus 1992, Smith 1973). The text of the Codex Borgia has been arbitrarily divided into a number of groups of pages or parts of pages that seem to make sense when taken together. Though these divisions seem today to be reasonable, they should not be considered to be absolutely authoritative. New insight may be gained by trying new ways of seeing and understanding the images of highland pre-Columbian writing systems.

An Abbreviated Commentary on the Codex Borgia

Plates (Original Pages) 1–8: The First Calendar, a 260-Day Ritual Calendar

A fundamental tool of ritual prognostication and divination throughout ancient Mesoamerica was the 260-day ritual calendar, known to the Aztecs as the *tonalpohualli*, or "the book of the days." (In many ancient Mesoamerican languages the term for the ritual calendar had much the same meaning; the Mixtecs, for example, had several names, including *tutu yehe dahui quevui,* "the book that has the days.") This ritual calendar, covering a period that is shorter than the solar year, was used for various purposes. It was much more than just a list of days: it expressed the relationship between time and space and between both of them and the world of the gods. The Mixtecs had another term for the calendar that conveys some of this interconnection: *nee ñuhu duyu dusa*, meaning more or less "all the spirits who support the disc of the earth" (Alvarado 1962[1593]:41v, Arana and Swadesh 1965). The disc of the earth is the plane upon which we live. It is composed of four cardinal directions and linked to the realms above and below by a central hinge that constitutes a fifth direction. Periods within the calendars are associated with specific supernatural figures and are linked to the five directions. Here the relationship of time, space and the supernatural world becomes evident.

The 260-day ritual calendar was constructed using two continuous sequences, one of 13 numbers and the other of 20 day signs. The 13 numbers run in sequence and then start again. Similarly the 20 day signs run in sequence and then start again. The total number of uniquely identified days using this system, then, is 13 times 20 or 260. In Figure 1, the 260 days of the calendar are arranged in 13 columns and 20 rows. To the left of each row is found the day sign, and in each cell of the diagram is the corresponding day number. The calendar in this form should be read from top to bottom and from left to right through 260 days. In this illustration the first day is 1 Alligator, the second day is 2 Wind and so on. The thirteenth day is 13 Reed, but be sure to note that the fourteenth day is 1 Jaguar, not 14 Jaguar, because only 13 numbers are used in the day-number cycle.

The first eight pages of the Codex Borgia enumerate the 260 days of the *tonalpohualli* together with images that seem to carry information about the qualities of these days. Here the 260 days are arranged in five narrow rows of day signs with the 13 numbers omitted. Above and below the rows of day signs are 104 taller images laid out in two rows. These 104 images are unique depictions of people, deities, places or things that presumably have supernatural qualities. They are usually taken to be qualifiers for the five specific days shown between each upper and lower pair. Some are clearly of standard deities. Tonatiuh, Tezcatlipoca, Xipe Tótec and others.[1] Others represent natural objects and artifacts: the scorpion, offerings, bundles, serpents, the sky, the sun and many other things. Still others seem more religious and iconographic: images of human sacrifice and other offerings, serpents descending from the sky, blood flowing from the sun, complex sacred bundles and other things laden with unknown meaning. The actual significance to a pre-Columbian priest of these many

different images remains obscure but can certainly be the subject of further study.

The enumeration of 260 days begins with a drawing of the Alligator at the lower right corner of the five narrow rows on Plate 1. It then proceeds from right to left across all eight pages of the *tonalpohualli*. At the end of that row, at the bottom left corner of Plate 8, the day sign for Grass is found. It is the fifty-second day sign and should, if 1 Alligator was the first day, represent the day 13 Grass. The next day in the sequence should be the day 1 Reed. The only place that Reed is found at either end of one of these five rows of day signs is at the right end of the next row up, the second row from the bottom on Plate 1. If the reading continues there, Reed is followed by Jaguar and Eagle and Vulture and so on. Following this pattern, the calendar is read as five rows of 52 day signs from right to left and from bottom to top. The last day in the calendar is the day Flower, which should be 13 Flower if the first day was indeed 1 Alligator.

Plates 9–13: The 20 Deities of the 20 Named Days

The next five pages of the Codex Borgia are also meant to be read as a unit, as they depict 20 deities, four to a page. Each quarter-page contains a deity, an elaborately drawn day sign and another figure or group of figures. These five pages undoubtedly carry information important to the interpretation of the supernatural qualities of each of the 20 days.

The five pages of the deities of the days are meant to be read in the order of the days, beginning with Alligator in the lower right quadrant of Plate 9. The reading order then proceeds from right to left along the lower register across pages in succession until the lower left quadrant of Plate 13 is reached with the deity of the day named Dog. The next day sign in sequence is Monkey, which is found on page 13 just above Dog—that is, in the upper left quadrant. The reading order then proceeds from left to right until you reach the day Flower in the upper right quadrant of Plate 9, just above the first of the 20 day names. This arrangement of the days sets up a cyclic structure: the reading can proceed continuously through the circle of 20 names again and again in a never-ending cycle, just as the calendar goes on and on.

The deities associated with each day sign are characters who have some relationship with the natural qualities of the name of the day, though these relationships are not always obvious. The identification of these 20 deities was accomplished by both Seler and Nowotny, who used the iconographic associations of the images as drawn here and in other native-tradition manuscripts. Another detailed analysis of the intricacies of the imagery and inter-deity associations is to be found in Spranz (1973). A summary is offered here; extensive explication of the main areas of influence of each of these deities is beyond the scope of this introduction.

DAY SIGN	DEITY (NAHUATL)	DEITY (ENGLISH)
Alligator	Xochipilli/ Tonacatecuhtli	Prince of Flowers/The Supreme Male Deity
Wind	Quetzalcóatl/ Ehécatl	Feathered Serpent/Wind Deity
House	Tepeyóllotl	Heart of the Mountain
Lizard	Huehuecóyotl	Old Coyote
Serpent	Chalchiuhtlicue	Goddess of Running Water/Precious Green Stone Skirt
Death	Tecciztécatl	Goddess of the Moon
Deer	Tláloc	Rain and Storm (Rain of Fire)
Rabbit	Mayáhuel	Goddess of Maguey

[1]Since we do not know the language spoken by the authors of the Codex Borgia the Nahuatl (Aztec language) names for deities will be used. The Nahuatl names are well known thanks to many records from the early Colonial period. The reader should understand that the attributes of the deities depicted in the Codex Borgia may not have exactly coincided with those of their Aztec counterparts.

FIGURE 1: DAY SEQUENCE FOR THE 260-DAY CALENDAR.

Alligator	1	8	2	9	3	10	4	11	5	12	6	13	7
Wind	2	9	3	10	4	11	5	12	6	13	7	1	8
House	3	10	4	11	5	12	6	13	7	1	8	2	9
Lizard	4	11	5	12	6	13	7	1	8	2	9	3	10
Serpent	5	12	6	13	7	1	8	2	9	3	10	4	11
Death	6	13	7	1	8	2	9	3	10	4	11	5	12
Deer	7	1	8	2	9	3	10	4	11	5	12	6	13
Rabbit	8	2	9	3	10	4	11	5	12	6	13	7	1
Water	9	3	10	4	11	5	12	6	13	7	1	8	2
Dog	10	4	11	5	12	6	13	7	1	8	2	9	3
Monkey	11	5	12	6	13	7	1	8	2	9	3	10	4
Grass	12	6	13	7	1	8	2	9	3	10	4	11	5
Reed	13	7	1	8	2	9	3	10	4	11	5	12	6
Jaguar	1	8	2	9	3	10	4	11	5	12	6	13	7
Eagle	2	9	3	10	4	11	5	12	6	13	7	1	8
Vulture	3	10	4	11	5	12	6	13	7	1	8	2	9
Movement	4	11	5	12	6	13	7	1	8	2	9	3	10
Flint	5	12	6	13	7	1	8	2	9	3	10	4	11
Rain	6	13	7	1	8	2	9	3	10	4	11	5	12
Flower	7	1	8	2	9	3	10	4	11	5	12	6	13

Day Sign	Deity (Nahuatl)	Deity (English)
Water	Xiuhtecuhtli	God of Fire
Dog	Mictlantecuhtli	God of the Underworld
Monkey	Xochipilli	Prince of Flowers
Grass	Patécatl	God of Pulque
Reed	Tezcatlipoca-Ixquimilli	The Smoking Mirror with Bandaged Eyes
Jaguar	Tlazoltéotl	Goddess of Filth and the Earth
Eagle	Tlatlauhqui Tezcatlipoca	Red Smoking Mirror
Vulture	Itzpapálotl	Obsidian Butterfly
Movement	Xólotl	God of Twins
Flint	Chalchiuhtotolin	Turkey of the Precious Stone
Rain	Tonatiuh	The Sun
Flower	Xochiquétzal	Flower-Quetzal Feather

Plate 14: The Nine Deities of the Night

The next page of the Codex Borgia changes the format to an arrangement of three rows of three deities each. These nine divine beings are generally understood to represent the supernatural rulers of the nine hours of the night, and are connected to the first nine day signs from the list of 20 days. Each of these gods stands offering a bundle of sticks, a rubber ball and a quetzal feather as the components of a burnt offering that perhaps symbolizes the night in some way.

The nine deities of the night hours are read in a serpentine pattern beginning at the bottom right and proceeding from right to left across the lower register. As the end of that register is reached, the reading proceeds, in the order of the days, directly up to the middle register at the left margin and then proceeds from left to right, and finally up to the upper register and there from right to left. The identifications of the deities who rule these nine parts of the night are indicated below. You will note that, though the calendrical signs tied to them are the same as the beginning of the list of 20 days given in the previous five pages, the deities are different (or at least associated with different day signs).

Night Hour	Deity (Nahuatl)	Deity (English)
Alligator	Xiuhtecuhtli	God of Fire
Wind	Itztli (Yayauhqui Tezcatlipoca)	Flint (Black Smoking Mirror)
House	Piltzintecuhtli	God of Youth (a solar deity)
Lizard	Cintéotl	God of Maize
Serpent	Mictlantecuhtli	God of Death (the Underworld)
Death	Chalchiuhtlicue	Goddess of Running Water/Precious Green Stone Skirt
Deer	Tlazoltéotl	Goddess of Filth and the Earth
Rabbit	Tepeyóllotl	Heart of the Mountain
Water	Tláloc	Rain and Storm

Plates 15–17: 20 Deities and 80 Days

The next two and one-third pages are filled with 20 images of deities connected to 20 groups of four days each. The signs of the days form a continuous sequence of 80 days. Each deity is depicted with subordinate characters who are shown as sacrifices, offerings, newborn children or nursing infants. The purpose of these subordinate figures is not clearly understood but seems in a way to characterize groups of the main deities.

Five groups of four day signs are needed to go through one complete set of 20 days. Only five of the 20 possible day signs can be found in the lead position in each group of four days. The first day of each group of four will always be Alligator, Serpent, Water, Reed or Movement. As a result of this peculiarity, the 20 deities can be grouped in two different ways. The five deities who illustrate one group of 20 consecutive days belong together. Similarly, the five deities who illustrate the same set of four day signs can be said to belong together. As it turns out, each of the four groups of five consecutive deities is also linked by their actions. Hence, one of each group is connected to each set of four day signs.

Seler assigns directional qualities to the days and their deities. The directional system of Mesoamerican religion has five cardinal directions—North, South, East, West and Center, with Center being a kind of linchpin connecting the four directions and linking them to the abodes of the gods above and below the disc of the Earth. Seler has suggested that the directional associations of the five groups of four days—the groups that begin with Alligator, Serpent, Water, Reed and Movement—are West, South, Center, East and North.

The reading order of days is the same as in the day lists given above. It begins at the lower right corner of Plate 15 with the day sign Alligator, and then proceeds from right to left across Plates 15 and 16. After 20 days, five groups of four days and five corresponding deity images, the count of day signs begins again in a continuous cycle. Each of these first five deities is seen to be sacrificing the eye of a smaller human figure with a sharpened bone awl. The reading then continues to the last image on the lower register of Plate 16 and, following the order of the days, moves up to the center register at the left side and from there continues from left to right back across Plate 16 and Plate 15. These five deities are all offering small figures who share attributes with them and indeed generally seem to be smaller versions of these very deities. On Plate 15, in the center panel of the page, the day-sign sequence begins again and the behavior of the deities again changes. This group of five deities is shown holding the umbilical cords of small figures that are in the pose of a newborn baby. Midway in this sequence the reading has moved up to the upper register of Plate 15 and has changed direction again to move from right to left. All five of the birth figures are found on Plate 15. As the reading continues to Plate 16, the fourth and last group of five deities and 20 days begins. In this group the deities are all female and four of the five are nursing infants, three of whom are human children and one an animal. The fifth deity is nourishing a full-sized skeletal figure with blood rather than milk, thus maintaining the pattern with an altered image. The last two images of this sequence are found on the upper register of Plate 17, a placement necessary to complete the pattern of 20 deities and 80 days.

A result of this structure is that the first five deities in the list of 20 may be taken to characterize the five cardinal directions for a certain quality, perhaps that of sacrifice. The second group of five may characterize the five cardinal directions for offering, the third for birth and the fourth for sustenance. Alternatively, we might group together the four deities who are linked calendrically to the West (and similarly for each of the other directions) and say that they describe four qualities of that direction, the qualities of sacrifice, offering, birth and sustenance.

An identification of most of the deities in this list of 20 is as follows (each will be listed with its directional association following Seler). The first group of five: W–Cintéotl (God of Maize); S–a complex deity not yet identified; C–Mictlantecuhtli (God of the Underworld); E–Quetzalcóatl (God of the Wind); and N–Xochipilli (Prince of Flowers). The second group of five: W–Xochiquétzal (Flower-Quetzal Feather); S–Tláloc (God of Rain and

Storm/Rain of Fire); C–Mictlantecuhtli (God of the Underworld); E–Tlahuizcalpantecuhtli (God of Venus as the Morning Star); and N–Mixcóatl (God of the Hunt). The third group of five: W–Xochipilli (Prince of Flowers); S–Tonatiuh (God of the Sun); C–Tezcatlipoca-Ixquimilli (Smoking Mirror with Bandaged Eyes); E–Xipe Tótec (Our Lord the Flayed One); and N–Macuilxóchitl (5 Flower, God of Games). The fourth and last group of five: W–Mayáhuel (Goddess of Maguey); S–Tlazoltéotl (Goddess of Filth and the Earth); C–Mictecacíhuatl (Goddess of the Underworld), E–Chalchiuhtlicue (Goddess of Running Water); and N–Xochiquétzal (Flower-Quetzal Feather).

Plate 17: Tezcatlipoca with the 20 Day Signs on His Body and Costume

The lower portion of Plate 17 contains a large and beautiful image of the deity Tezcatlipoca in his black guise. This image expresses the magical relationships between certain parts of his body and costume and each of the 20 day signs. The association of day signs with body parts presumably has at least some connection with ritual curing, but since several day signs are associated with costume elements rather than with body parts, the curing explanation is limited. Seler and Nowotny believe that these day signs express attributes that are in some way appropriate to the form or function of the costume elements involved. Why Tezcatlipoca rather than some other deity is used as the base upon which to show these relationships is not clear.

Plates 18–21: Eight Supernatural Scenes with Calendrical Associations

The next four pages of the codex form an abbreviated 260-day calendar that follows the structure of the first *tonalpohualli,* found on the first eight pages of the manuscript. Each of these four pages is divided into upper and lower halves, with each half further divided into a band of five day signs and a wider band of images of supernatural characters and their appurtenances.

The reading order begins with the lower register of Plate 18, proceeds from right to left across all four pages, moves up to the upper register of Plate 21 and from there proceeds from left to right until Plate 18 is again reached. The five day signs on each of these eight panels are equivalent to a single column of five day signs in the *tonalpohualli* found on Plates 1 to 8. For example, the first panel—the lower panel on Plate 18—shows five day signs beginning with Alligator and continuing with Reed, Serpent, Movement and Water. These are not in the order one would expect from the sequence of 20 day signs, but if you direct your attention to the rightmost column of day signs on Plate 1 you will find these same five day signs in identical order from bottom to top. At the left side of the larger panel on the lower half of Plate 18 there are six red dots. These represent the next six columns of day signs found in the first *tonalpohualli.* The eighth column of day signs in the *tonalpohualli* (Plate 2, second column from the right) includes the day signs Rabbit, Flower, Grass, Lizard and Vulture. These are the same as the day signs depicted in the lower register of Plate 19. The entire ritual calendar is represented in this fashion: a column of day signs (that is, a column in the first *tonalpohualli*), red dots as spacers, a column of day signs, red dots as spacers and so on.

With this explanation, the pattern of reading the day signs and interpreting them as an abbreviated 260-day calendar has been established. The five day signs on each half-page of Plates 18–21 represent one column of days in the calendar arranged as five rows of 52 days each (Plates 1–8). The dots between pages on Plates 18–21, to the left on the lower register and to the right on the upper register, serve as spacers or place holders and represent the given number of columns of days. Each of the sets of enumerated days can be found in the first *tonalpohualli* by skipping over the number of columns equal to the number of red dots indicated, and then looking at the next column of days. Adding up all of the dots and the eight groups of days that are actually enumerated, we get 52 groups of five days, the entire 260-day *tonalpohualli.*

This unusual arrangement suggests that the images in the eight larger panels were not intended to qualify or characterize eight periods within the *tonalpohualli.* Rather, they seem to refer to five separate short periods of seven or five days each (interpreting the red dots as time included with the five named days) or five single days separated by six or four days each (reading the red dots as spacers between the relevant periods). In either case, the possibility that images in the major bands were intended to have significance apart from the simple counting of days must be considered.

The first panel, on the lower half of Plate 18, contains an image of the solar deity, Tonatiuh, who is making an offering in front of a temple.

The second panel, found on the lower half of Plate 19, contains the image of Quetzalcóatl standing in front of a platform that supports a tree and the God of Venus as the Morning Star.

The lower half of Plate 20 contains an image of Chalchiuhtlicue, the Goddess of Running Water. She stands making an offering of blood before a smoking stream that contains a fire serpent and supports minimal images of two deities identified by Seler as Xochiquétzal, Goddess of Love, and Nanahuatzin, a God of Lechery and of the Evening Sun.

The lower part of Plate 21 contains the fourth scene of this series. It is dominated by the image of the Black Tezcatlipoca to the right of a ball court and the smaller image of the Red Tezcatlipoca to the left.

The reading order reverses now as we move to the upper register of Plate 21. Here the Red and Black Tezcatlipocas have changed their relative sizes and their sequence. The Red Tezcatlipoca is shown as a traveler with a walking stick and a backpack. The smaller Black Tezcatlipoca is placed at the end of the path.

The next image, on Plate 20, shows the rain deity Tláloc cultivating corn using a *coa* or wooden digging stick. A smaller Tláloc shown at the center of the image throws curved lightning at a corn plant, which is thus destroyed.

The seventh panel of this group is found at the top of Plate 19. It shows the God of the Planet Venus (perhaps as Evening Star) chopping branches from a tree with an ax.

The last of the eight scenes follows on the upper half of Plate 18. Here the background is obscured in a representation of the night or the darkness of the underworld. The two main deities seen here are the male and female gods of death and the underworld, Mictlantecuhtli and Mictecacíhuatl. An inset rectangle placed between them represents the dark sky with the moon and stars.

The manner in which these eight pages would have been used by an ancient Mesoamerican priest remains obscure. The physical pattern of relationship to the calendar is very clear. The significance of that relationship is far from clear. How the eight panels are related one to the other, and what directional significance should be attached to the days tied to each of them, is difficult to interpret.

Plate 22: Two Deer That Represent One Half of a 260-Day Calendar

The upper portion of Plate 22 uses the same shorthand system of referring to the first *tonalpohualli* that we have just seen in the

previous four pages. In this case the page is divided into two halves, right and left. Each half is divided into three bands, the upper band containing the image of a deer and 12 place-holding red dots, and the middle band containing five day signs. (The lower band is part of the next passage, to be discussed below.)

The two rows of five day signs in the middle register represent columns of day signs from the *tonalpohualli* found at the beginning of the Codex Borgia, on Plates 1 through 8.

As we read from right to left across the upper two registers, the first half of the page contains the image of a white male deer, which is apparently dead, and the five day signs of the first column of the *tonalpohualli*. The 12 red dots drawn to the left of the deer mark the place of the next 12 columns of days and, together with the five day signs enumerated below, represent one quarter of the days in the *tonalpohualli*, those shown in the first quarter of the calendar. Note that these are not the first 65 consecutive days of the calendar round of 260 days. They represent five discontinuous groups of 13 days each.

Continuing the reading on the upper two registers of the left half of the page, we find a tan male deer, which is being pierced by an arrow, and the five day signs of the fourteenth column of the *tonalpohualli*. Just as before, to the left of the wounded deer we see 12 red dots, which this time represent the fifteenth through twenty-sixth columns of day signs in the *tonalpohualli* from the first eight pages of the Codex Borgia.

These images are odd in that they refer to only half of the *tonalpohualli*, the first two quarters of the calendar. No reference is made to the third and fourth quarters. The directional associations generally identified with the first two parts of the calendar are East and North. Why these two clusters of days are defined here and the others are not mentioned is not yet completely understood.

Plates 22–24: 20 Supernaturals Associated with the 20 Day Signs

The bottom third of Plate 22, and the next two pages, contain another list of 20 deities or their representatives in association with the 20 day signs. These figures are not all images of deities. Some seem to be priests dedicated to deities, others seem to be objects symbolic of deities and one seems to be a world region. Many of the deities are unusual composites and are difficult to identify. The relationship of this list to that of the deities of the day signs enumerated on Plates 9 through 13 of this codex is not understood. Clearly, the supernaturals associated with the day signs are different but we do not know why. It may be that this list is of patrons of some particular parts of the days or that it refers to the numbers 1 to 20 rather than to days.

The reading order of this series of 20 images is serpentine. The day signs are found in normal order, beginning with Alligator at the bottom right of Plate 22. Reading then flows from right to left across Plates 23 and 24. Upon arrival at the bottom left panel of Plate 24, with the day sign Rabbit, the sequence moves up to the middle register and the day sign Water. Reading proceeds from there from left to right back across Plates 24 and 23 until the day sign Jaguar is reached and the order moves up to the top right of Plate 23, where Eagle is found. From there again reading proceeds from right to left until the top left of Plate 24 is found at the day sign Flower.

The relationship, if any, of the 20 days and their supernatural figures is unknown. Rather than belabor what we do not know, I will conservatively follow Seler in attempting to identify the 20 images on these three pages. Where an identification has eluded us a question mark will be found.

DAY SIGN	SUPERNATURAL (NAHUATL)	SUPERNATURAL (ENGLISH)
Alligator	priest of Quetzalcóatl	Feathered Serpent/Wind Deity
Wind	?	a god of death and blood
House	Quetzalcóatl	Feathered Serpent/Wind Deity
Lizard	Quetzalcóatl as bird	Feathered Serpent/Wind Deity
Serpent	Chalchiuhtlicue as bird	Goddess of Running Water
Death	?	jaguar supporting sky
Deer	Nanahuatzin?	God of Lechery and Evening Sun
Rabbit	Xipe Tótec	Our Lord the Flayed One
Water	Xochipilli?	Prince of Flowers in his solar or fire aspect
Dog	Tamoanchan	The Western Region (a place)
Monkey	?	An animal/human god of music
Grass	Tonatiuh	Sun God
Reed	Tonatiuh	Sun God as autosacrificer
Jaguar	Teyollocuani	priest—eater of hearts
Eagle	?	black priest—related to Tláloc
Vulture	Patécatl (symbolically)	pulque vessel and rabbit
Movement	Tlazoltéotl	Goddess of Filth and The Earth
Flint	Íztac Mixcóatl	Old God of the Heavens
Rain	Chalchiuhtlicue	Goddess of Running Water
Flower	Xochipilli (symbolically)	corn plant and fire serpent

Plates 25–28: The Five Directions with Calendrical Notations

Here follow four pages in each of which the world is shown divided into five parts. In each of these representations the implication is that there are four cardinal directions and a fifth, central, direction. Of course, in addition to the spatial significance of these images there is in each case a calendrical significance as well. Plate 25 presents four deities, placed in the four corners of the page. They are divided by a peculiar arrangement of the 20 day signs. The day signs are arranged in a cross surrounding an enlarged Movement sign, which is given the number 10 (the ten dots). Three leftover day signs are tacked on in the upper left corner of the page. The order of the day signs can easily be followed but is very unusual, beginning with Alligator in the upper arm of the cross but then going to the left arm with Wind, House and Lizard, and from there to Serpent, Death and Deer in the lower arm, and from there to Rabbit, Water and Dog in the right arm, and from there to Monkey, Grass and Reed in the upper arm, from there jumping to the three signs in the corner, Jaguar, Eagle and Vulture, and finally hopping back to finish the count from the central Movement and then Flint from the left arm, Rain from the lower arm and Flower from the right arm. Though there is a pattern, there is no readily apparent reason for this odd display.

The four deities are the patrons of the four cardinal directions. Each is tied physically to an arm of the cruciform calendar by a red line. The patron of the West is Xipe Tótec, Our Lord the Flayed One, shown in the lower left corner. The patron of the South is Tláloc, the god of rain and storm, shown in the lower right corner. The patron of the East, shown in the upper right corner, is a complex figure who bears elements of the solar deity and a god of pulque. The patron of the North is Mixcóatl, the god of the hunt, shown in the upper left corner. No patron deity is shown for the central direction. It is simply named "10 Movement."

Plate 26 contains another unusual display of the five-directional scheme coupled with an unusual arrangement of the 20 day signs.

The human skull in the center is surrounded by the 20 day signs in a new and unusual array. These, in turn, are surrounded by four deceased and bundled deities, who have been placed on thrones, and by four human figures interspersed between them.

The calendrical figures (the day signs) begin, as usual, with Alligator at the bottom of the group of four signs on the right side of the central skull; one reads up that column and from there across the second group of four day signs, above the skull. That gets the reading through Rabbit and up to Water. The day sign Water is found at the corner next to Rabbit, and the reading order proceeds counterclockwise around the four corners of the square (Dog, Monkey, Grass). After the day sign Grass (located at the top right corner) the reading picks up again at the top of the left column of day signs with the sign for Reed and proceeds down that group of four and on to the fifth and last group across the bottom of the square, which is read from left to right.

The four deities located at the four sides of the calendar square and the skull in its center are to be associated with the cardinal points of the compass. The deities are shown as deceased: their eyes are closed, they are wrapped in cloth and tied in funerary bundles, and they bear funerary banners. The figure at the right side of the page is Chalchiuhtlicue, the goddess of running water, as patron of the four day signs of the West. At the top of the page we find Mixcóatl, god of the hunt, as patron of the day signs of the South. At the left side of the page is Xochipilli, the young prince of the flowers, as patron of the day signs of the East. At the bottom of the page is a dark deity as patron of the day signs of the North. This character seems to be the same as the unidentified patron of the Eagle day sign at the top right corner of Plate 23. The central direction is characterized by a skull and four long bones painted within the square formed by the 20 day signs.

The directional associations given here disagree with those given by Seler in his discussion of this part of the manuscript, but agree with his determination of the directionality of the day signs as discussed earlier, in the analysis of Plates 15–17.

The use of a death's-head as the symbol of the Center direction and of the dead deities on the four sides suggests that this page describes the directional scheme of the world in the land of the dead and relates that spatial information to five divisions within the sequence of 20 day signs.

Plate 27 repeats the basic theme of these pages, the division of the world into the five directions and their relationship to the calendar. This page, however, is different from all the previous temporal information presented in the Codex Borgia because here, for the first time, the year being referred to is not the magical 260-day *tonalpohualli* but the solar year of 365 days.

The solar year can be formed from the 13 day numbers and the 20 day signs by using 18 cycles of 20 signs plus 5 other named days $((18 \times 20) + 5 = 365)$ or by using 28 cycles of 13 numbers plus 1 other day number $((28 \times 13) + 1 = 365)$. A mathematical consequence of these relationships is that every year will begin one day number and five day signs ahead of the previous year. That means that all the solar years will start with one of only four possible day signs and will count smoothly through the 13 day numbers and then begin again in a perpetual cycle. A further consequence of the comparison between the 365-day solar year and the 260-day magical year is that the initial dates of the years do not repeat until 52 solar years have passed. This 52-year period can be divided into four parts of 13 years each. As it turns out, each of these quarters begins with a date that has the coefficient of 1 and one of the four year bearers.

If the calendar starts with the day 1 Reed, as most Mesoamerican calendars do, then the four quarters of the 52-year period are begun by days named 1 Reed, 1 Flint, 1 House and 1 Rabbit. These days

are shown on Plate 27, one in each quarter of the page. Oddly, there are four other days indicated besides these normal year-bearing days. These other days are 1 Alligator, 1 Death, 1 Monkey and 1 Vulture. These four days are separated from each other in exactly the same fashion as the more normal year bearers. If the solar calendar began on the same day as the ritual calendar, then the year bearers would have these four day names. These four days, 1 Alligator, 1 Death, 1 Monkey and 1 Vulture, would be the initial dates of the four quarters of the 52-year period in such a calendar. Their association here with the more normal solar calendar seems to show the relationship of the *tonalpohualli* as related in the Codex Borgia to the familiar solar calendar. How this relationship influenced the interpretation of the days is not fully understood.

Plate 27 is composed of four quarters and a central panel, representing the four cardinal directions and the Center. Each of these five sections contains an image of Tláloc, the god of rain and storm, looking skyward and pouring water onto the earth below. Each of these deity figures is colored and dressed differently, though each is clearly a manifestation of the rain deity. In the four corners the Tlálocs are standing over fields of corn which are, in turn, resting on two day signs with the numerical coefficient of 1, indicated by an embellished dot. In the center Tláloc is standing over a representation of the earth with two small figures of Chalchiuhtlicue, goddess of running water. The Tláloc in the center is a White-and-Red-Striped Tláloc, who embodies both fertility and pestilence. Since the 52-year period is completed by the periods associated with the four quarters or directions, there are no time markers associated with the Center direction.

The four cardinal directions and the years associated with them are each shown to have different qualities. In the lower right quadrant the Black Tláloc represents the first quarter of the 52-year cycle and the direction East. His period of 13 years begins with the year 1 Reed (1 Alligator). He sheds rain on a healthy field of corn, suggesting that the East is a fertile and fecund region. The upper right quadrant contains a Yellow Tláloc representing the second quarter and the North. His period begins with the day 1 Flint (1 Death). Here locusts are shown destroying the corn despite the rain. The upper left quadrant contains a Blue Tláloc representing the third quarter and the West. His period begins with the year 1 House (1 Monkey). The cornfield here is inundated with water, perhaps suggesting excessive rain. The lower right quadrant completes the 52-year period and depicts a Red Tláloc representing the fourth quarter and the South. His period begins with the day 1 Rabbit (1 Vulture). In this panel the ears of corn are being eaten by small furry animals with little skeletal jaws.

Plate 28 has much in common with the previous page of Tlálocs in their relation to the solar year and to the 52-year period, but it is also quite distinct. This page, too, contains five images of Tláloc, set in the center and the four corners. It, too, shows rain falling on corn and it, too, has indications of a solar calendar in the dates painted below the Tláloc figures. It stands apart, though, in that the dates are different, each containing a year sign and two day dates seemingly selected at random. It is also different if Seler's interpretation is correct and the directions are placed differently on the page. It is further different in that supplementary supernaturals are shown in containers or on the earth below each Tláloc.

A guiding characteristic of this arrangement is that each of the directional panels is labeled with a date that incorporates a year sign. These years are consecutive and are the first five years of the 52-year cycle. The bottom register of the page is badly damaged in the original and is not completely reconstructed by Díaz and Rodgers. Seler has been able to infer some information about this row of dates that cannot now be seen. For example, in the lower right panel there are three dates. The leftmost of these must have

had a year sign, in the form of an intertwined capital A and O, behind it and must have been the year 1 Reed. We know this because the pattern continues in the upper right quadrant, where the rightmost date is 2 Flint with an A-O year sign behind the Flint. From there the upper left quadrant has the year 3 House with the A-O year sign as its rightmost date. The lower left quadrant should have 4 Rabbit with the year sign as its leftmost date but it, too, is illegible. The center, which here has time indicators unlike on the previous page, has the year 5 Reed as its leftmost date. These five years are the first five of the 52-year period of solar years. It is this interpretation by Seler that unequivocally ties this page to the solar-year cycle.

Though the day dates seem to be chosen at random, there may be some as yet unrecognized underlying order to them. It seems unlikely that they are truly insignificant.

The five directions with their Tláloc figures are differently located and characterized when compared to the previous page. Here reading begins as before at the lower right quadrant, where the first year sign was once located, the year 1 Reed. Tláloc is black in this panel and has the face paint of Tezcatlipoca, the God of the Smoking Mirror and God of the Night. This conjoined Tláloc/Tezcatlipoca is interpreted by Seler as the patron of the North. The second year, 2 Flint, is found in the upper right panel, where a White-and-Red-Striped Tláloc has the face paint of Tlahuiz-calpantecuhtli, the god of Venus, in this case as the Evening Star. This compound deity is said to be the patron of the West. The third year is 3 House, found at the upper left corner of the page. Tláloc here is yellow and has the fact paint of Xiuhtecuhtli, the god of fire, thought to be the patron of the East. The fourth year, 4 Rabbit, is at the lower left and is protected by the black figure of Tláloc. This Tláloc has only two elements of facial adornment to suggest a composite nature. They are a yellow beard, barely visible in the original and not reproduced in the Díaz and Rodgers restoration, and a yellow line at the front of the face. These tiny features are characteristic of Quetzalcóatl, the Feathered Serpent and the wind deity. His presence is further indicated by the small effigies of Quetzalcóatl that emerge from the ears of corn and the streams of water in other parts of the image. This Tláloc/Quetzalcóatl is conceived as the patron of the East. It is noteworthy that this rain/wind deity also has smoke coming from his eye. This is a nonstandard trait of Quetzalcóatl that will be important in identifying a particular person in the long ritual passage on Plates 29 through 46. The fifth year, 5 Reed, is located in the center image and is again seen in front of a partly hidden A-O year sign. Its Tláloc, said to represent the Center, has a red body and wears the face paint of Xochipilli, the young prince of flowers.

Plates 29–46: A Long Supernatural Journey and Ritual Sequence

This passage of 18 pages is the longest and most elaborate of the entire Codex Borgia. It has the character of a story or narrative rather than a calendar, and in that is unique. The narrative, if such it is, is filled with ritual acts and with apparently real as well as supernatural characters. It is certainly religious in nature, though there does seem to be an element of physical reality that runs through the pages. This has been recognized by Nowotny (1961a) as well as by many others.

In this section of the codex the orientation of the pages shifts from that of a long horizontal strip read from right to left to that of a long vertical strip read from top to bottom (from the right edge of the page to the left edge of the page). This orientation prevails through page 46, the end of the current passage, after which the

earlier orientation returns. The imagery of these pages is consummately complex. It is out of the question here to describe these plates fully or to discuss all the potential interpretations, even concisely. Nevertheless, an overview of the structure may be helpful.

This long passage begins with a series of five enclosures (Plates 29–32) that serve to make supernatural statements. Two major temples dedicated to heaven are then identified (Plates 33 and 34). Then begins a ceremonial sequence in which a principal participant, known to us as Stripe Eye (a name given to him by Peter van der Loo), engages in a long ritual journey in which he performs several specific deeds (Plates 35–44). Finally the series is closed by a short passage (Plates 45 and 46) from which Stripe Eye is apparently missing but in which a new fire, symbolizing a new beginning, is ignited.

The account begins on Plate 29, the first of several enclosures formed by the body of a goddess of death. Within this enclosure is a large black disc. On the disc is a large blue vessel from which emerges a dark foamy substance. From this substance emerge numerous animate creatures who are characterized as winds by the Quetzalcóatl features they display. In addition to the many winds, two skeletal figures are shown, one a deity of death and the other a representation of Tlazoltéotl as the earth below the blue vessel. At the left edge of the page (the lower edge of the image) two intertwined starry wind serpents spit out smaller wind figures to lead the reader to the next page.

There (Plate 30) a similar scene is found. The body of the death deity forms an enclosure containing a large circular device that in turn contains the two intertwined wind serpents and their two small wind figures. Other significant features of this page are the 20 day signs arranged counterclockwise around the central device and the presence of four Tláloc–plant combination figures at the corners of the enclosure. Among the day signs four have been singled out by their placement in medallions that are pierced by the four Tlálocs wielding sacrificial instruments. These four days are Alligator, Death, Monkey and Vulture. The Tlálocs are each adorned with trees. This page can be said to represent the abundance of the Eastern direction.

The selection of these four day signs for special treatment is indicative of the use of a different form of the 260-day calendar from that which we have encountered so far. The *tonalpohualli* on Plates 1–8 of the Codex Borgia is arranged with 52 day signs in a row, a layout that requires five rows to include all of the 260 days. If, instead, 65 days comprised a row, then only four rows would be needed to incorporate all 260 days. As it turns out, the four days singled out here on Plate 30 would be the first day signs in each of these four rows. The directional qualities of this calendar are such that these four days and the four groups of 13 days that they begin are days ruled by the East. In a calendar composed of four rows rather than five, the days governed by one direction are found together. It is important to understand which form of the *tonalpohualli* is being used in any given case, because the directional qualities and the supernatural patrons of the days and periods of the calendar are different.

Plate 30 ends with the intertwined wind serpents again leading the way to the next page by spitting out two small wind creatures.

Plate 31 is divided into two halves, each of which depicts enclosures similar to those of the previous two pages. Calendrical medallions are found at the four corners of these two enclosures. The first of these scenes, on the right side of the page (top half of the image), has Deer, Grass, Movement and Wind singled out. These are the day signs that begin the third, Western, section of the calendar as laid out in four rows. The colors of this scene are generally dark and obscure, appropriate to the direction in which

the sun sets. In the center of this half of the page are a variety of death deities or skeletal spirits. The central image is of a naked goddess with bandaged eyes, whose heart is exposed outside of her chest. Two small death creatures lead the way through the passage to the next enclosure.

The left side of the page (bottom half of the image) is similar, though its color scheme is red, the color of blood. The day signs featured in medallions at the corners of this enclosure are those of the North. They lead the second group of four rows of 13, the days Jaguar, Rain, Lizard and Water. Again death and earth images abound in the various small figures within this border.

Plate 32 has the calendrical associations of the South, bearing the day signs of the fourth segment of the calendar as described above, the signs of Flower, Serpent, Dog and Eagle. This enclosed space is constructed differently from the previous four. It does not have a death deity in its border; instead, at the left margin of the page (the bottom of the image) a female skeletal figure, who seems to be an earth goddess as well as a death goddess, appears as a border and a passage to the next scene. The border of the enclosure is composed of rows of flint knives surrounding a broad dark band of obscurity. This band is occupied by eight figures carrying decapitated heads in both hands, four Tezcatlipocas in the corners and four other supernatural figures. The central image of the panel is of a white-and-red-striped figure with two large flint knives in place of a head. Tezcatlipocas emerge from flint knives at its arms and legs and appear as the heads of the serpents below. The overall imagery of this scene is very clearly about blood sacrifice by cutting and decapitation. The page ends at the left margin, where a figure of Quetzalcóatl is born from between two large flint knives found in an opening in the body of the white Death/Earth Goddess. This Quetzalcóatl is unusual in that he has two volutes indicating smoke emerging from the corner of his eye.

Considering that the subsequent 12 pages seem to refer to a ceremony or series of ceremonies undergone by Stripe Eye, it may be that these first four pages should be read as a sort of invocation undertaken in preparation for the performance of the central events being described in this long passage. The sequence of events could be as follows: first, a pot is prepared that liberates the winds (Plate 29); second, the winds and rains of the East are propitiated (Plate 30); third, the death and sacrifice of the West and the North are observed (Plate 31); fourth, the blood sacrifice of the Tezcatlipocas who influence the South is honored so that fifth, and finally, the Quetzalcóatl character can emerge ready for what is to come (Plate 32). This is certainly speculative interpretation but it seems to me to be a plausible framework for reading these pages as a prescription for the performance of a ceremony of major importance.

The next two pages of this passage, Plates 33 and 34, are taken up by two very large and distinctive structures with some activity going on around them. These two temples are unusual in at least two ways. They are by far the largest and most elaborate buildings illustrated in the codex. They are identified as "Temples of Heaven" by the presence in their roofs of three bands of stars and Venus symbols. Atop each of these two structures sits a Flint-helmeted deity from whom descends a white rope. The building on Plate 33 has a pointed, conical roof, a form associated with Quetzalcóatl, the wind deity. Quetzalcóatl appears seated on a throne within the temple, where he is being addressed by Tlahuizcalpantecuhtli, the god of Venus as the Morning Star. At the top of the stairs in the front of the temple lies Xipe Tótec, Our Lord the Flayed One. Other deities in the scene include Xólotl, the god of twins, standing behind the temple building; Cintéotl, the corn goddess, also behind the temple but above Xólotl, and a second appearance of Quetzalcóatl and Tlahuizcalpantecuhtli performing

heart sacrifice in front of the temple building. A monstrous black serpent winds around the building and several horizontal male figures are drawn on the roof and on the tiers of the platform that supports the temple.

The temple on Plate 34 is similar, though it has a rectangular roof with "ears" at its peak. It is also topped by a Flint-helmeted deity, is entwined by a monstrous serpent, has Cintéotl, the corn goddess, behind the temple and bears horizontal figures on its roof and platform, though this time the serpent is red and the figures are female. The innermost part of the temple is occupied by Tepeyóllotl, the Heart of the Mountain. In front of him fire is started on a jewel in the chest of a representation of Tlazoltéotl, the goddess of the moon. In front of the temple, heart sacrifice is again performed by a second appearance of the deity shown within, in this case Tepeyóllotl. These two buildings provide the scene and place for the ceremonies that follow. They are prominently portrayed in undoubted relation to their importance to these ceremonies.

Plates 35–38 give an account of a sacred-bundle ritual performed before the Temple of Heaven. The actions that now take place all seem to be physically possible; they present a sense of reality grounded in real space rather than of ethereal, supernatural events occurring on another plane. It seems reasonable, therefore, to interpret these images as rituals that occur or could occur in the real world. It seems to John Pohl and to me that these pages present a prescription for the proper enactment of a very complex ceremony in which a person is elevated to the role of king or ruler of a community. The actors in this account, then, should be interpreted as real people whenever possible.

The account begins on Plate 35 in the top right corner of the image (bottom right of the page). Here we see a priest wearing a goggle-eyed mask who is passing the sacred bundle to two associates standing on an eagle place at the end of a blue road. The upper associate combines attributes of Quetzalcóatl (his wind mask) and Tezcatlipoca (his face paint), and the second is a black Quetzalcóatl who has a puff of smoke painted near his eye. The temple in which the goggle-eyed priest is sitting also has stars in its roof, though the configuration of the roof shows that this structure is different from either of the Temples of Heaven depicted on the previous pages and thus must represent some other building. After the priests Wind Mask and Smoke Eye receive the sacred bundle, they transport it along the blue road to a point where it ends at the edge of the next page. John Pohl and I have discussed these buildings, this road and the activity that follows elsewhere (Byland and Pohl in press).

Next to the road, in the ball court, the character now known as Stripe Eye makes his first appearance. The angular black stripe that runs from his hairline to his eye and then to the corner of his jaw is a variant of the facial painting of Quetzalcóatl. Seler (1904–09) noted that this character is the subject of a continuous story that runs through this and the next nine pages of the codex. Seler identified Stripe Eye as Quetzalcóatl, failing to recognize that he was different from other Quetzalcóatl figures in the passage. While it is indeed possible that he is meant to represent Quetzalcóatl, the nature of his behavior also suggests that he is the idealized king of this ceremonial center.

After the ball game, Stripe Eye appears on Plate 36 in front of the sacred bundle that the Wind Mask and Smoke eye priests have brought from the shrine above. The bundle is then opened under the supervision of Wind Mask and another priest (or deity) who wears the costume of Xólotl, a Dog Mask. Stripe Eye is then enveloped in a heavenly mist and magically transported across Plates 36 and 37. On Plate 38 he emerges from the mouth of Ehécatl-Quetzalcóatl. While Stripe Eye is on this magical journey, a number of priests, notably including Dog Mask, enact a series of

rituals (Plate 37) in a large area that appears to lie in front of the eared-roofed Temple of Heaven and a smaller structure similar to that portrayed on Plate 35. On Plate 38 Stripe Eye and Dog Mask engage in other ritual acts.

It is noteworthy that this series of events seems to be moderated or overseen by a series of specialized priests. The Quetzalcóatl priest known as Smoke Eye first appeared on Plate 32, as the initial series of sacred enclosures came to an end and we were about to arrive at the two major Temples of Heaven. After sacrificial rituals were undertaken at the two temples, Smoke Eye was joined by a Tezcatlipoca priest wearing a Wind Mask. The two of them proceeded to the place where the sacred bundle dedicated to Quetzalcóatl was opened for the idealized king known as Stripe Eye. There Wind Mask took over and Smoke Eye dropped out of the account. Wind Mask was then joined by a Xólotl priest who wore the Dog Mask. After the bundle was opened Wind Mask's role ended and he dropped out, leaving Dog Mask to oversee the action until just after Stripe Eye emerged from his sacred journey. From this point on Stripe Eye does not have priestly guides to perform actions on his behalf. It is as though the experience of witnessing the opening of the bundle and of undertaking the supernatural journey had transformed him into a person of new status and capacity, one who now was qualified to act on his own behalf in a highly charged ritual. Future appearances of these priests show them to be clearly acting as assistants while Stripe Eye conducts the central activities himself, until the very end of the long passage.

Plate 38 is the last page of the obverse side of the Codex Borgia. The story of Stripe Eye and his ritual activity continues on the reverse side beginning with Plate 39. Entrance to Plate 39 is afforded at the right of the page (top of the image), where a Quetzalcóatl figure without the eye stripe emerges from the body of the earth goddess. Stripe Eye is depicted in the center of the page paired with a red Quetzalcóatl, in a red field surrounded by a blue road upon which dance 12 women or female spirits known as *cihuateteo*. The four calendar signs dedicated to the West are found in medallions at the four corners of the dance scene: Deer, Grass, Movement and Wind. Arrayed at the left and right sides of the image are six deities. Counterclockwise from the bottom right, they are: the Black Tezcatlipoca, a black Mictlantecuhtli, a blue Xochipilli, Tlahuizcalpantecuhtli, Tepeyóllotl and the Red Tezcatlipoca. The blue road enters the jaws of the earth monster, identified by Seler as the supreme deity, Tonacatecuhtli.

Tonacatecuhtli's body forms a large rectangle that covers the remainder of this page and all of Plate 40. Within this outline is found a band of day signs. In the Díaz and Rodgers reconstruction there are a few errors in the replacement of the most seriously damaged of these, mostly on the bottom margin of the page and a few at the upper left corner. The progression of these day signs begins at the top of the rectangle, just to the right of the head of Tonacatecuhtli. The first day signs visible are Wind and House just below the clawed arm of the deity. We can imagine that Alligator is obscured by the head of the god. The 20 day signs then proceed in normal order clockwise until the twentieth, Flower, is reached. Then the cycle begins again and runs for 12 or 13 additional days. It seems that Death is obscured by the leg of the god, that Dog was left out in the original and that Water was replaced by Rain in the Díaz and Rodgers reconstruction. Seler did not recognize the last sign in the series, Reed, but Díaz and Rodgers did recognize it, and it is here drawn just below the red-and-white-filled box at the center left side of Plate 40. The left half of this band of day signs seems to be organized with directional significance (as indicated in the *tonalpohualli* arranged in four rows of 65 days) paramount. The first nine day signs are the four that are associated with the North

repeated twice, and with the first one drawn a third time. Following Seler, they should be Jaguar, Water, Lizard, Rain, Jaguar, Water, Lizard, Rain and Jaguar; all but the last are incorrectly reconstructed here. It should be noted that the original is so badly damaged on this edge of the page that none of these signs but the last is really recognizable. Continuing clockwise in the same pattern for nine days are the day signs of the Center direction, Rabbit, House, Flint and Reed. Then come nine signs associated with the West: Wind, Movement, Grass and Deer. These proceed correctly to the top right edge of Plate 40, where the sign for grass is omitted by Díaz and Rodgers; then, at the continuation on Plate 39, the first two signs should be Deer and Wind. Finally, descending along the top margin of the frame, back on Plate 39, are the signs of the East: Vulture, Monkey, Death, Alligator and Vulture. Here only five signs are visible as the rest of the presumed sequence of nine are obscured under the head and arm of the god Tonacatecuhtli.

Entering from the top into the space framed by the calendar band and the body of Tonacatecuhtli are the two Quetzalcóatl figures seen first in the center of Plate 39. The one on the right is presumably the figure of Stripe Eye, though his face paint is now dark. The central figure of Plate 40 is that of Stripe Eye, who, assisted by eight priests, is conducting a heart sacrifice of the solar deity, Tonatiuh. Pohl has suggested that this scene is similar to scenes of confirmation depicted for the lords of Tilantongo in the Mixtec historical codices Zouche-Nuttall and Bodley (Byland and Pohl 1993). In these documents Lord 8 Deer journeys to the Sun God's oracle as part of his process of confirmation as legitimate ruler of Tilantongo. Stripe Eye, as the idealized ruler of the ceremonial precinct depicted here, similarly visits the solar deity, though here a symbolic sacrifice is shown.

The remainder of Plate 40 is taken up by a small ball court and two temples. Interestingly, the two temples are shown as a conical temple dedicated to Quetzalcóatl, with a smoke-eyed Quetzalcóatl priest in it, and an eared temple, with Tezcatlipoca (minus his wind mask) shown in front of it. There is, however, no obvious indication that these are the same temples as the important ones referred to earlier. The ball court contains images of Tlazoltéotl, to the right, and the Red Tezcatlipoca, to the left, both looking at an odd skeletal monster who is giving birth. There is no passage indicated to lead the reader out of this page's effigy of Tonacatecuhtli and on to the next page.

The entry to Plate 41 is shown as an elongated skeletal earth goddess, Tlazoltéotl, drawn perhaps as Teteoinnan, the mother of the gods, similar to her depictions on Plates 32 and 39. At an opening in her belly a skeletal figure enters a small cloudy-bordered enclosure. There two fleshed Tlazoltéotls, shown as the goddess of the moon, descend with a Black Tezcatlipoca. They seem to be directed toward a large cogged disc, which is half in and half out of a blue road that emerges from the headdress and feet of the skeletal Tlazoltéotl and that forms a larger rectangular enclosure. On the left branch of this road we find Stripe Eye, a Black Tezcatlipoca and a black *cihuatéotl*, the spirit of a woman who died in childbirth. On the right branch of the road we find a parallel sequence of characters, a white Quetzalcóatl with red dots, a Red Tezcatlipoca and a red-costumed *cihuatéotl*.

The central disc is shown calendrically to represent the Southern direction. It is marked with a day sign (in a medallion) of an Eagle, one of the four days of the South. Arranged around the outside of the disc are four other day signs related to each of the other four directions: House–Center, Deer–West, Rain–North and Monkey–East. Within the disc a Quetzalcóatl with a dark face (presumably Stripe Eye) and his associate, the Quetzalcóatl with a white body and red dots, perform autosacrifice by piercing their sexual organs

with bone implements. The blood flows into the mouths of Chalchiuhtlicue and her male counterpart.

Just below this disc, 13 consecutive day signs, beginning with Eagle, are painted between the roofs of two temples, one with a round roof and the other with an eared roof. The roofs of these buildings are on Plate 41 and their bases are on Plate 42. Note the parallel construction between the placement and the construction of these two buildings and the two temples seen earlier on Plate 40. The identity of these two sets of buildings seems unequivocal. The round temple on Plate 42 has Stripe Eye within it and the eared temple has a version of Xochipilli. Between the temples is a platform with a sacrificial stone on which Stripe Eye extracts the heart of the white Quetzalcóatl with red dots. In this he is assisted by the Black Tezcatlipoca. Above them floats a medallion with the day sign Jaguar, which is taken to represent the North, in contraposition to the South of the cogged disc on the previous page. From this sacrifice scene, the white Quetzalcóatl with red dots is taken to the underworld and to a ball court. Next we see him on a cruciform device with five little images of Nanahuatzin, the dead and cooked god of lechery and the evening sun, emerging from his four limbs and his heart. Seler interpreted this as the transformation of Quetzalcóatl into Xólotl-Nanahuatzin. Nanahuatzin is shown to the left and right of this image as well. Stripe Eye participates in the cooking of him at the left.

On Plate 43 an opening in another elongated image of Tlazoltéotl provides entry for Stripe Eye to a precinct bounded by ears of corn and rays of sunlight. Within this enclosure we see a large image of a dark solar deity who supports the birth of corn from the earth. The figure of the deity is in the pose of childbirth; its body is covered by a dark solar disc with stars on its periphery. This solar deity wears the skin of a jaguar and the jaws of a serpent. Its face is dark and its eye is hanging out of its socket. This suggests that it may represent the sun-at-night, the "dark sun," or the moon. Below the solar disc is a Tlazoltéotl figure surrounded by ears of maize and encrusted with stars. Around these figures are eight small characters who are shown sustaining the growth of maize plants with blue and (originally) green fluids that emanate from their mouths. A dark-faced Quetzalcóatl leaves the sun/maize precinct through an opening at the left side of the page and descends, bearing a basket full of maize, to the next page.

On Plate 44 another elongated Tlazoltéotl with an opening in its belly allows Stripe Eye to descend, in his last appearance in the story, into the next in this series of precincts or compounds. This one is composed of a broad wall surrounded by flowers on its exterior and lined by flint knives on its interior. The four corners of the broad wall hold medallions with the four day signs of the South: Flower, Serpent, Dog and Eagle. The walls of the precinct are open at the four sides where four figures enter, three serpents and a bat, all with human heads. Placed on the broad wall, adjacent to these four figures, are symbols of sacrifice: decapitated heads, severed arms and legs and skeletal ribs with hearts. The three human-headed serpents are being tormented by rapacious animals, and the bat is facing the priest whom we know as Smoke Eye. He is wearing a hummingbird costume. From a heart in the hands of the bat flows a bifurcated torrent of blood that lands at the head and feet of a recumbent variant of Xochiquétzal, shown as the young goddess of the moon. She has a lunar disc in her chest that holds a heart, from which grows a multicolored tree.

Plate 45 is entered through an opening in the chest of Tlazoltéotl, the skeletal earth goddess. This time her orientation is reversed and the entering figure is a cloudy wind serpent similar in form to the one that emerged from the sacred bundle on Plate 36. The main character, Stripe Eye, does not appear on this page or the next. The activities seem to have been taken over by the Quetzalcóatl priest

we know as Smoke Eye; he appears several times, both here and on the next page.

In the four corners of Plate 45 are four houses of eagles, each with a figure of Smoke Eye. One of the houses is drawn as a conical-roofed round temple and another has eagle down rather than an adult eagle on its roof. On either side of the page are images that Seler has interpreted as representing the life and death of warriors. Life is represented by a pot of pulque, an intoxicating liquor made from maguey, with a drunken figure beneath it and the Black and Red Tezcatlipocas above it. Death is represented by a red-and-white-striped figure in a stream whose heart is torn out by Smoke Eye dressed as an eagle. The center of the page contains a skull-rack platform upon which stands a skeletal figure identified by Seler as Tlahuizcalpantecuhtli, the god of Venus as the Morning Star. This figure supports a tree from which emerge six banners. The bottom of the page contains an image of Smoke Eye with a Venus star as his headdress. He is bleeding from his buttocks and is covered by a net or blanket that bears nine faces painted with the four directional colors and the dots indicative of Tlahuizcalpantecuhtli. This image is surrounded by four full figures of Tlahuizcalpantecuhtli with similar-colored face paint.

The final page (Plate 46) is framed by a pair of elongated Tlazoltéotl figures. Smoke Eye enters from the top and leaves from the bottom. The remainder of the image is framed by two structures and two thrones. The structures contain images of Xiuhtecuhtli, the old fire god, presenting Smoke Eye and a Black Tezcatlipoca priest. This may hark back to the two priests who attended the opening of the sacred bundle on Plates 35 and 36. The two thrones are occupied by a Black Tezcatlipoca and a figure who seems to be an amalgam of a Black Tezcatlipoca, Quetzalcóatl and Xiuhtecuhtli.

The center of the page contains a four-sided red field bounded by four fire serpents, and an image of Smoke Eye starting a fire in the chest of a combined image of the Fire Serpent and Xiuhtecuhtli. The red field contains a pot in which Smoke Eye is being cooked, perhaps only symbolically in preparation for the lighting of the fire.

These last two pages are reminiscent of the early activities of the priests in preparing the way for Stripe Eye to undergo his complex ceremonial sequence. Here, though, they seem to be bringing the ceremonial sequence to a close, performing the acts that mark the end of the ceremony and the beginning of the new era.

Plates 47 and 48: Three Groups of Five Deities

These two pages represent three groups, each with five supernatural figures. They are read simply from right to left in the three registers (the orientation of the text is back to the horizontal arrangement normal to most of the codex). Each of the upper two registers includes a sixth panel depicting the birth of the five associated characters.

The bottom row represents five elaborately dressed female deities, who all bear the significant attributes of Tlazoltéotl, the goddess of the moon and of the earth. In each case she is dressed differently and has different figures accompanying her. Each Tlazoltéotl is given a separate calendrical name: from right to left, 9 Reed, 4 Flint, 6 Reed, 8 Reed and 1 Eagle. Seler interprets them as having directional significance as well: from right to left, East, North, West, South and Center.

The second row of figures are five *cihuateteo*, the deified spirits of women who died in childbirth. Their collective birth is indicated in the panel at the right margin of Plate 47 by the image of the birth of a female figure with bandaged eyes. There, on a blue field, a monstrous being is the source of five serpents and four centipedes.

Around the edge of the field are five dates that all begin with the number 13. Seler has shown that they are the dates that fall immediately before the first day indicated in each of the five panels of *cihuateteo*. Just as with the Tlazoltéotls, the five *cihuateteo* are each differently dressed and painted and have different accompanying figures. They also are each associated with a calendrical notation, one that is a bit more complex than those accompanying the Tlazoltéotls. For each of these female figures, 13 consecutive days are indicated, with the first, fifth and thirteenth shown by their day sign and the others shown by red-dot place holders. The names and directional associations of the *cihuateteo,* then, are: 1 Deer–East, 1 Rain–North, 1 Monkey–West, 1 House–South and 1 Eagle–Center.

The top row of figures are five male deities of sensual pleasures, the *ahuiateteo*. They are part of a group of deities whose names begin with 5 and whose best-known member is Macuilxóchitl, 5 Flower, the god of games and pleasure. The first image of the top row, similarly to that of the center row, represents the birth of the five *ahuiateteo* by showing a stone (?) from which five serpents extend and from which a male figure is born. There are five dates around this image, all of which begin with the number 4. The male figure in this image is identifiable as Nanahuatzin, the god of lechery, who is another aspect, or another personality, of Xólotl, the god of twins. This relationship is reinforced by the presence of a dog (*xólotl*) standing on the rock. The names of the five *ahuiateteo* are given by the fifth day sign in the series of 13 shown with each image. These are, with their directional qualities: 5 Lizard–East, 5 Vulture–North, 5 Deer–West, 5 Flower–South and 5 Grass–Center.

Plates 49–53: The Five Directions and Their Supernatural Patrons

The next four and one-half pages present a sort of definition of the qualities and protectors of the five directions of the world. The first four pages describe the four cardinal directions: East, North, West and South. The right half of page 53 represents the Center. Each page is constructed with a band of day signs at the bottom. Above this is a wide band showing a directional tree and bird. On Plates 49–52 this wide band also contains other figures, including a temple and various deities. Above the wide band is another band of day signs. Finally, at the top of each page, a wide band shows the supernaturals who support the heavens and walk on the earth in each of the directions. Seler has suggested that these supernaturals are associated with the opposite direction from that depicted in the lower register, so that for the first page, for example, the tree is of the East but the upper-register deities are of the West.

The largest fields describe the qualities of the cardinal directions. Their central image is a tree with a bird in its branches and an earth goddess from which it springs. Above this image on Plates 49–52 is a temple with a special patron deity of the direction. Clockwise from the temple, the other images are of a sacrificer, two celestial spirits descending, the maker of fire, a throne and deity seated before it, a place where a male and female deity are married, an animal ball player and a tree with a pair of sacrificed animals.

For the East, depicted on Plate 49, the central tree is one of precious jewels. It was originally painted blue and green (blue and tan in this edition, as in the current state of the original) and has jewels as its fruit. Its bird is a green quetzal. The temple above is an eared temple dedicated to the sun and is attended by Tonatiuh, the solar deity. In the upper register on the right the Western starry blue sky is supported by Tlahuizcalpantecuhtli, the god of Venus as the Morning Star, and on the left Xipe Tótec, Our Lord the Flayed One, walks the earth with his blue-and-white flowered staff.

For the North, shown on Plate 50, the central tree is a cactus covered with spines. It is painted blue and green and has small flowers and what are perhaps prickly pears as fruit. Its bird is a black-and-white eagle. The temple above is a house of flint knives with the image of the moon inside. A broad channel of darkness descends from above and fills the interior of the temple. The attendant of the temple is a male moon god, Metztli. The god who supports the Southern dark starry sky in the upper register at the right is Xiuhtecuhlti, the old fire god. On the left the god of death walks with his red staff tied with red-and-white banners.

On Plate 51 the Western direction is shown with a tree of unusual qualities. It has been identified as a young corn plant with tassels but without fruit. The bird is a blue raptorial bird of indeterminate species. The temple is again an eared-roofed building with flowers in its roof. In the temple is a yellow object that Seler identifies as a gourd for holding tobacco. The deity attending the temple is a combination of several and cannot be easily identified. He manifests aspects of Xochipilli, Tonacatecuhtli, Cintéotl and perhaps Xiuhtecuhtli. In the upper register Quetzalcóatl, the Feathered Serpent, god of the wind, supports the Eastern blue starry sky, and Xochipilli, the young prince of flowers, the god of sustenance, walks the earth with his flowering tree as a staff.

The South is shown on the lower register of Plate 52. Its red spiny tree has solar discs as its fruit. The red bird in the tree is perhaps an owl, associated with Xiuhtecuhtli. The temple above is a skeletal building with an owl in its interior. Mictlantecuhtli, the God of Death, stands before it and offers blood from the neck of a headless person. In the upper register Mictlantecuhtli supports the Northern dark starry sky, and Cintéotl, the corn god, walks the earth with a precious red staff.

The right half of Plate 53 contains the images of the Center direction. The tree here is a large green maize plant that is producing ears of corn as its fruit. The tree emerges from the earth alongside two huge ears of corn. Two figures perform autosacrifice by piercing their sexual organs with bone awls and shedding blood on the base of the tree. These figures are: on the right, Macuilxóchitl, 5 Flower; and, on the left, Quetzalcóatl in the form of the lord Stripe Eye (see Plates 35 through 44). This image beautifully portrays a mythic relationship held between people and the earth such as that described for the Mixtec people of the village of Nuyoo by John Monaghan (1987): the people feed the earth their blood and their bodies, and in return the earth feeds the people by yielding maize. Having the king make this sacrifice idealizes the perpetual nature of this relationship and sanctifies it for the people of the kingdom. In the upper register of the right half of Plate 53 a human figure descends into the mouth of an earth monster that has a decidedly rectilinear, architectural aspect. This descent into the mouth of the earth corresponds well with the up-and-down nature of the Center as the middle of the earth, the central hinge of space and time.

Plates 53 and 54: Xochipilli as a Deer, and Five Frames of Piercing Sacrifices with Calendrical Notations

The upper left corner of Plate 53 contains an image of a deer with the 20 day signs attached to its body. The deer is an animal closely associated with Xochipilli, the young prince of flowers. This deer is marked as a representative of Xochipilli by its face paint. Arrayed on a curved white panel in front of the deer are five of the day signs, the sixth through the tenth in the series of 20: Death, Deer, Rabbit, Water and Dog. These are taken, one each, from the list of days linked to each of the five directions: East, West, Center, North and South. After offering two other forms of expressing the directional

qualities of the calendar and the characteristics of the directions in this image the Codex Borgia presents a third way of describing these associations. The relationship of this image of Xochipilli to the preceding pages or to the following page is unclear. We do not know why it is inserted here.

Directly below the Xochipilli deer we find the first of five representations of Tlahuizcalpantecuhtli, the Venus deity, performing a spear sacrifice. Each of these images is in a frame bounded on two sides by an unusual arrangement of dates. The names of these dates are drawn from the five directions in the *tonalpohualli* as arranged in four rows of 65 days: Alligator, Serpent, Water, Reed and Movement. The days give a certain directional quality to these five images. In contrast to these qualities, the deities or objects being speared have other directional associations. To further complicate the issue, Seler assigns to the image of Tlahuizcalpantecuhtli in each of the five panels the direction opposite to the one associated with his adversary.

In the first of them, in the lower left corner of Plate 53, a black-skull-faced Venus god strikes the leg of Chalchiuhtlicue, the goddess of running water. The day signs around the scene include all the numbers from 1 to 13 paired with Alligator, beginning with 1 Alligator at the lower right. The day sign Alligator yields an association of this scene with the East. Chalchiuhtlicue is a goddess of the East, and because of the conflict between the characters Seler represents Venus as being the West. Floating above Chalchiuhtlicue are the next three day signs, Wind, House and Lizard. If these were taken to represent three days in the *tonalpohualli* following 1 Alligator, then the fifth day in that sequence would be 5 Serpent.

This is the day that begins the display on the lower right corner of Plate 54. There an owl-faced Venus god strikes the leg of the Black Tezcatlipoca. The day sign Serpent belongs to the group associated with the South. The Black Tezcatlipoca is the god of the North, so that Seler assigns Venus here to the South. Above Tezcatlipoca are the next three days signs, Death, Deer and Rabbit. If we continue the count from 5 Serpent, the next day in the sequence should be 9 Water.

This is the date that appears at the lower right end of the next quadrant of the page. In this corner, the lower left, a dog-faced Venus god strikes the corn god, Cintéotl, on the leg. Here the Water day sign can be calendrically tied to the North, but Cintéotl is a god of the West and Seler assigns this Venus to the East.

Continuing the pattern, after the day signs of Dog, Monkey and Grass should come 13 Reed, and indeed it appears as the first in the list of Reed dates in the upper left quadrant of the page. In this panel a rabbit-faced Venus god strikes the leg of an unusual figure identified by Seler as embodying *tlatocáyotl*, the concept of kingship. Reed is an indication of the Center direction, but the residence of the sumptuous gods, including the *tlatocáyotl*, is in the South. Consequently, Venus in this panel is of the North.

In the fifth and last of these images, a white-skull-faced Venus deity strikes a round shield and cluster of arrows, the *yaóyotl*, symbol of warfare and warriors. The day sign associated with this panel is Movement, which is of the West. The young warriors symbolized by the shield and other implements of war reside in the Center. Since the center is both up and down, it is its own opposite and this Venus is also of the Center.

Plate 55: Six Deities with 20 Day Signs

On this page the reading order is once more from right to left and in a reverse S-curve from bottom to top. Guides to indicate this reading order are plentiful: the day signs proceed in this order, the

deities face in these directions and the footprints on the path of the days are pointed in these directions.

Each of the six panels on this page presents a deity standing in a pose that suggests walking. Seler calls them "the six celestial walkers." The first is Tonatiuh, the solar god, who makes offerings of a rubber ball and a bundle of sticks to a temple that contains a precious bowl. The second is Tlazoltéotl, the moon goddess, who walks in front of a rabbit in the moon in a dark sky and a bleeding serpent. The third is a blue-faced deity who wears a costume of turquoise and carries a turquoise staff. He is Yacatecuhtli, god of merchants and of wealth. The fourth is the Black Tezcatlipoca (his skin is red but he carries the shield and arrows characteristic of the black form of the deity), who walks with a spiny staff. The fifth is the Red Tezcatlipoca (his skin is yellow but he carries the quetzal bird characteristic of the red form of the deity), who walks with a jeweled staff. The sixth and final one of these travelers is Íztac Mixcóatl, the old god of fire, who carries a fire serpent as a walking stick. Why these six are displayed here and why the day signs are divided as they are is unclear.

Plate 56: Gods of Life and Death, and the 260-Day Ritual Calendar

This is a strikingly beautiful page, which portrays gods of life and death back to back, framed by day signs to the right and left and place-holding dots above and below. Quetzalcóatl, the wind god and god of life, is on the right and Mictlantecuhtli, the god of death and the underworld, is on the left. The image conveys the duality of existence, the joining of opposites and the inevitable relationship of life and death.

The 20 day signs are arranged in the order of the first signs of each group of 13 days in the *tonalpohualli*. The first day is 1 Alligator, located at the bottom right corner of the page. This is followed by 12 place-holding dots standing for the other 12 days in the group of 13. The fourteenth day sign is Jaguar and the day is 1 Jaguar. This sign is found at the extreme lower left corner of the page. It begins the second group of 13 days, the rest of which are again symbolized by the 12 place-holding dots. The twenty-seventh day sign, the first day of the third period of 13 days, would be the day 1 Deer, which is found immediately above the Alligator. Following this pattern of alternating between sides of the page, we can traverse the entire 260-day *tonalpohualli* in a much abbreviated form.

Plate 57: Six Supernatural Couples

This page is divided into six panels, each of which has five day signs placed below a pair of deities who face each other across a central device. The gods of each pair are male and female and represent male and female aspects of divinity relevant to a particular area of responsibility. Each pair sits beneath a celestial disc: sun, moon or obscure sky (in most cases only the lower half of the disc appears), and each is accompanied by a group of red-dot place holders to mark unnamed days in the ritual calendar. The significance of the association of these pairs of deities with particular parts of the *tonalpohualli* is unknown. The reading order follows the same sinuous route that we have seen so often.

Beginning at the lower right panel, the first day sign is Alligator. Following that sign the entire *tonalpohualli* is indicated either by day signs or place holders. The day 1 Alligator is followed by seven unnamed days, indicated by the seven red dots at the left edge of the panel. The ninth day sign is Water, which is found in the first

position of the lower left panel in the series. That day should be 9 Water. It is followed by seven days indicated by the dots at the left edge of that panel. The next day should be 4 Movement, and Movement is found in the first position, this time at the left end of the row, in the left center panel on the page. Proceeding in this fashion, 52 days are counted by the time the last dot on the upper left panel is reached. The next day after those 52 would be the day 1 Reed, which is found adjacent to the Alligator in the starting position in the lower right panel. If the progression is followed five times, all the day signs on the page are accounted for and 260 days have passed. This page represents yet another shorthand way of expressing the entire ritual calendar.

The gods in each panel are shown as married pairs. In the first panel they are Tonacatecuhtli and Tonacacíhuatl, the father and mother of the gods, the lord of sustenance and the lady of life. Between them is a rich offering consisting of a turquoise bowl, a gold box, turquoise beads and a young man. They all rest under the bright sun. In the second panel the deities are Patécatl and Tlazoltéotl as the god and goddess of pulque, the intoxicating liquor made from the sweet sap of the maguey. They sit on either side of a vessel marked with a skull and two intertwined snakes. The disc of the heavens is half sun and half obscure night sky, an image that is probably appropriate to pulque. The third panel, the center left one, has the images of Cintéotl, the corn god, and a female counterpart, a goddess of corn. They sit across from each other and are holding a pair of large flowering maize plants growing from a bowl that also contains four ears of corn. The sun again shines on this scene. The fourth panel contains Tláloc and Chalchiuhtlicue, the god of rain and the goddess of water. Their offering is a precious bowl with four ears of corn, green-and-blue twined garlands and a young man. The sun above this scene is bright and has four jewels hanging from it. The fifth panel is unusual in that the supernatural couple are seated with their backs to one another. They are Xochipilli and Xochiquétzal, the young prince of flowers, who is also the young sun god, and the young goddess of flowers, who is also the young goddess of the moon. Their offering is an eagle descending into a precious bowl. The sun shines clearly on them. The final scene is of Mictlantecuhtli and Mictecacíhuatl, the god and goddess of death and the underworld. Their offering contains a skull devouring a person, and the moon rather than the sun shines above them.

Plates 58–60: 25 Couples (Numerological Marriage Prognostications)

These three pages contain 25 panels, each of which contains a married couple, a celestial symbol, a number of dots from two to 26, and some ancillary images. The unusual aspect of this group of images is that they do not include day signs. In my opinion the best interpretation of these pages yet offered has been made by Peter van der Loo (personal communication). He has suggested that they represent a sort of numerological prognostication of the success of marriages. If one were to consider only the day numbers of the names of a young man and woman and add them together, the sum of their day numbers could range from $1 + 1 = 2$ to $13 + 13 = 26$. The predicted qualities of the relationship are suggested by the activities of the couple, the objects around them and the heavenly disc above them.

In general it seems that odd-number totals are more favorable than even totals. A few examples should suffice to illustrate this process. The first pair, whose number is 2, is found in the lower left panel of Plate 58, and they are depicted as Mictlantecuhtli and Xochiquétzal. She is cutting the throat of one child and he is

devouring another. The sky above them is half dark, on her side, and half sun, on his side, perhaps because he is following his nature but she is not. For them the future would be read as unfavorable, certainly on her side and perhaps on his. The second pair, whose number is 3, is just left of the first pair. They are shown as Xochiquétzal and an unidentified man. Their sun is bright, and between them is an offering bowl made of turquoise and containing precious beads and ears of corn. For them the future is good. The third couple is identified as Xochiquétzal and the Red Tezcatlipoca. For them the celestial symbol is replaced by a precious bowl that overflows with a frothy material. That their predicted life together is poor is indicated by the overturned bowl between them spilling out its contents.

The reading order follows the count of numbers, indicating by the red numeral dots from two to 26. It begins at the lower right corner of Plate 58 and reads from right to left across the three pages. The sequence then moves up the page to the center row and proceeds from left to right back across the three pages, finally moving up to the top of the page and going back to the left to the twenty-fifth panel at the top left of Plate 60. Despite much damage to the original, the Díaz and Rodgers reconstruction has missed only two numeral dots in the whole series; the fourth panel should have five dots and the twenty-second panel should have 23 dots.

Plates 61–70: Another 260-Day Ritual Calendar

The next ten pages present a second complete 260-day *tonalpohualli*, or ritual calendar. Each page contains 26 day signs (two 13-day groups) and two images of gods, objects and actions that presumably characterize the 13-day groups. This arrangement of the calendar divides it into 20 equal periods, each of which is begun uniquely by one of the day signs. These 20 groups of 13 days are known as *trecenas*. The deities whose images are painted in the panels of each of the periods may be thought of as patrons of the period initiated by the appropriate day sign. It is worth pointing out, as Seler does, that the associations of gods and periods of the calendar are not obvious. For example, the period that begins with the day sign Flower does not have Xochiquétzal, the goddess of flowers, as its patron or regent. On the other hand, the period that begins with Rain is indeed governed by Tláloc, the god of rain and storm, in a very obvious concordance of meanings.

The nature of the influence over the 13-day period wielded by each of these 20 patrons is not clear. How their influence was combined with that of the patrons of the day signs themselves, as discussed in connection with Plates 9–13 of the codex, is similarly unknown. Further, their relationship to the 104 images associated with the *tonalpohualli* on the first eight pages of the codex is also not understood. Ultimately it must be said that, despite all the information we have gleaned from interpretations of the Codex Borgia and the various other religious manuscripts of the Borgia Group, we do not know very much about how prognostication worked for the Mesoamerican priests. The intricacies of the magical process remain obscure.

The 260-day sequence of this *tonalpohualli* begins at the lower right corner of Plate 61 with the day sign Alligator. This, following a long-established pattern, should be considered as the day 1 Alligator. Armed with this crucial bit of information, we require no other indication of the day number because we know that the 13 numbers are used in a continuous cycle. Accordingly, every group of 13 day signs, every *trecena*, must begin with a day numbered 1. The reading order follows the order of the day signs across the bottom of the page and up its left margin to Reed, the thirteenth day sign. The next day sign in the order of the 20 is Jaguar, which

is found at the bottom right margin of Plate 62. The same pattern is followed across ten pages, until the day sign Dog is located at the top of the left column of day signs on Plate 70. There the sequence simply moves up to the upper register and changes to the left-to-right direction. The first day of the second half of the *tonalpohualli* is the day 1 Monkey and the last day of its period of 13 days is the day 13 House. After counting through the days named in the upper register of these ten pages, we reach the last day of the ritual calendar at the upper right corner of Plate 61, the day 13 Flower.

A brief table will identify the deities who are patrons of the 20 *trecenas* of this calendar.

FIRST DAY SIGN OF THE PERIOD	DEITY (NAHUATL)	DEITY (ENGLISH)
Alligator	Tonacatecuhtli	Supreme Male Deity
Jaguar	Quetzalcóatl	God of Wind
Deer	Tepeyóllotl, Tlazoltéotl	Heart of the Mountain; Goddess of the Earth, Moon and Filth
Flower	Huehuecóyotl	Old Coyote, God of Dance
Reed	Chalchiuhtlicue	Goddess of Running Water/Precious Green Stone Skirt
Death	Tecciztécatl, Tonatiuh	Goddess of the Moon, God of the Sun
Rain	Tláloc	Rain and Storm
Grass	Mayáhuel	Goddess of Maguey
Serpent	Xiuhtecuhtli, Tlahuizcalpantecuhtli	God of Fire, Venus as the Morning Star
Flint	Mictlantecuhtli, Tonatiuh	God of the Underworld, God of the Sun
Monkey	Patécatl	God of Pulque
Lizard	Itztlacoliuhqui, Yayauhqui Tezcatlipoca	God of the Bent Knife, Black Smoking Mirror
Movement	Tlazoltéotl	Goddess of the Earth, Moon and Filth
Dog	Xipe Tótec	Our Lord the Flayed One
House	Itzpapálotl	Obsidian Butterfly
Vulture	Xólotl	God of Twins
Water	Chalchiuhtotolin	Turkey of the Precious Stone
Wind	Chantico	Goddess of Fire
Eagle	Xochiquétzal	Flower-Quetzal Feather
Rabbit	Xiuhtecuhtli, Xipe Tótec	God of Fire, Our Lord the Flayed One

Plate 71: The Sun and the Moon with 13 Birds

Plate 71 is composed of a large central panel surrounded on three sides by 13 smaller panels of approximately equal size. The large panel contains a representation of the solar deity sitting on a bench; a skeletal-jawed animal sacrificing a quail to the sun; the moon in a dark and starry sky; the jaws of the earth monster with a quail's head; and the day sign 1 Reed, which is the calendrical name of Quetzalcóatl. The image of Tonatiuh, the solar deity, is given the name 4 Movement. This is the name of the actual sun in the current creation as conceived by the Aztecs.

The 13 smaller panels contain 13 birds or, more accurately, 12 birds and one butterfly. Each is individually drawn to represent a particular kind of bird, some identifiable and some not. Each is also accompanied by one of the numbers from 1 to 13. These flying creatures are the winged companions of the 13 numbered days/deities not identified in the Codex Borgia. They represent the 13 levels of creation above the plane of the earth.

Plate 72: The Four Directions with Plumed Serpents and Deities

This page is divided into four quarters, each surrounded by the image of a serpent with its head near the center of the page and its body all but enclosing the four sides of a rectangle. In each case the serpent's belly forms the outer edge of the rectangle border and its back forms the inner edge. At the center of the page is a little spiritual beast known as a *tzitzímitl*. Within each rectangle is the image of a deity who is physically connected to five of the day signs.

Beginning at the lower left corner and proceeding counterclockwise, the deity assigned by Seler to the East is Tláloc, the god of rain and storm; he has attached to his body the day signs for Alligator, Serpent, Water, Reed and Movement. The deity of the North is Tlazoltéotl, the goddess of the earth, filth and the moon; she has attached to her body the day signs for Wind, Death, Dog, Jaguar and Flint. The deity of the West is Quetzalcóatl, the god of the wind; he has attached to his body the day signs for House, Deer, Monkey, Eagle and Rain. The fourth deity, the deity of the South, is Macuilxóchitl, 5 Flower, the god of games and pleasure; he has attached to his body the day signs for Lizard, Rabbit, Grass, Vulture and Flower.

The astute reader will have noticed that these day signs are regularly spaced in the series of 20. They follow the arrangement of the columns of day signs in the first representation of the *tonalpohualli* in the codex, beginning on Plate 1. If they are to be assigned directional significance here, as Seler has done for the quarters of the *tonalpohualli* when arranged as five rows of 52 days, the five day signs associated with the East are found in the first column of the *tonalpohualli*, the days of the North are in the fourteenth column, the West in the twenty-seventh column and the South in the fortieth column. In each case the five day signs are found in the first column of the quarter of the calendar assigned to the appropriate direction. This same grouping of days was used in the preparation of Plates 18–21 and 22 (and will be used on Plates 75 and 76), though Seler did not use the directional aspect of it for his interpretation of Plates 18–21.

Plate 73: Gods of Death and Life with 26 Days and the 20 Day Signs

The image of life and death on Plate 73 harks back to the compositionally similar image of a wind deity, representing life, and a death deity on Plate 56. There the image of Quetzalcóatl as the wind god is on the right side of the page and Mictlantecuhtli as the god of death is on the left side. Here those positions are reversed. The overall structure remains the same, though; the two deities are shown back to back, looking outward, and holding staves. The image of Quetzalcóatl is differently colored, black on Plate 56 and blue on Plate 73. His face paint and some of his costume elements are also changed. The image of Mictlantecuhtli is very similar in the two representations.

On Plate 56 these gods are accompanied by a shorthand version of the *tonalpohualli*. On Plate 73 they are ringed by 26 consecutive day signs (six are repeated; note the appearance of Death in the lower left corner just inside the ring) and have the 20 day signs attached to their bodies and costumes.

This parallel structure, appearing so many pages apart, suggests that these two pages may serve as bookends of a sort, unifying the various sections found between them. These sections are the six supernatural couples, the 25 divinatory couples, the second complete 260-day calendar, the sun and moon with their 13 birds and

the four directions with plumed serpents. The motive for this potential relationship is not immediately evident.

Plate 74: Male and Female Gods of Sensuality

This page presents images of two deities who are, at least in part, dedicated to sensuality and procreation. The bottom half of the page is given over to a male deity of sensuality, an *ahuiatéotl,* and a set of the 20 day names. The upper half contains an image of Tlazoltéotl and another set of the 20 day names. Tlazoltéotl is principally known as the old goddess of the earth and of the moon and as the eater of filth. She is also known as Teteoinnan, the "mother of the gods," and as Toci, "our grandmother." It is in these capacities that she displays the characteristics of a goddess of sensuality and voluptuousness.

The original of the Codex Borgia has been very badly damaged on this page through burning and the loss of the white lime surface that underlies the paintings. As a result much of this page is reconstructed by Díaz and Rodgers following a drawing of the page made for Lord Kingsborough in the nineteenth century. Neither Kingsborough nor Díaz and Rodgers could decide where to put the day sign for Movement on the lower half of the page, so it is omitted though it was surely there at one time. On both halves of the page, 14 of the day signs are arranged around the margins, and six are in the center with the image of the god. In both cases these six are consecutive days. For the *ahuiatéotl* they are the last four and the first two, and for Tlazoltéotl they are the last six of the series of 20.

Plates 75 and 76: Eight Deities

The last two pages, the most seriously damaged of the entire codex, are meant to be read together. Each page is divided into four parts, with each quarter dominated by the figure of a god seated on a throne. In front of each deity are several other things, including a small figure of a priest offering incense and blood, and an urn with other sacrifices in it. Beneath each set of images are five day signs taken from a column of the *tonalpohualli* as arranged in five rows of 52 days, like the one on Plates 1–8 of the codex. At one side of each panel is a group of either five or six red dots as calendrical place holders.

The reading order begins at the bottom right corner of Plate 75 and proceeds from right to left across the two pages. It then goes up to the top register at the upper left corner of Plate 76 and proceeds from left to right back across the two pages. After five circuits of the

eight images an entire 260-day *tonalpohualli* will have been counted. If we begin reading with the day 1 Alligator at the bottom of Plate 75 and count the six place markers as days 2 through 7, the next day will be 8 Rabbit, which is the first of the painted day signs in the next panel. From there five place markers take us past days 9 through 13, making the next day 1 Jaguar. Clearly, each pair of figures represents two parts of a single group of 13 and, just as clearly, each pair of figures can be associated with the direction linked to that part of the *tonalpohualli.* The reason for this association is not so clear, though it may be based on principles similar to those that informed the painting on Plate 72 with its four plumed serpents.

The deity in the first panel is Tláloc, the god of rain and storm. Before him are a bowl full of ears of corn, instruments of autosacrifice and an urn with a rubber ball and an ear of corn. The second panel contains Tonatiuh, the sun god, enthroned before a hill with instruments of warfare at its peak. These two panels are attributed to the East by Seler.

The next pair of panels, at the bottom of Plate 76, contain a red skeletal figure, as a symbol of the moon as well as of death, on the right, and Tlazoltéotl, the goddess of the moon, on the left. This pair is connected to the second portion of the *tonalpohualli,* that of the North. The skeletal figure is seated before a pair of autosacrificial tools and an urn containing a ball of rubber, a bundle of sticks, three loose sticks, a plant and a fire serpent's tail. Tlazoltéotl is seated before a hill with a crossroads and a bundle of sticks.

The third pair of panels is found at the top of Plate 76. The first of the pair was almost completely destroyed by the late-eighteenth-century fire. The second, on the right side of the page, is a representation of Tlahuizcalpantecuhtli, though the diagnostic five dots on his face are not in evidence. He sits before a hill that has instruments of warfare at its peak and water running down its sides. These panels are tied calendrically to the West.

The fourth and final pair, at the top of Plate 75, is connected to the South in the calendar. The first of the pair contains a figure of a green skeleton covered with green grass (the green has become tan). Before him are broken instruments of autosacrifice and an urn very similar to that of the third panel (which featured the red skeleton) and with nearly identical contents. Again, the second panel of this last pair was almost completely destroyed by the unfortunate fire and by friction.

The relationship between these four quarters, in the form of eight paired images, and the four plumed serpents on Plate 72 was first noted by Seler, who remarked that correspondences of color and imagery suggest that these two sections of the codex were about similar matters.

References Cited

Adelhofer, O.
 1963 *Codex Vindobonensis Mexicanus I.* Academische Druck- u. Verlagsanstalt, Graz, Austria.
Alvarado, Fray Francisco de
 1962 [1593] *Vocabulario en Lengua Mixteca.* Facsimile edition with a study by Wigberto Jiménez Moreno. Instituto Nacional Indigenista e Instituto Nacional de Antropología e Historia, México.
Anders, Ferdinand
 1967 *Codex Tro-Cortesianus (Codex Madrid).* Akademische Druck- u. Verlagsanstalt, Graz, Austria.

 1968 *Codex Peresianus (Codex Paris).* Akademische Druck- u. Verlagsanstalt, Graz, Austria.
 1972 *Codex Vaticanus 3773 (Codex Vaticanus B).* Akademische Druck- u. Verlagsanstalt, Graz, Austria.
Anders, Ferdinand, and H. Dekkert
 1975 *Codex Dresdensis (Sächsische Landesbibliothek Dresden Mscr. Dresd. R 310).* Akademische Druck- u. Verlagsanstalt, Graz, Austria.
Arana, Evangelina, and Mauricio Swadesh
 1965 *Los elementos del Mixteca antiguo.* Instituto Nacional Indigenista e Instituto Nacional de Antropología e Historia, México.

Benson, Elizabeth, editor
 1973 *Mesoamerican writing systems, a conference at Dumbarton Oaks, October 30th and 31st, 1971.* Dumbarton Oaks Research Library and Collection, Trustees for Harvard University, Washington, D.C.

Biedermann, Hans
 1989 *Jade, Gold und Quetzalfedern.* Akademische Druck- u. Verlagsanstalt, Graz, Austria.

Burland, Cottie A.
 1965 *Codex Egerton 2895 (Codex Waecker Götter).* Akademische Druck- u. Verlagsanstalt, Graz, Austria.
 1966 *Codex Laud (MS. Laud Misc. 678, Bodleian Library).* Akademische Druck- u. Verlagsanstalt, Graz, Austria.
 1971 *Codex Fejérváry-Mayer (Museum of the City of Liverpool).* Akademische Druck- u. Verlagsanstalt, Graz, Austria.

Byland, Bruce E., and John M. D. Pohl
 in press *In the Realm of 8 Deer: The archaeology of the Mixtec Codices.* University of Oklahoma Press, Norman.

Carrasco, David
 1990 *Religions of Mesoamerica.* Harper and Row, New York.

Caso, Alfonso
 1927 Las ruinas de Tizatlán, Tlaxcala. *Revista Mexicana de Estudios Históricos* 1(4):139–72.
 1960 *Interpretation of the Codex Bodley 2858.* Translated by Ruth Morales and revised by John Paddock, Sociedad Mexicana de Antropología, México.
 1964 *Interpretation of the Codex Selden 3135 (A. 2).* Translated by Jacinto Quirarte and revised by John Paddock, Sociedad Mexicana de Antropología, México.

Caso, Alfonso, and Mary Elizabeth Smith
 1966 *Interpretación del Códice Colombino/Interpretation of the Codex Colombino* (by Alfonso Caso), *Las glosas del Códice Colombino/ The glosses of the Codex Colombino* (by Mary Elizabeth Smith). Sociedad Mexicana de Antropología, México.

Ehrle, Franz
 1898 *Il manoscritto Messicano Borgiano del Museo Etnografico* Duque de Loubat, Rome.

Furst, Jill Leslie
 1978 *Codex Vindobonensis Mexicanus I: A commentary.* Institute for Mesoamerican Studies, State University of New York at Albany Publication 4, Albany.

Glass, John B.
 1975 A survey of Native Middle American pictorial manuscripts. In *Handbook of Middle American Indians; vol. 14, Guide to Ethnohistorical Sources, part three.* H. F. Cline, editor, University of Texas Press, Austin, pp. 3–80.

Humboldt, Alexander von
 1810 *Vue des cordillères et monuments des peuples indigènes de l'Amérique.* F. Schöll, Paris.

Kingsborough, Lord Edward King
 1831–48 *Antiquities of Mexico, comprising facsimiles of ancient Mexican paintings and hieroglyphics.* 9 vols., London.

León-Portilla, Miguel
 1963 *Aztec Thought and Culture.* University of Oklahoma Press, Norman.

Lopez Austin, Alfredo
 1973 *Hombre-dios: Religion y política en el mundo nahuatl.* Universidad Nacional Autónoma de México, México.

Marcus, Joyce
 1992 *Mesoamerican writing systems: Propaganda, myth, and history in four ancient civilizations.* Princeton University Press, Princeton.

Miller, Arthur
 1975 *The Codex Nuttall: A picture manuscript from ancient Mexico.* The Peabody Museum facsimile edited by Zelia Nuttall. New introductory text by A. G. Miller. Dover Publications, New York.

Monaghan, John
 1987 *"We are the people who eat tortillas": Household and community in the Mixteca.* Ph.D. dissertation, University of Pennsylvania, University Microfilms, Ann Arbor.

Nicholson, Henry B.
 1971 Religion in pre-Hispanic central Mexico. In *Handbook of Middle American Indians; vol. 10, Archaeology of Northern Mesoamerica, part one.* edited by Gordon Ekholm and Ignacio Bernal, University of Texas Press, Austin, pp. 395–446.

Noguera, Eduardo
 1927 *Ruinas de Tizatlán, Tlaxcala: Los altares de sacrificio de Tizatlán, Tlaxcala.* Secretaría de Educación Pública, Mexico.

Nowotny, Karl A.
 1961a Tlacuilolli: Die mexikanischen Bilderschriften (Stil und Inhalt: mit einem Katalog der Codex-Borgia-Gruppe). *Ibero-Amerikanische Bibliothek, Monumenta Americana 3,* Berlin.
 1961b *Codices Becker I/II.* Akademische Druck- u. Verlagsanstalt, Graz, Austria.
 1968 *Codex Cospi (Calendario Messicano, Cod. 4093).* Akademische Druck- u. Verlagsanstalt, Graz, Austria.
 1976 *Codex Borgia (Cod. Borg. Messicano 1).* Akademische Druck- u. Verlagsanstalt. Graz, Austria.

Pohl, John M. D., and Bruce E. Byland
 n.d. The Temple of Heaven in the Mixtec Codices. Manuscript in the author's possession.
 1990 Mixtec landscape perception and archaeological settlement patterns. *Ancient Mesoamerica* 1(1):113–31.
 1991 The Mixteca-Puebla Style and Early Postclassic Socio-Political Interaction. Paper presented at the International Congress of Americanists, New Orleans, 1991. Special Session on the Mixteca-Puebla Style organized by H. B. Nicholson and Eloise Quinones-Keber.

Robertson, Donald
 1963 The style of the Borgia Group of Mexican pre-conquest manuscripts. In *Latin American art and the Baroque period in Europe: Acts of the Twentieth International Congress of the History of Art,* vol 3, Princeton University Press, Princeton, pp. 148–64.

Seler, Eduard
 1904–09 *Codex Borgia. Eine altmexicanische Bilderschrift der Bibliothek der Congregatio de Propaganda Fide.* 3 vols., Berlin.
 1963 *Comentarios al Códice Borgia.* Mariana Frenk, translator. 3 vols., Fondo de Cultura Económica, México (translation of Seler 1904–09).

Sisson, Edward B.
 1983 Recent work on the Borgia Group Codices. *Current Anthropology* 24(5):653–56.

Smith, Mary Elizabeth
 1963 The Codex Colombino: A document of the south coast of Oaxaca. *Tlalocan* IV (3):276–88.
 1973 *Picture writing from ancient southern Mexico: Mixtec place signs and maps.* University of Oklahoma Press, Norman.
 1983 Codex Selden: A manuscript from the Valley of Nochixtlan? In *The Cloud People.* edited by Kent Flannery and Joyce Marcus, Academic Press, New York, pp. 248–55.

Spranz, Bodo
 1964 *Göttergestalten in den mexikanischen Bilderhandschriften der Codex Borgia-Gruppe.* Franz Steiner Verlag GmbH., Wiesbaden.
 1973 *Los dioses en los códices mexicanos del Grupo Borgia: Una investigación iconográfica.* (María Martínez Peñaloza, translator), Fondo de Cultura Económica, México (translation of Spranz 1964).

Troike, Nancy
 1980 The identification of individuals in the Codex Colombino-Becker. *Tlalocan* VII: 397–418.
 1987 *Codex Zouche-Nuttall (British Museum ADD.MSS 39671).* Akademische Druck- u. Verlagsanstalt, Graz, Austria.

van der Loo, Peter
 1982 *Rituales con manojos contados en el Grupo Borgia y entre los Tlapanecos de hoy día.* Coloquio internacional: Los indígenas de México en la epoca prehispánica y en la actualidad. Rijksmuseum voor Volkenkunde, Leiden.
 1987 *Códices, costumbres, continuidad: Un estudio de la religión mesoamericana.* Indiaanse Studies 2, Leiden.

THE PLATES

The painted pages of the Codex Borgia restoration are here reproduced in numerically reverse order to make the reading of them as close to that of the original screenfold as possible (without the necessity of turning the book around halfway through). The codex is read from right to left, so that the reader is asked to turn to codex page 1 (= Dover Plate 1) and to read the color pages straight through from right to left and from back to front. Please note the detailed remarks in the introduction and commentary for the reading order on individual pages and groups of pages. The brief explanatory captions accompanying the plates have been provided by the writer of the introduction, Bruce E. Byland.

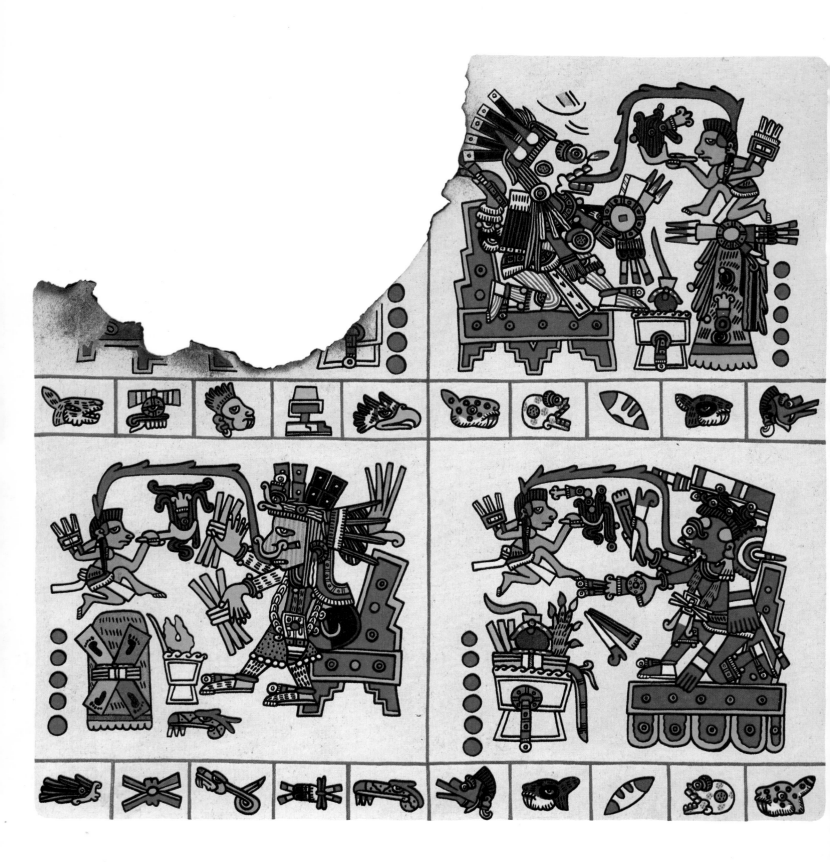

PLATE 76: Page 2 of eight deities

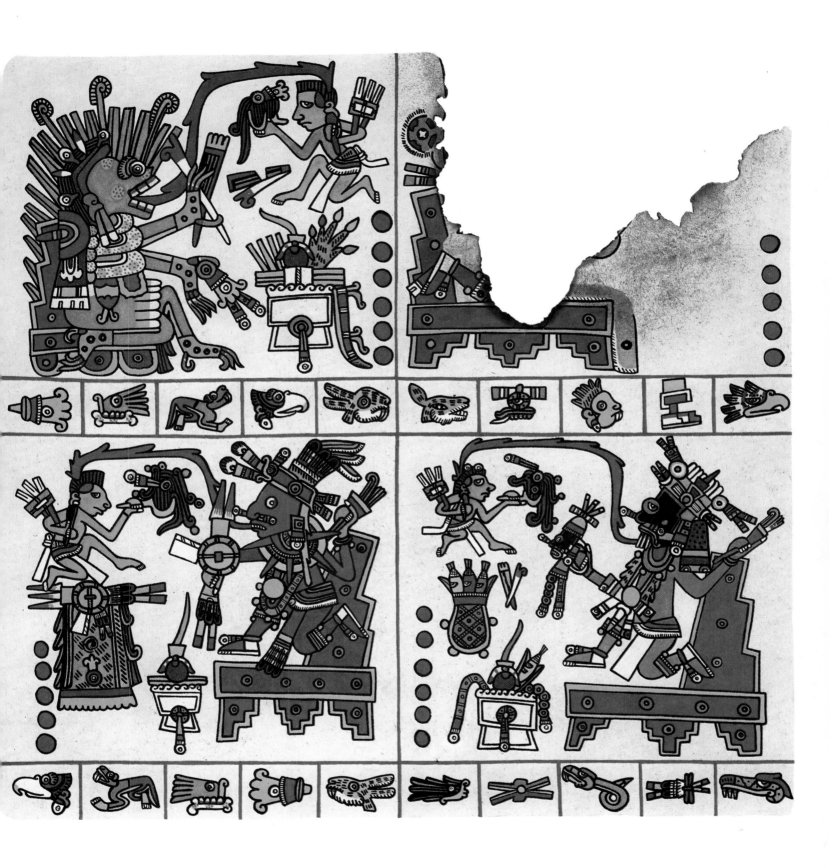

PLATE 75: Page 1 of eight deities

3

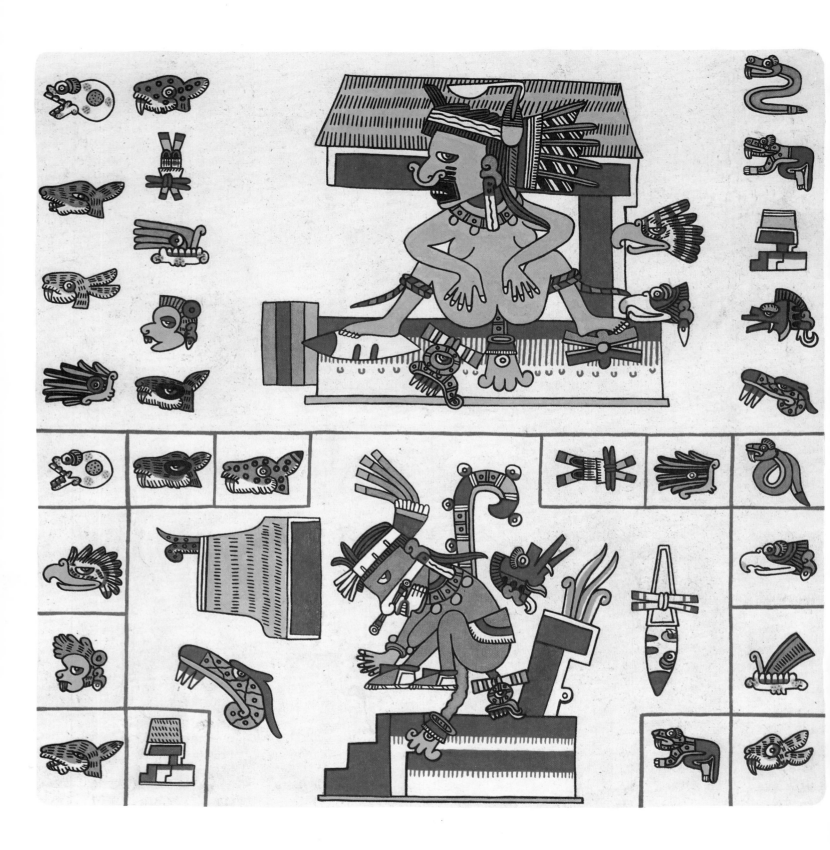

PLATE 74: Male and female gods of sensuality

4

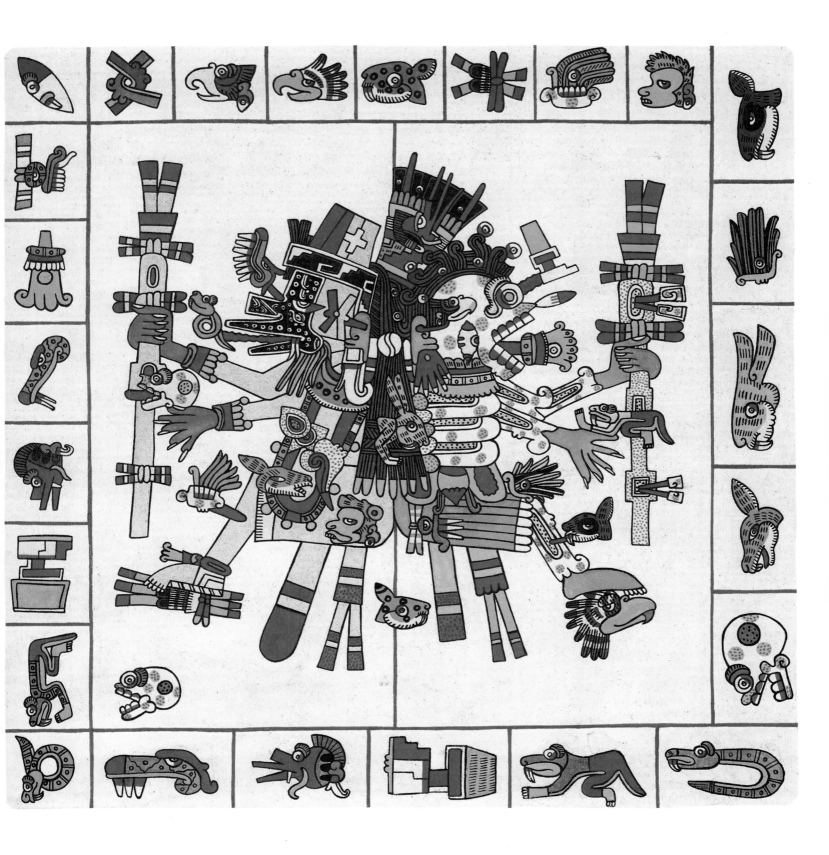

PLATE 73: Gods of death and life with 26 days and the 20 day signs

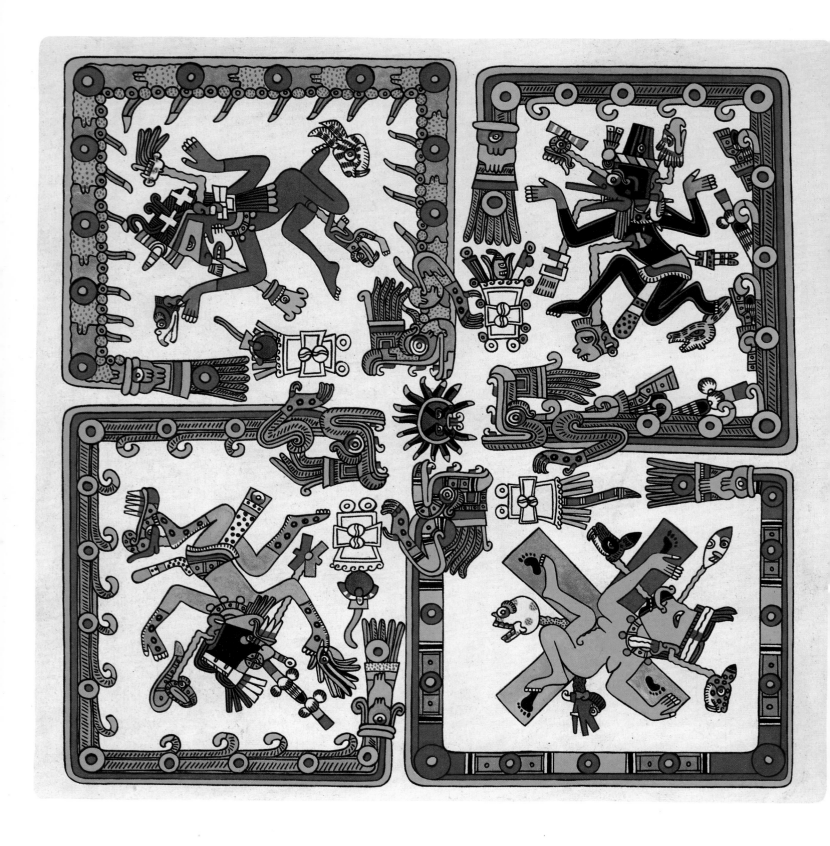

PLATE 72: The four directions with plumed serpents and deities

6

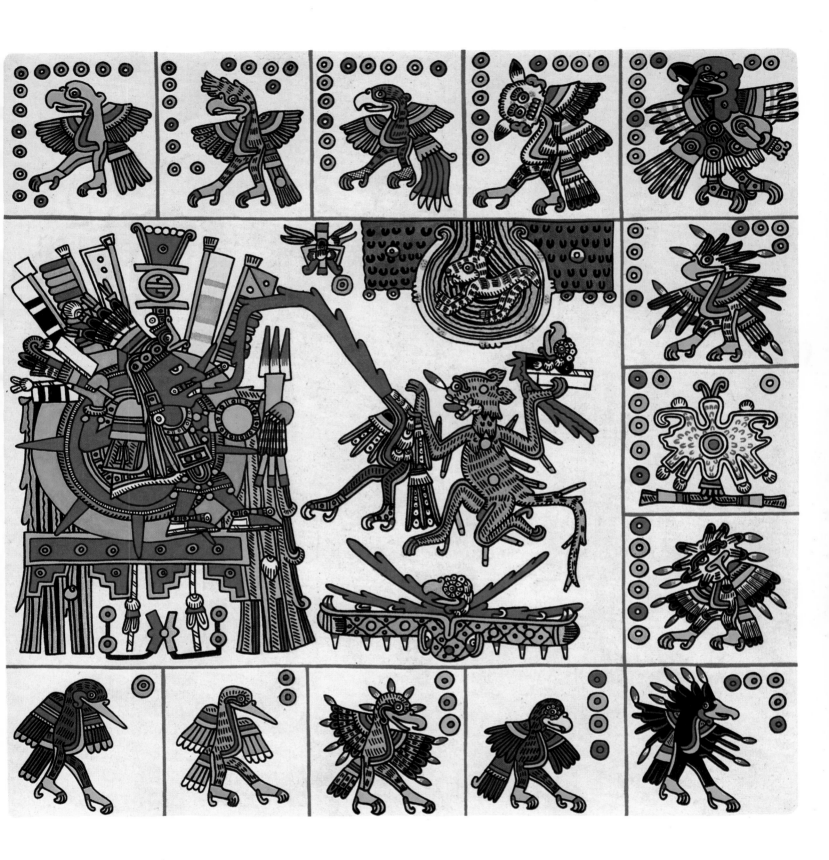

PLATE 71: The sun and the moon with 13 birds

7

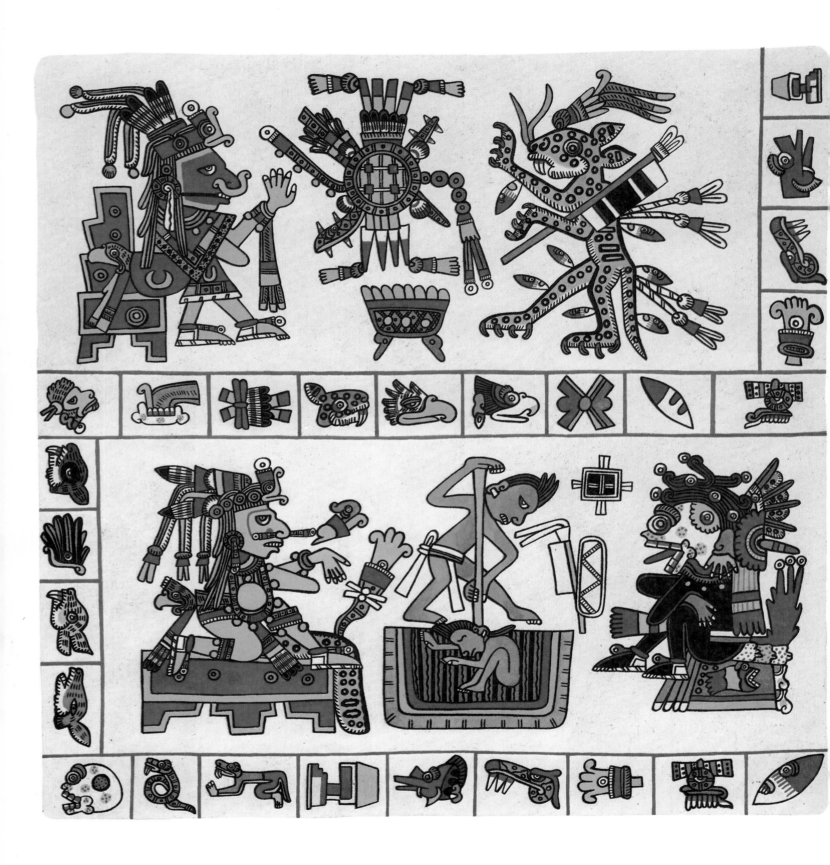

PLATE 70: Page 10 of the *tonalpohualli* arranged as 20 groups of 13 days

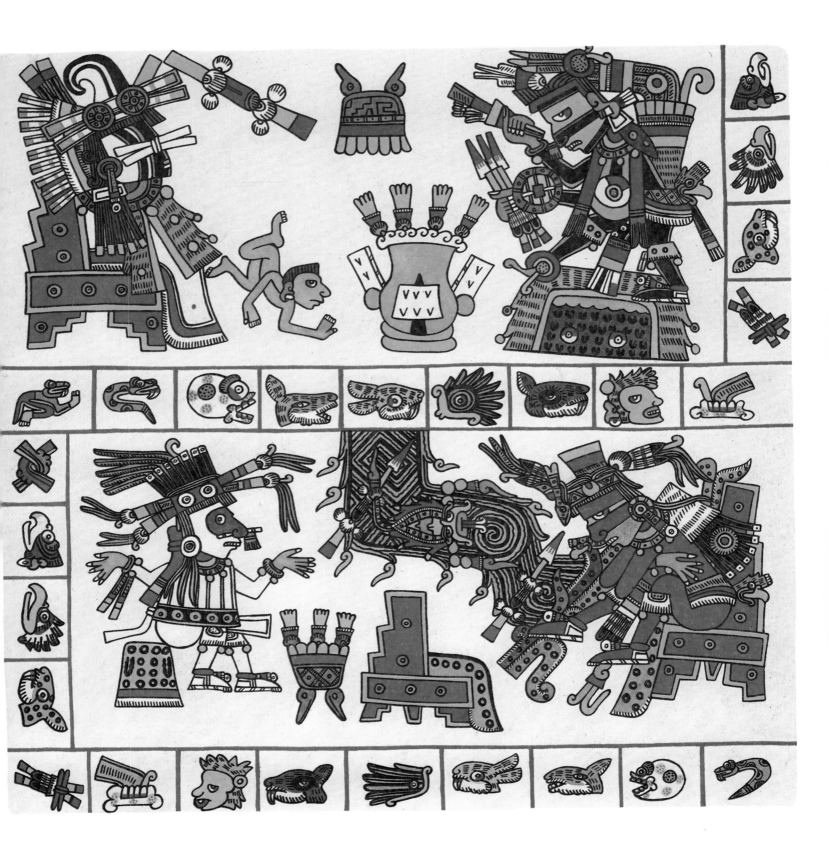

PLATE 69: Page 9 of the *tonalpohualli* arranged as 20 groups of 13 days

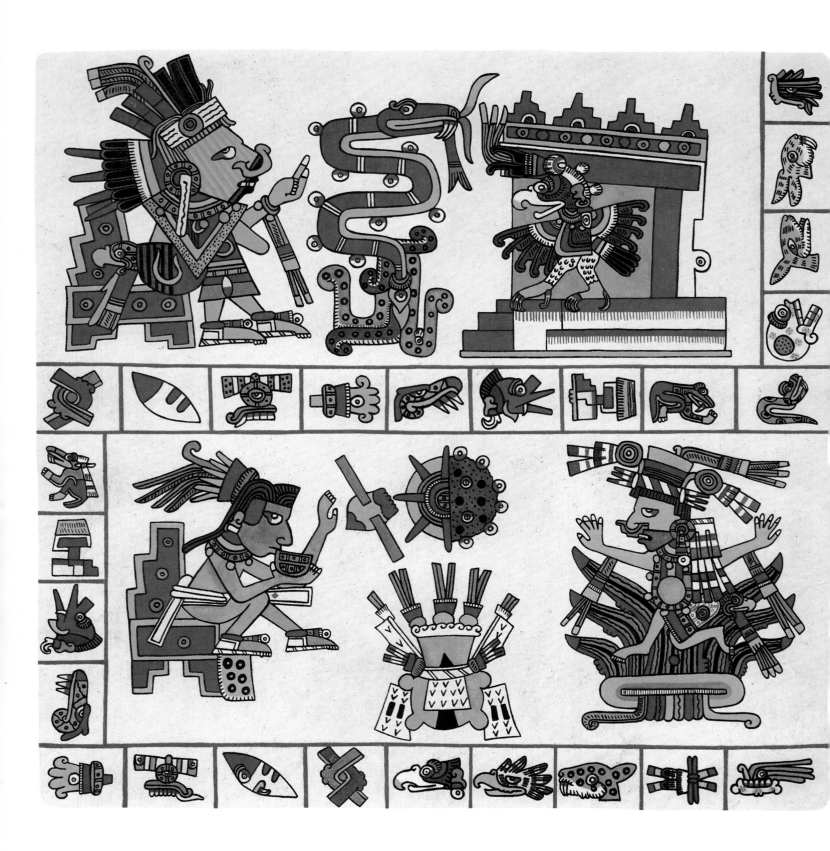

PLATE 68: Page 8 of the *tonalpohualli* arranged as 20 groups of 13 days

10

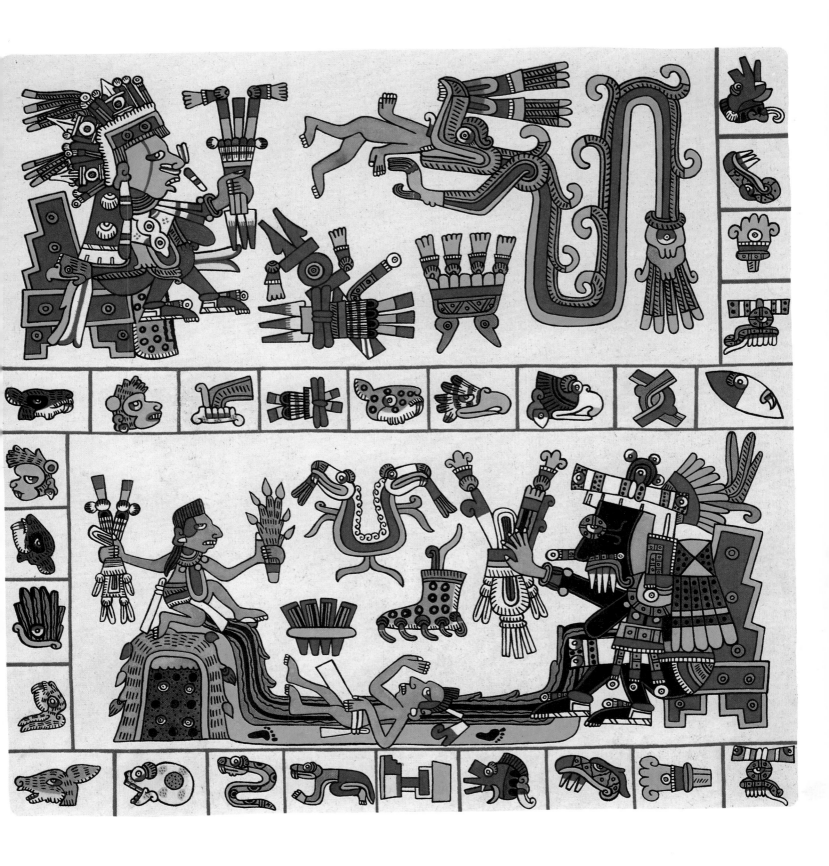

PLATE 67: Page 7 of the *tonalpohualli* arranged as 20 groups of 13 days

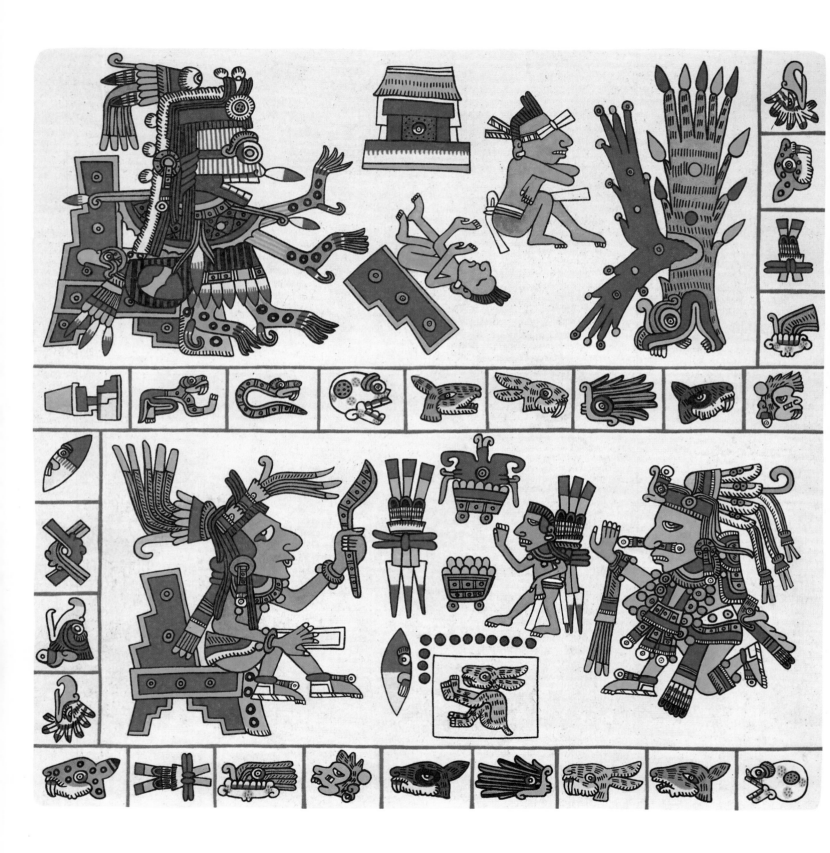

PLATE 66: Page 6 of the *tonalpohualli* arranged as 20 groups of 13 days

12

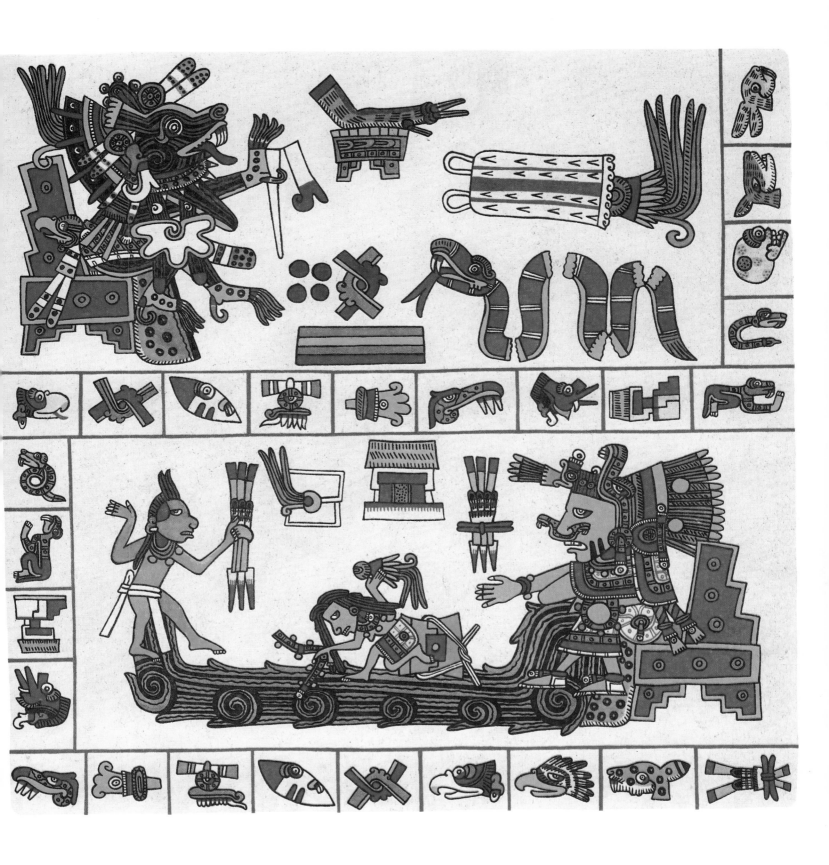

PLATE 65: Page 5 of the *tonalpohualli* arranged as 20 groups of 13 days

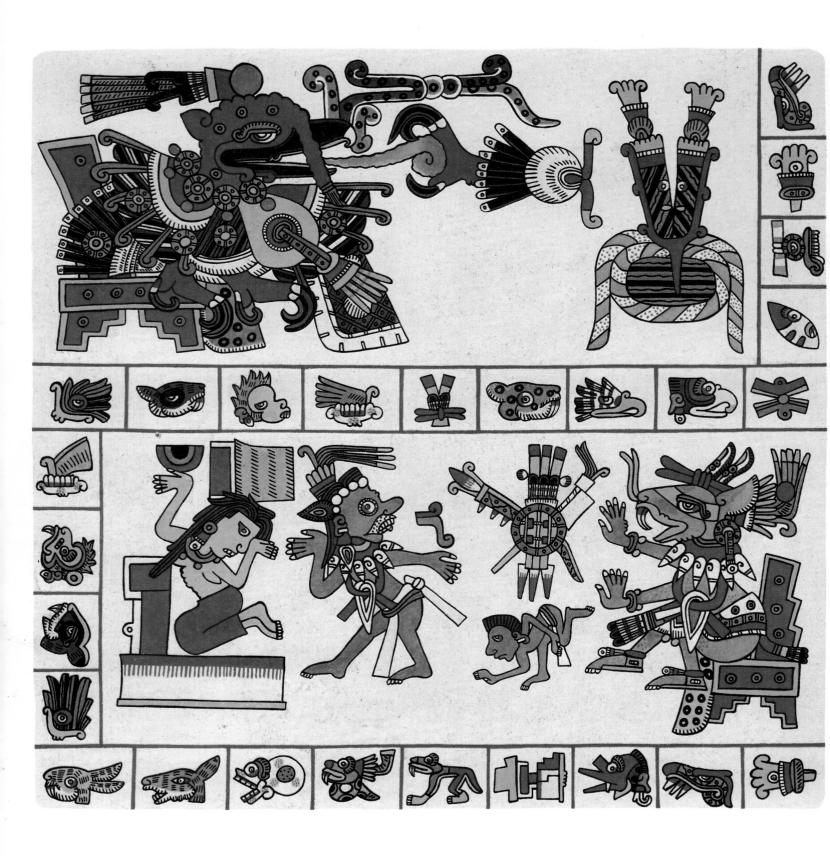

PLATE 64: Page 4 of the *tonalpohualli* arranged as 20 groups of 13 days

14

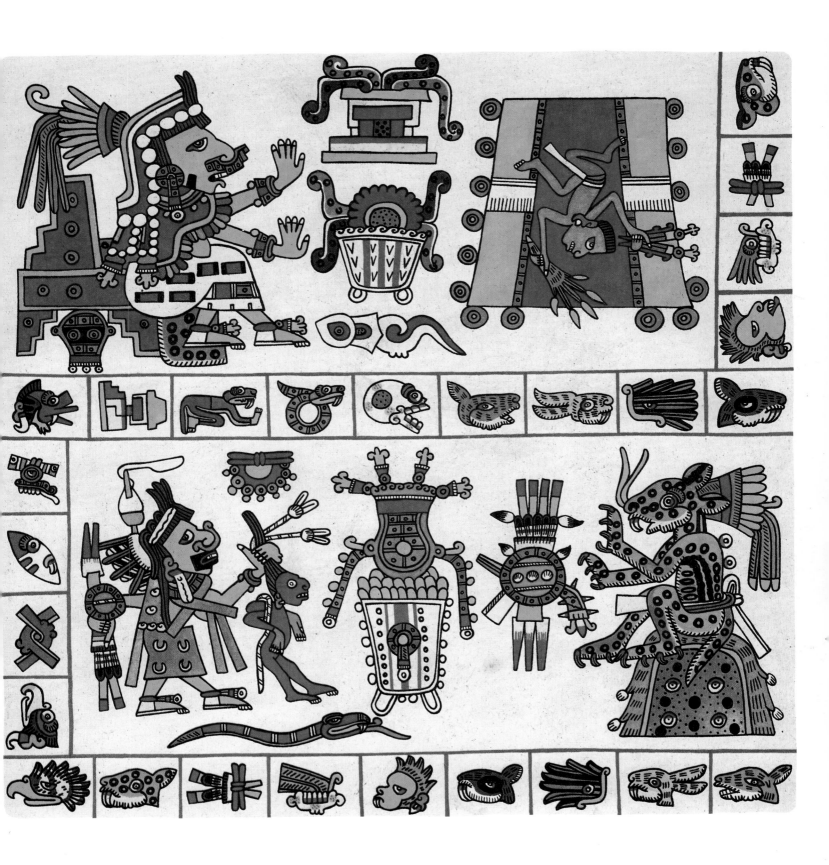

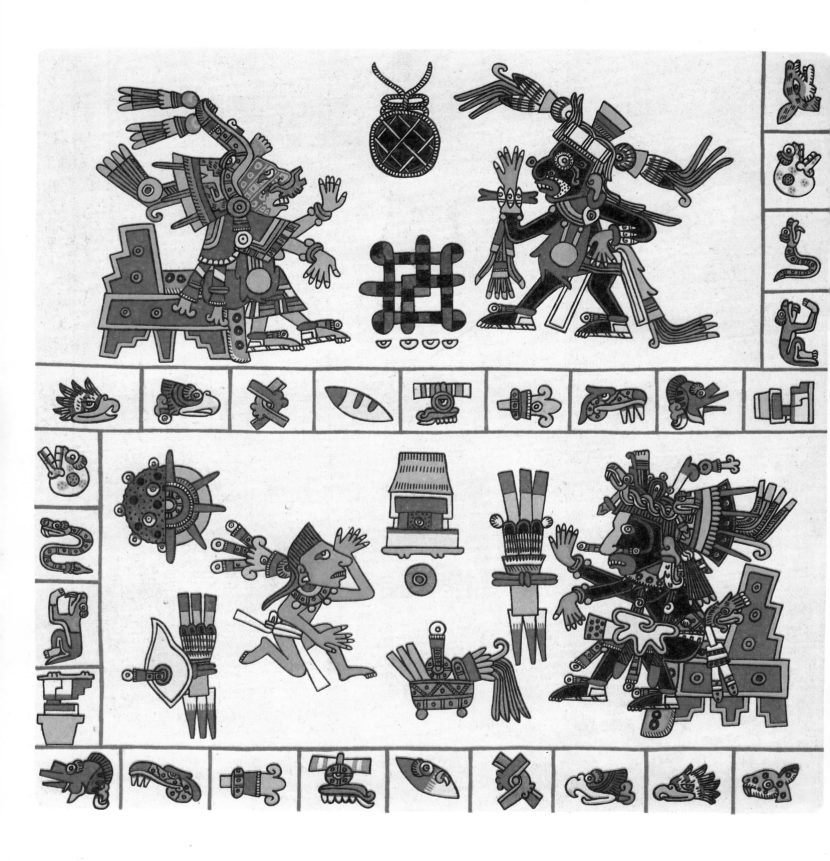

PLATE 62: Page 2 of the *tonalpohualli* arranged as 20 groups of 13 days

16

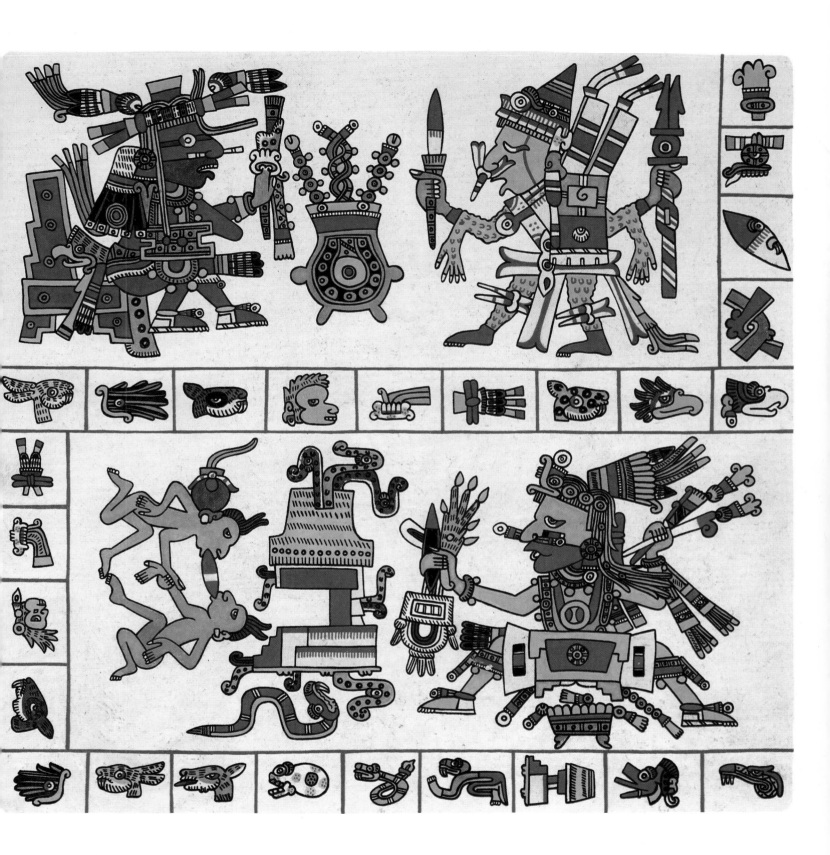

PLATE 61: Page 1 of the *tonalpohualli* arranged as 20 groups of 13 days

17

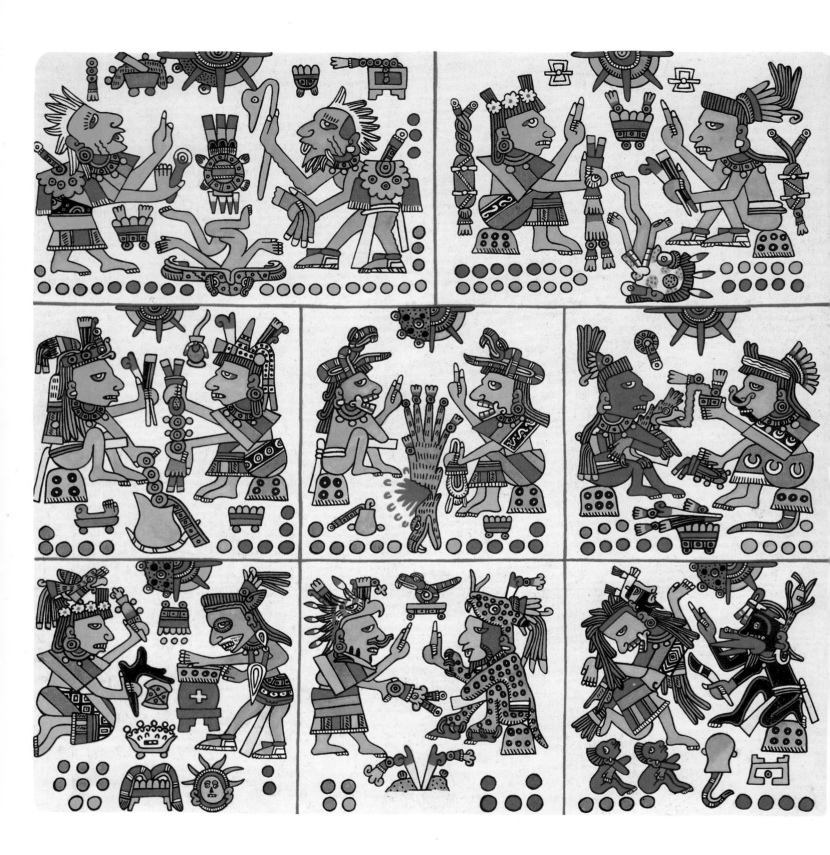

PLATE 60: Page 3 of the numerological marriage prognostications

18

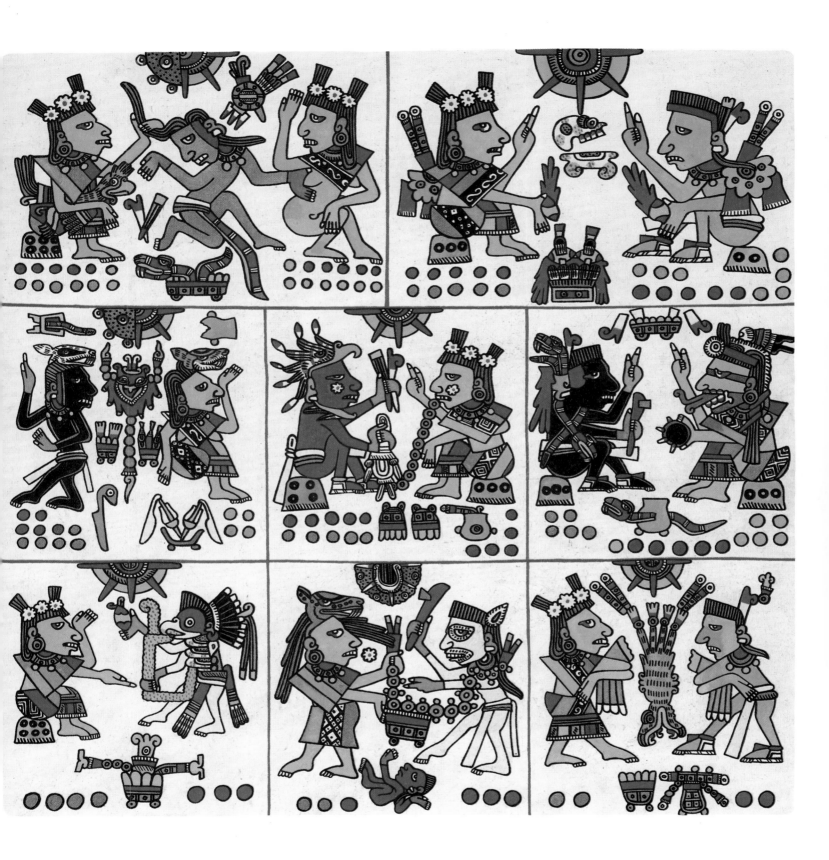

PLATE 59: Page 2 of the numerological marriage prognostications

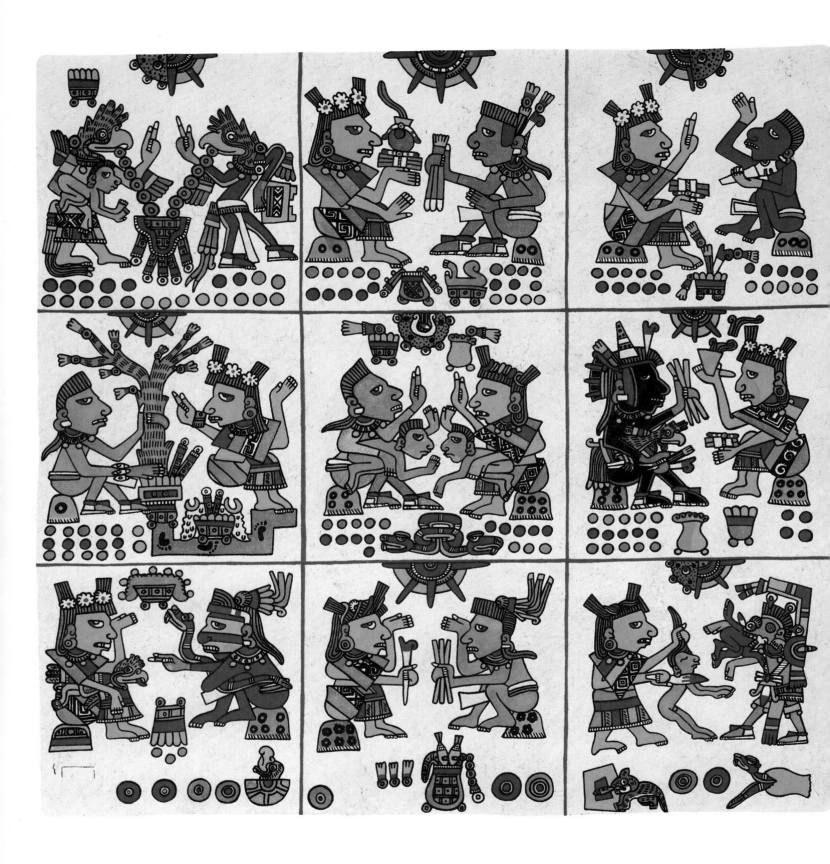

PLATE 58: Page 1 of the numerological marriage prognostications

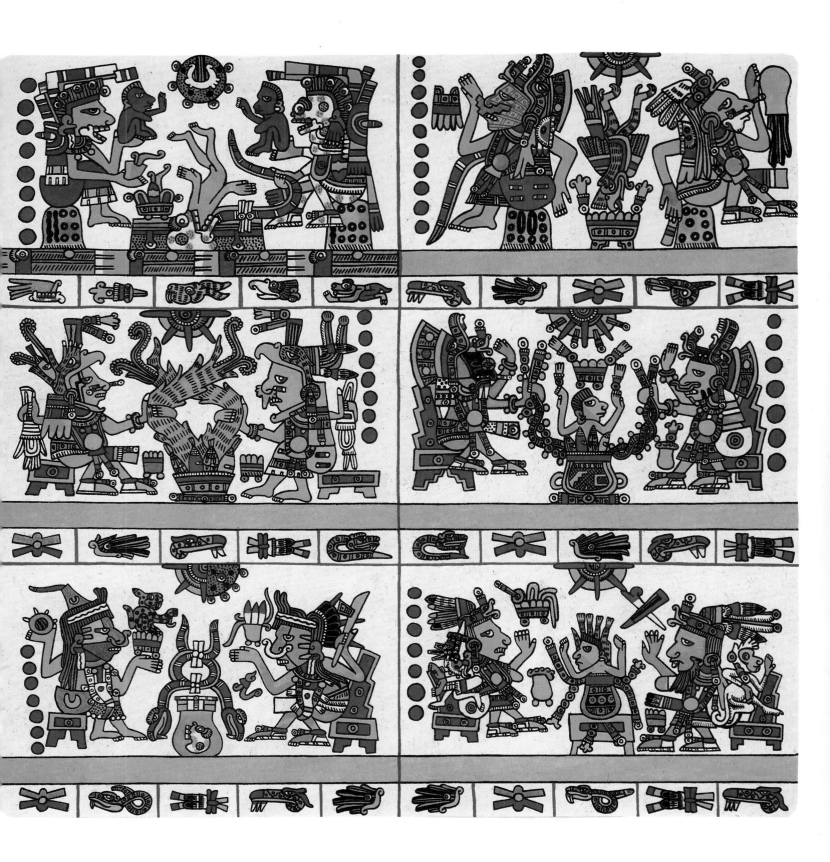

PLATE 57: Six supernatural couples

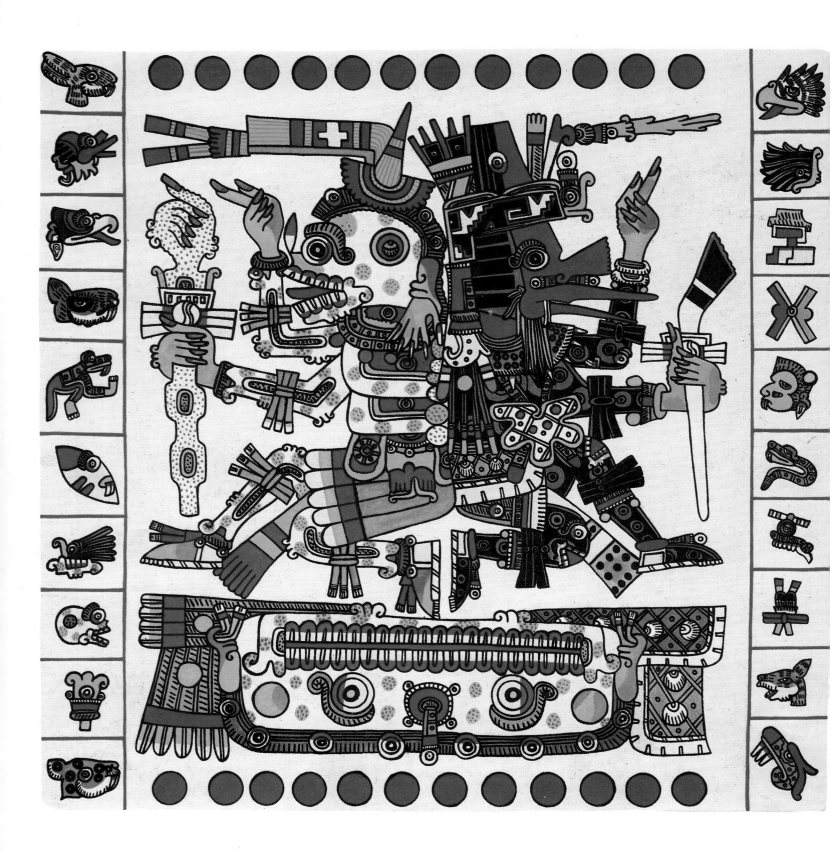

PLATE 56: Gods of life and death, and the *tonalpohualli*

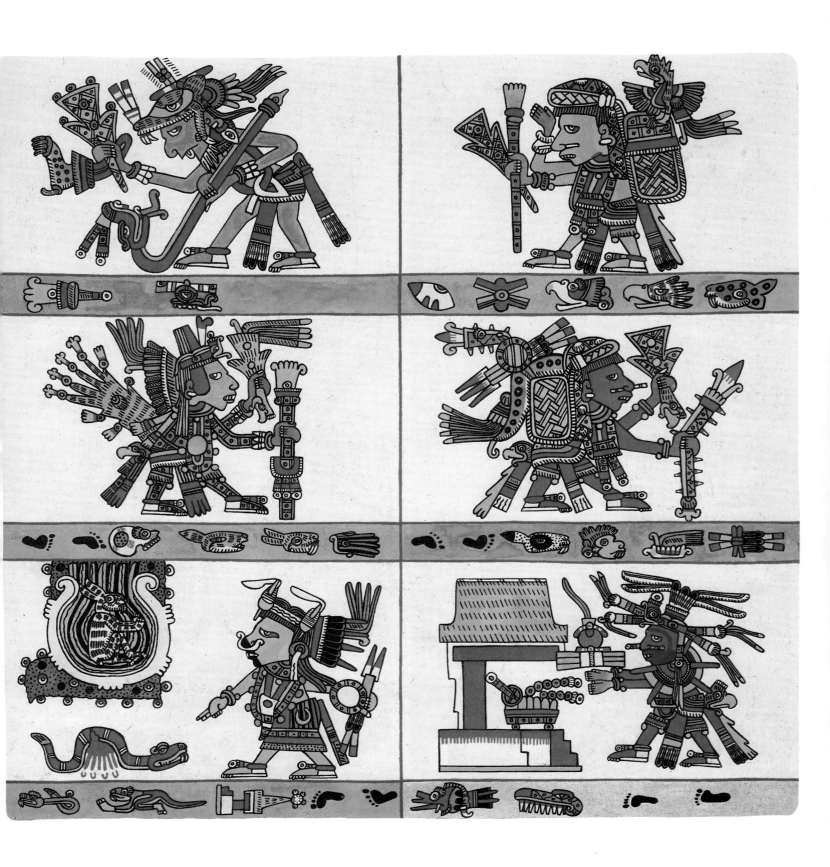

PLATE 55: Six deities with 20 day names

23

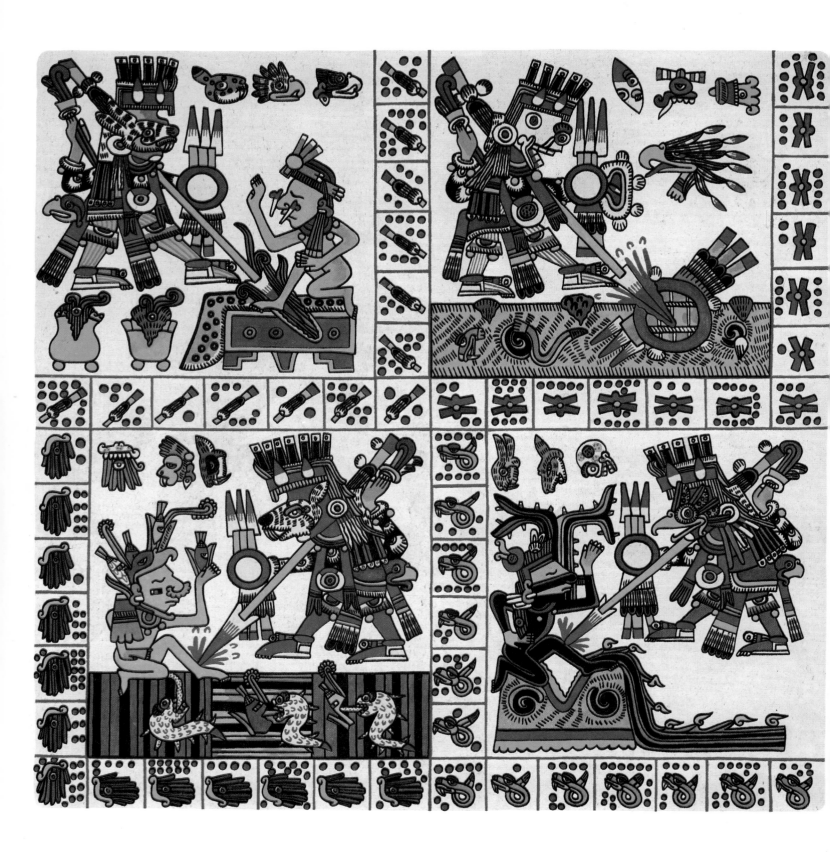

PLATE 54: Four more piercing sacrifices

24

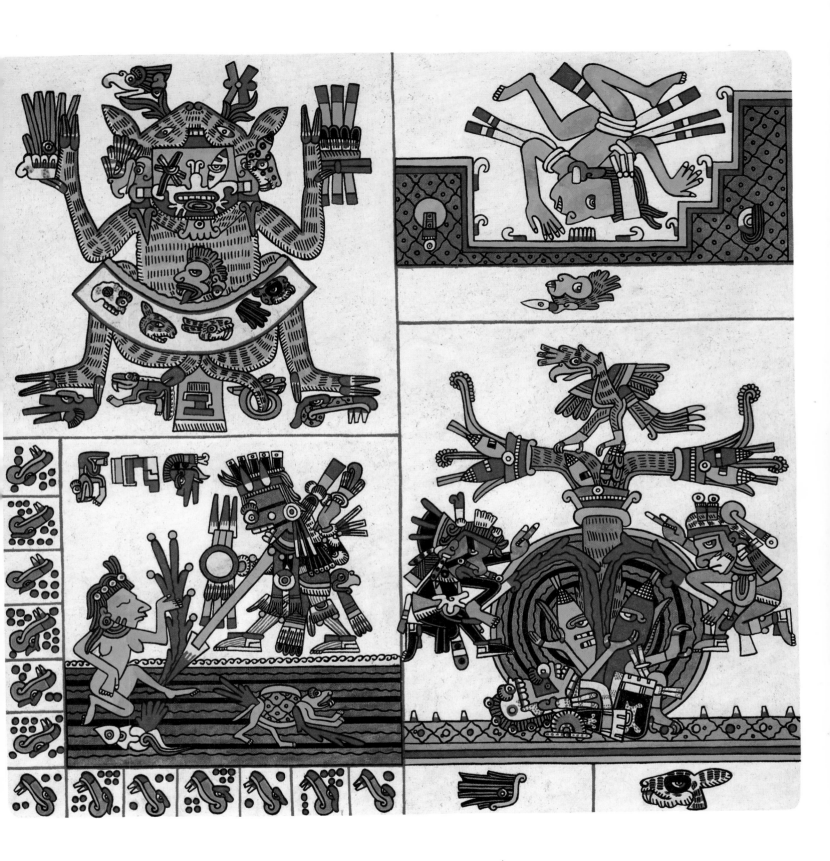

PLATE 53: Page 5 of the five directional trees, the Center; Xochipilli as a deer; and the first of five piercing sacrifices

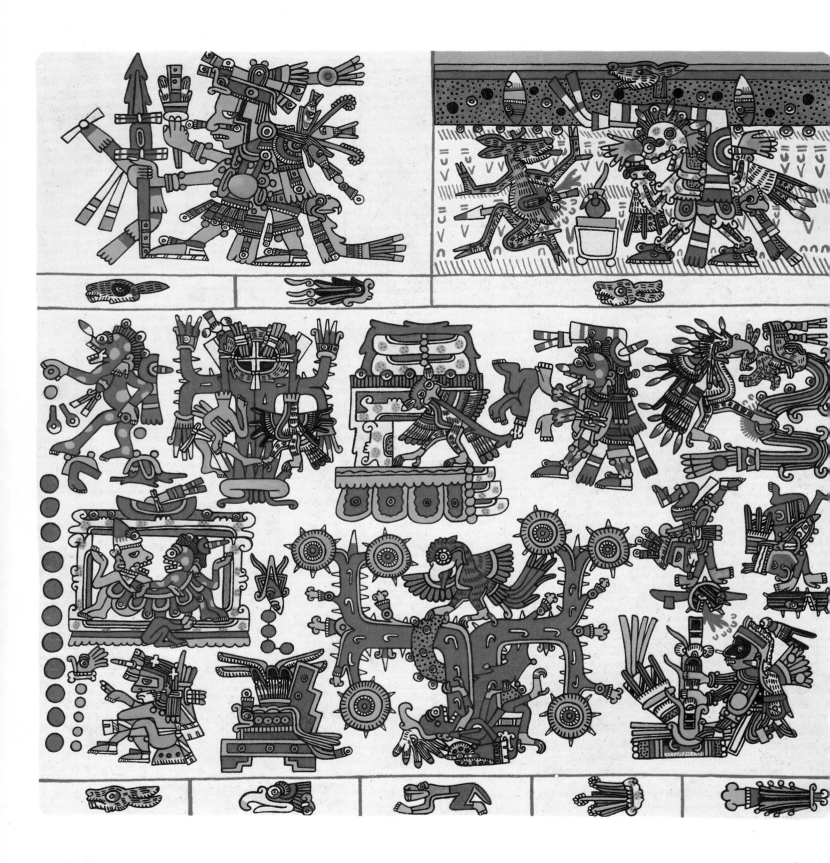

PLATE 52: Page 4 of the five directional trees, the South

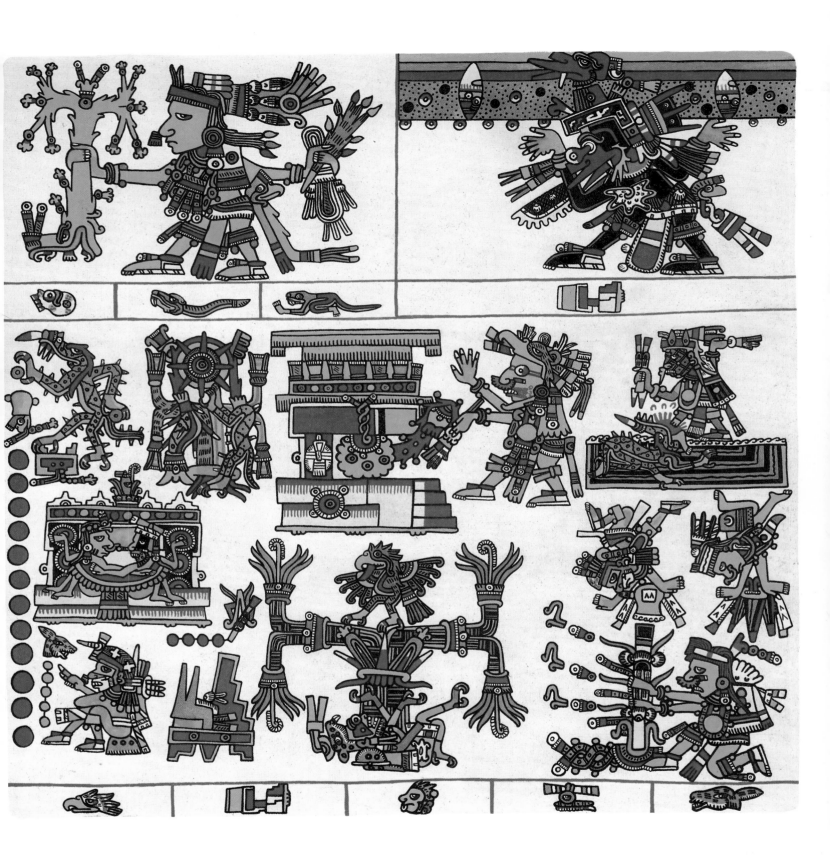

PLATE 51: Page 3 of the five directional trees, the West

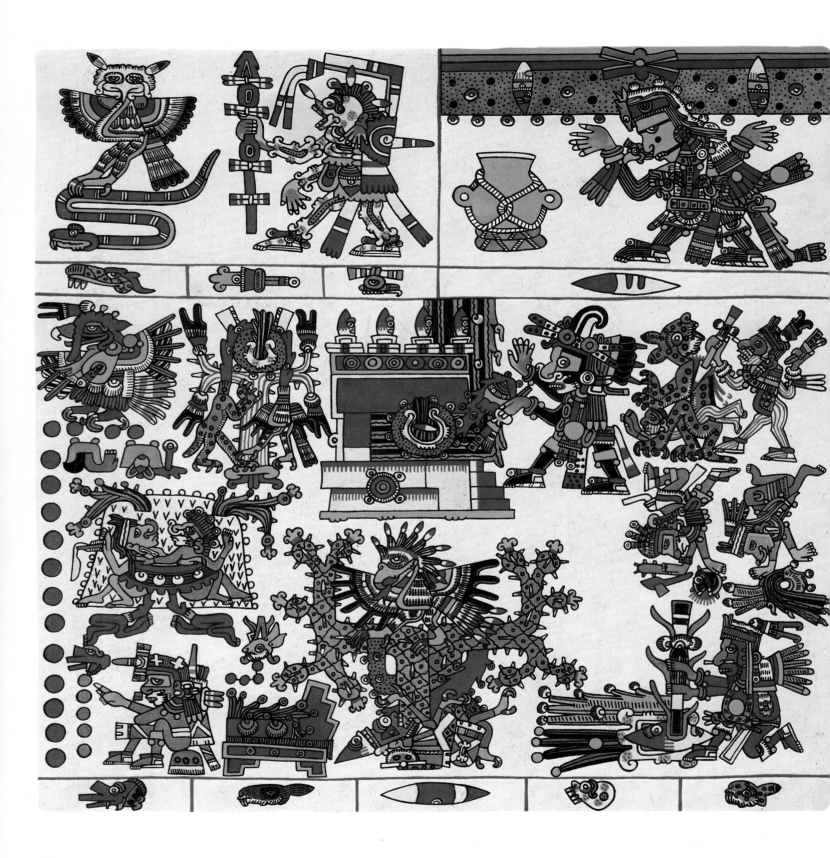

PLATE 50: Page 2 of the five directional trees, the North

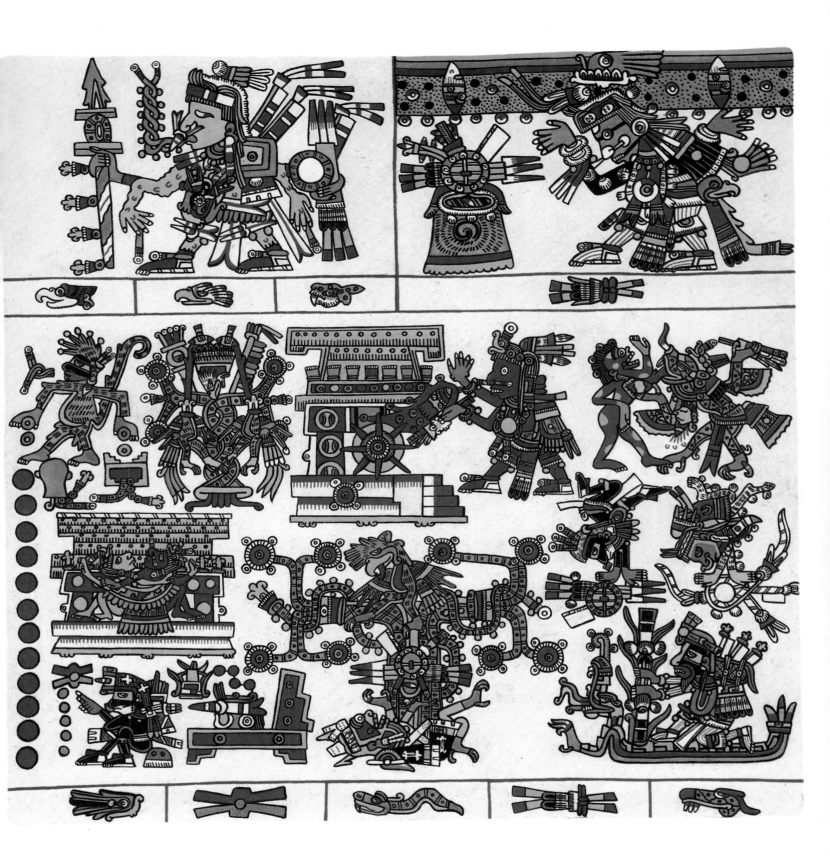

PLATE 49: Page 1 of the five directional trees, the East

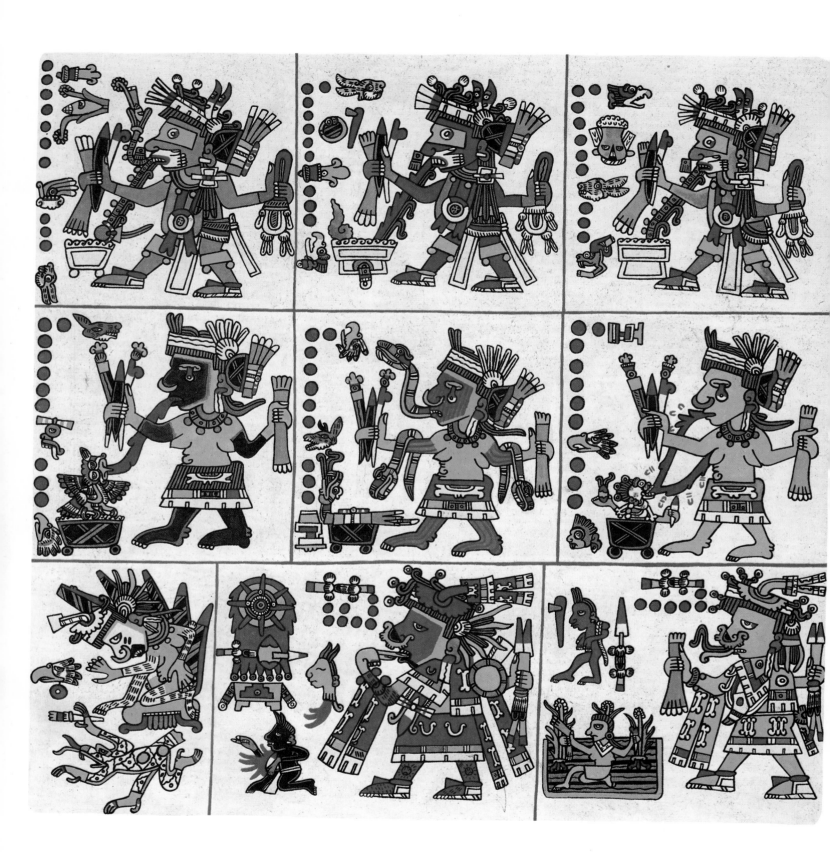

PLATE 48: Page 2 of three groups of five deities

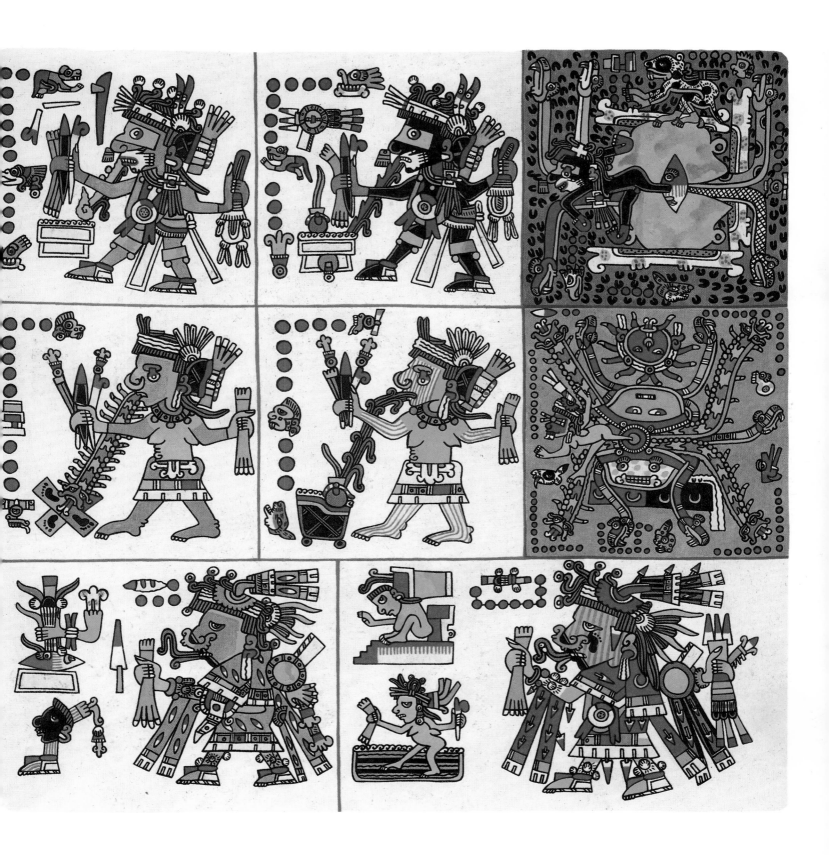

PLATE 47: Page 1 of three groups of five deities

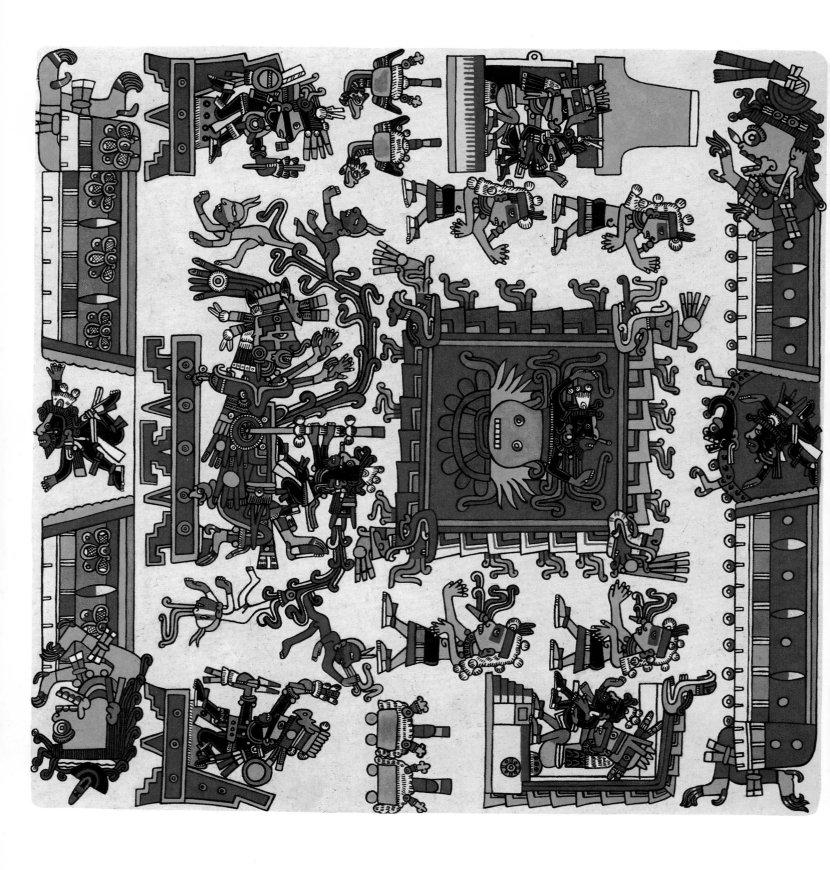

PLATE 46: Page 18 of the ritual sequence, a page of closing ceremony with new-fire lighting

32

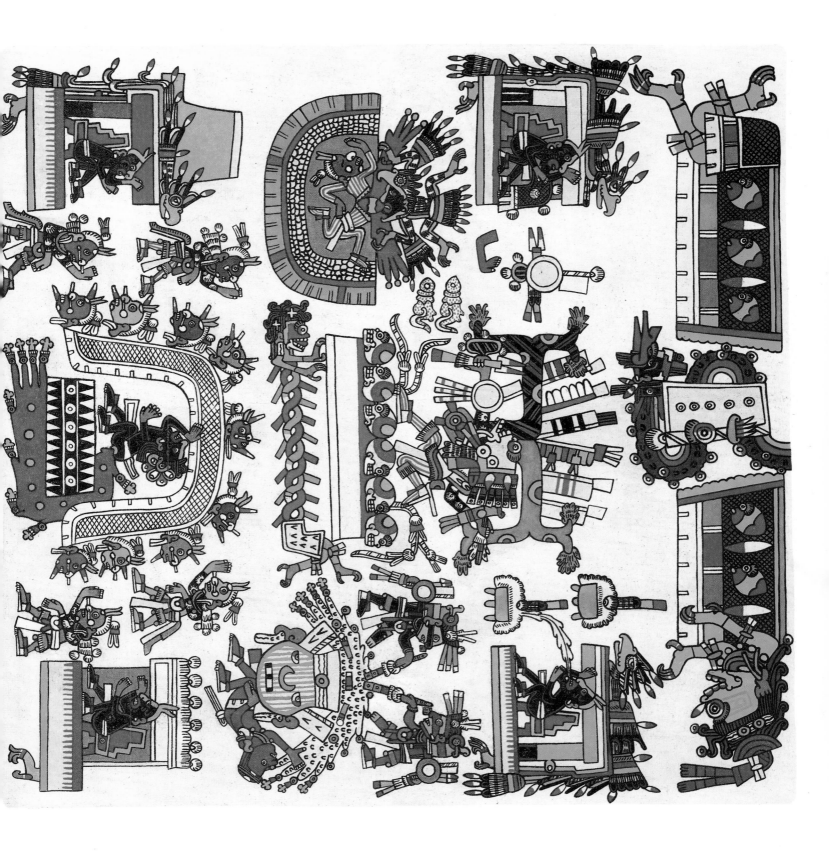

PLATE 45: Page 17 of the ritual sequence, a page of closing ceremony

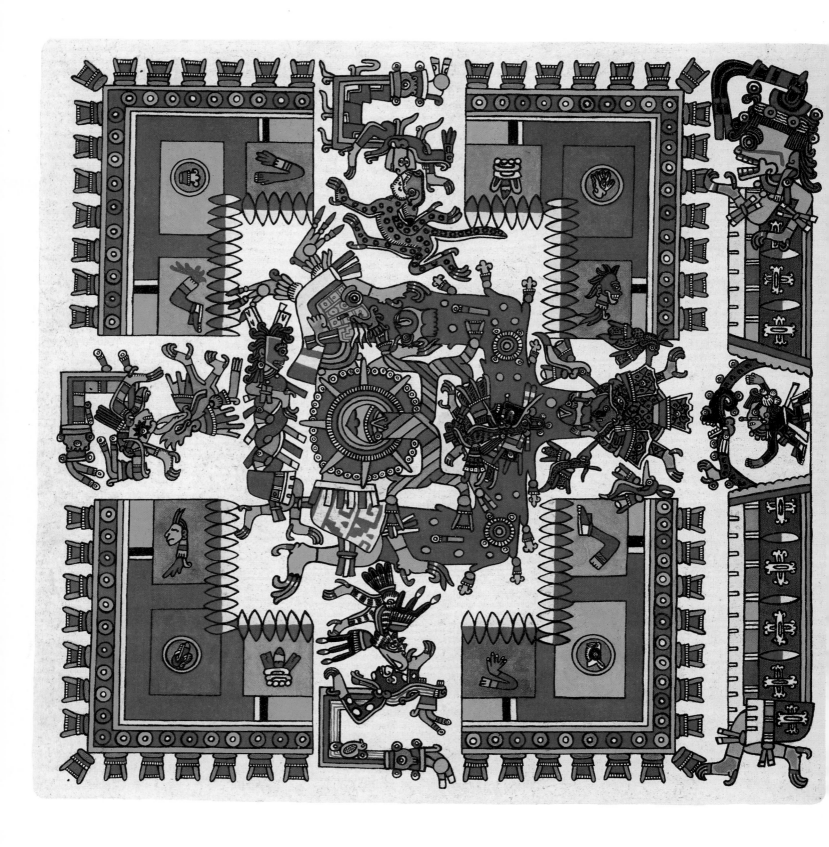

PLATE 44: Page 16 of the ritual sequence, Stripe Eye enters a flower/flint compound

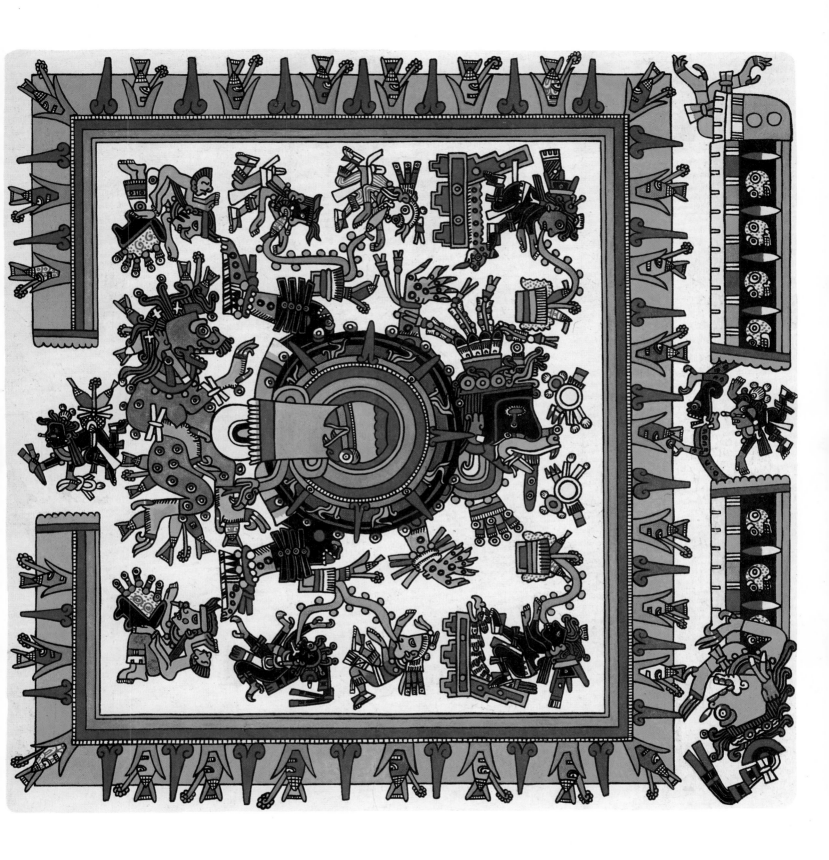

PLATE 43: Page 15 of the ritual sequence, Stripe Eye enters a corn/sun compound

35

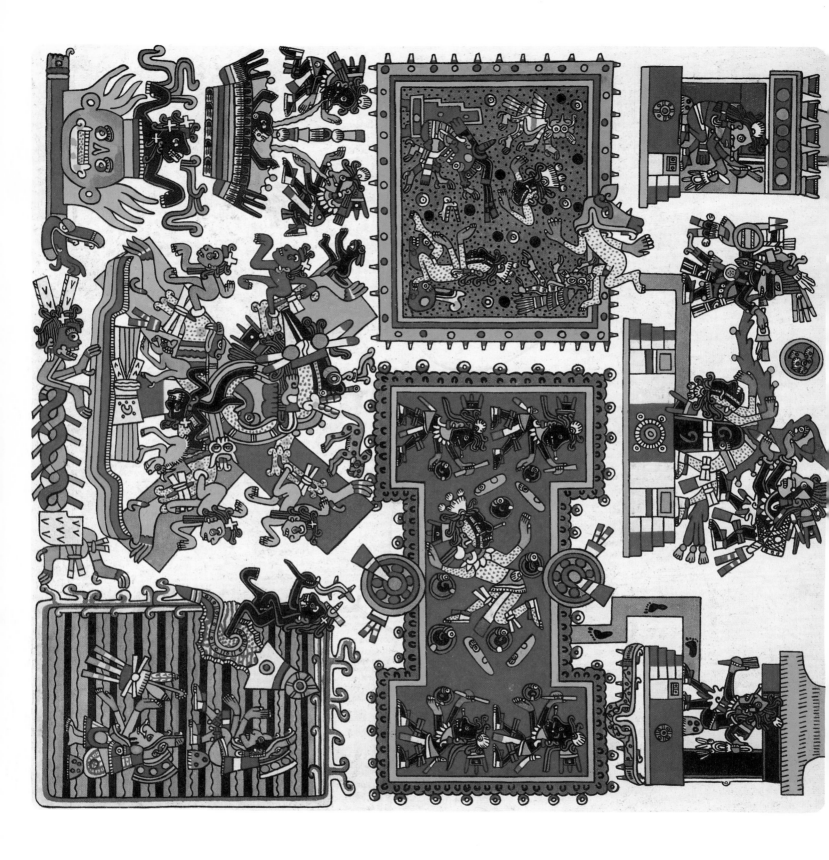

PLATE 42: Page 14 of the ritual sequence, Stripe Eye leads ceremonies of sacrifice

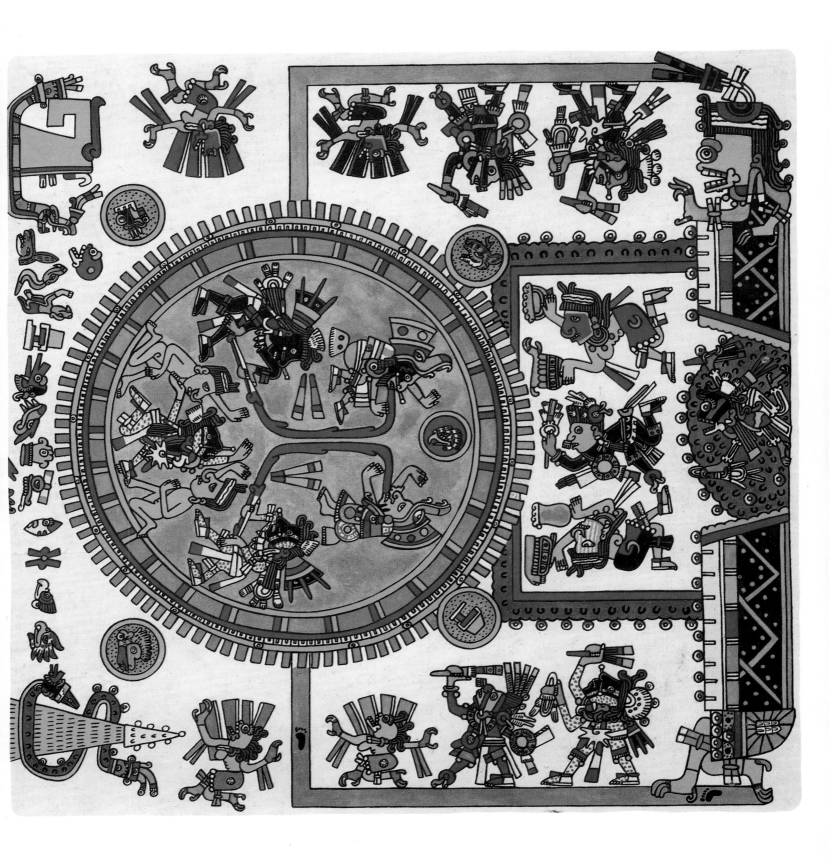

PLATE 41: Page 13 of the ritual sequence, a blue road and a cogged disc as Stripe Eye continues

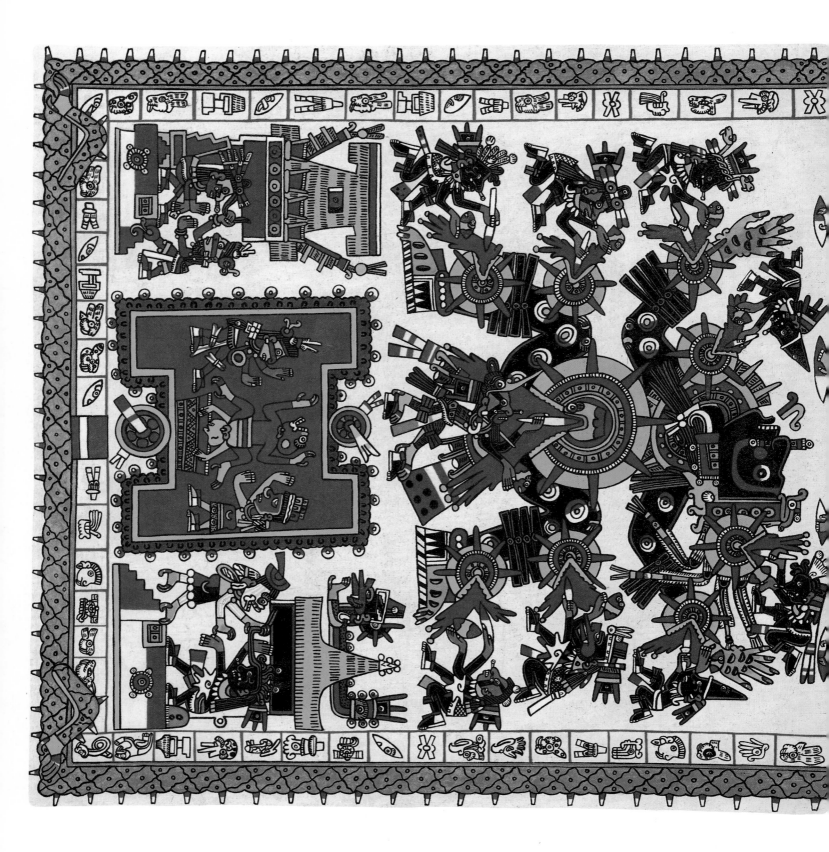

PLATE 40: Page 12 of the ritual sequence, Stripe Eye sacrifices the solar deity

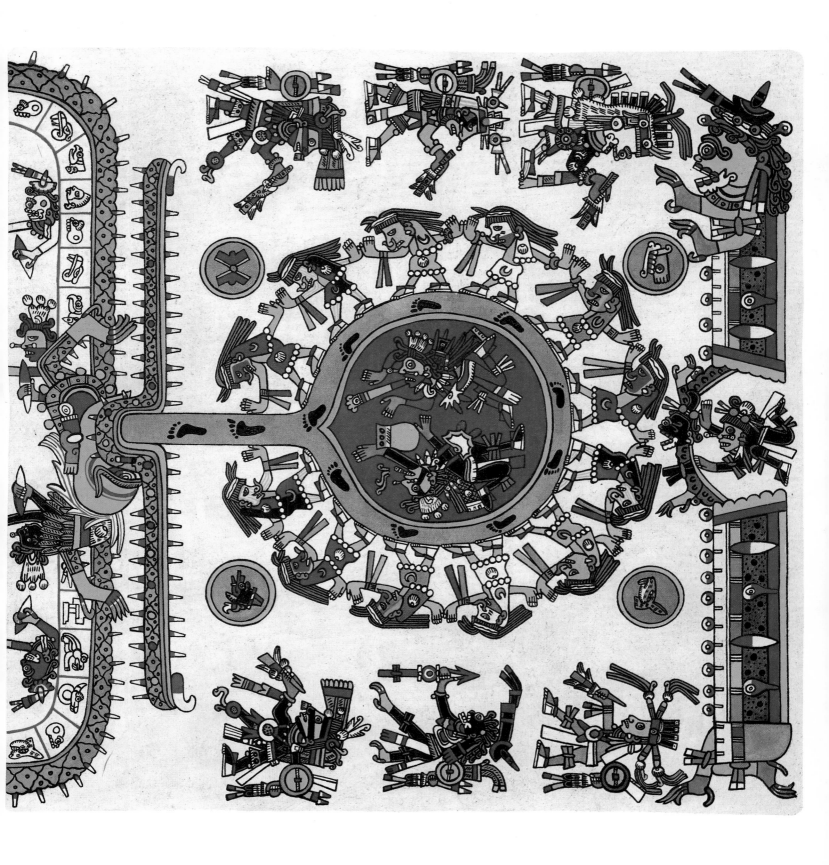

PLATE 39: Page 11 of the ritual sequence, Stripe Eye in another ceremony

39

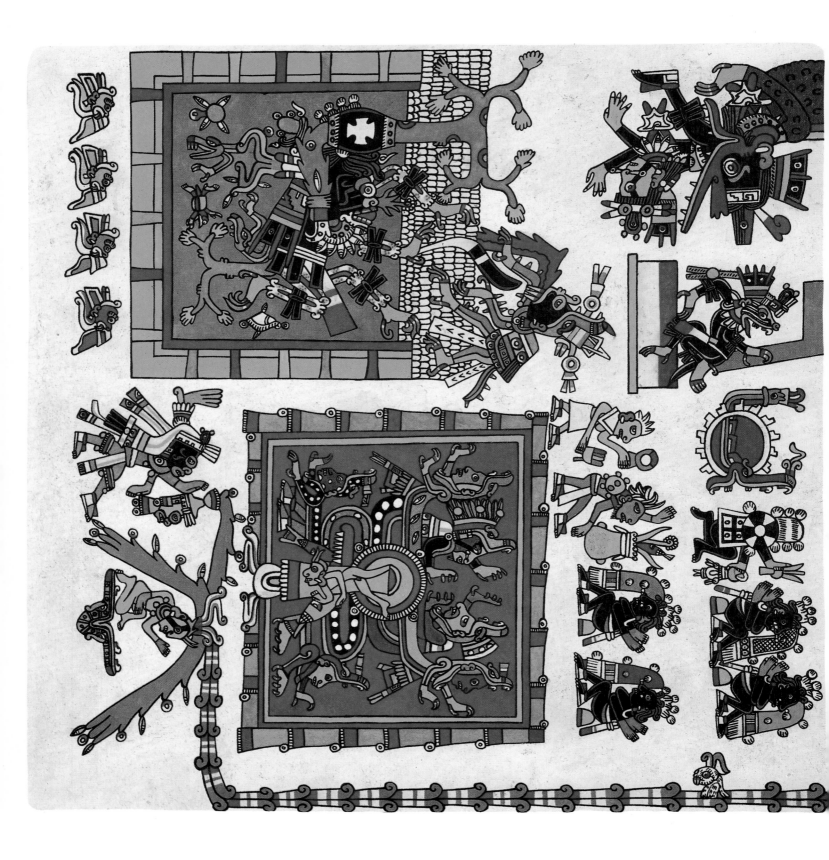

PLATE 38: Page 10 of the ritual sequence, rituals as Stripe Eye ends his magical journey

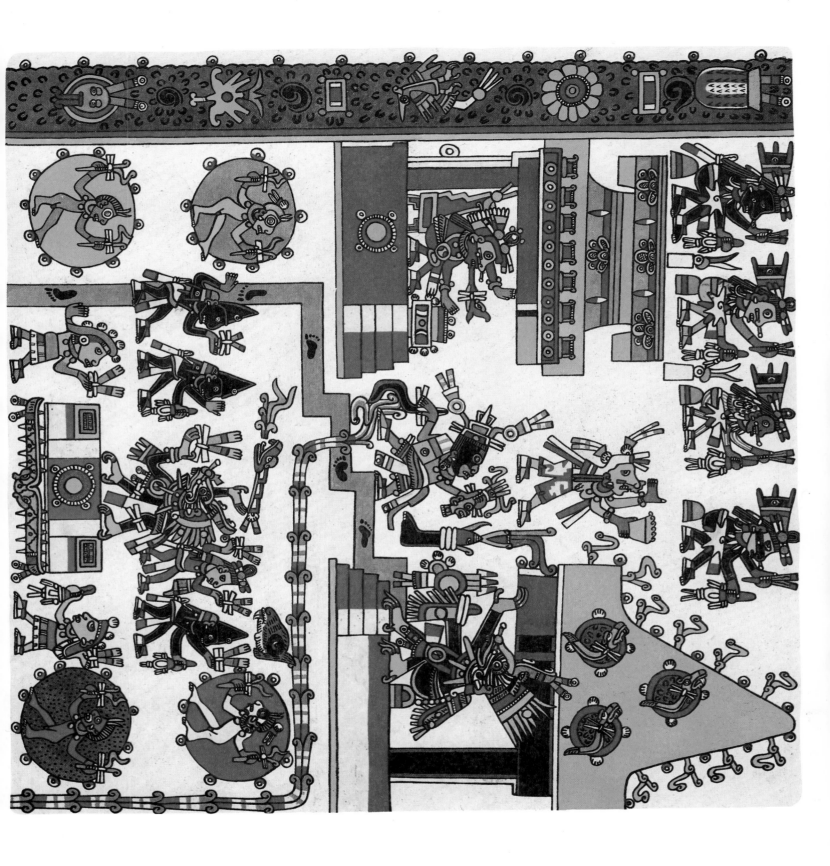

PLATE 37: Page 9 of the ritual sequence, rituals in the plaza of the heaven temple while
Stripe Eye magically journeys

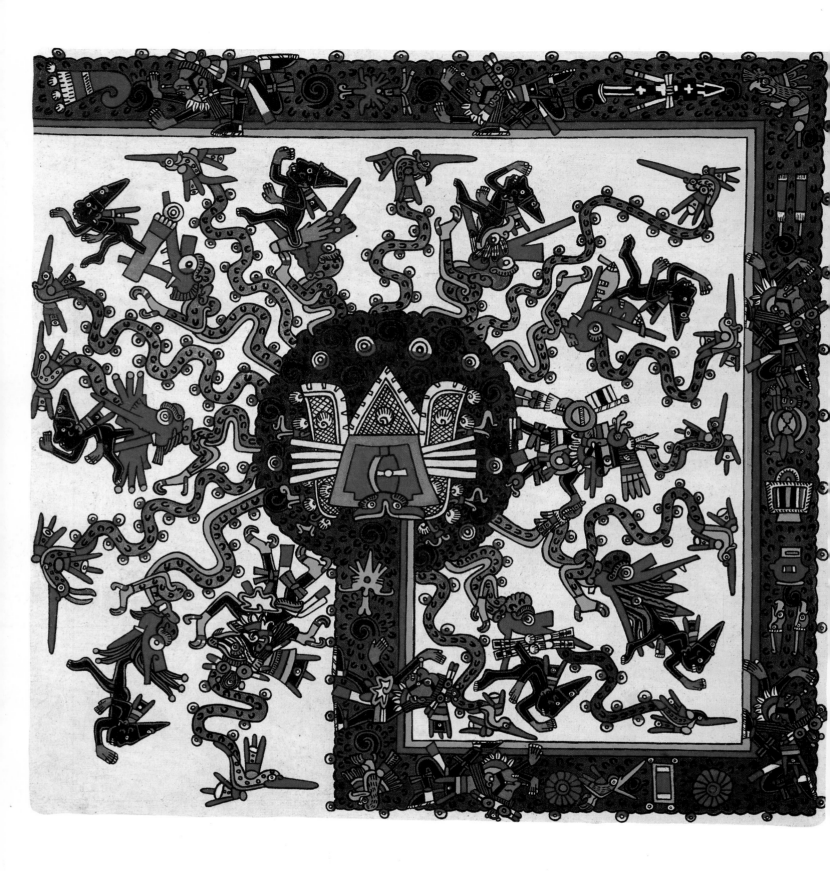

PLATE 36: Page 8 of the ritual sequence, the wind bundle is opened

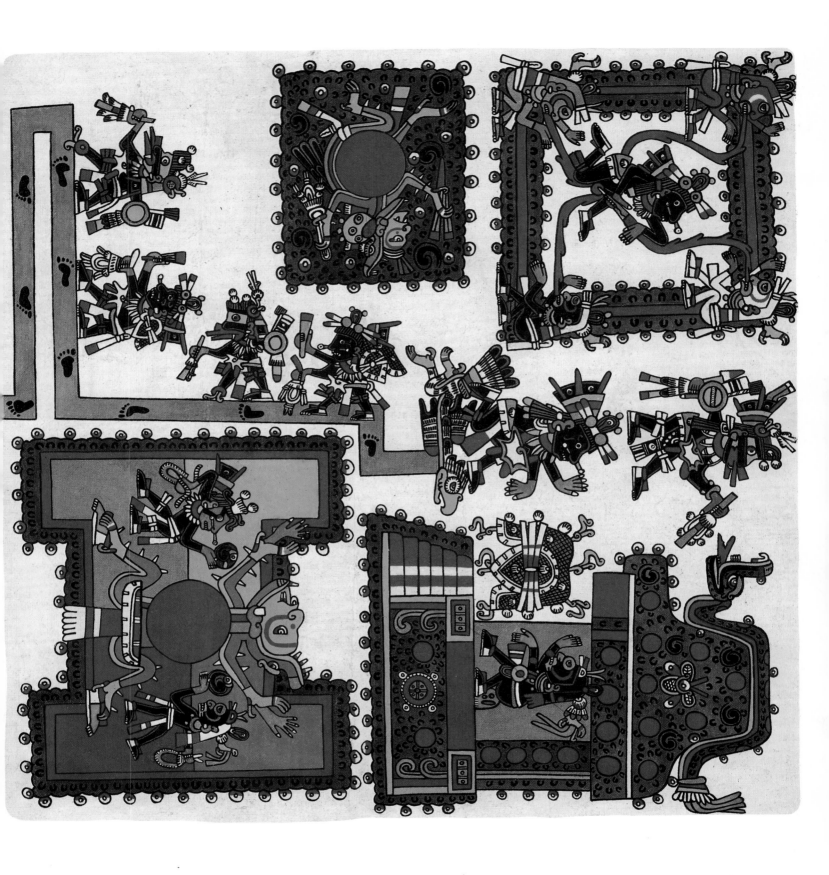

PLATE 35: Page 7 of the ritual sequence, Stripe Eye's journey begins on the blue road

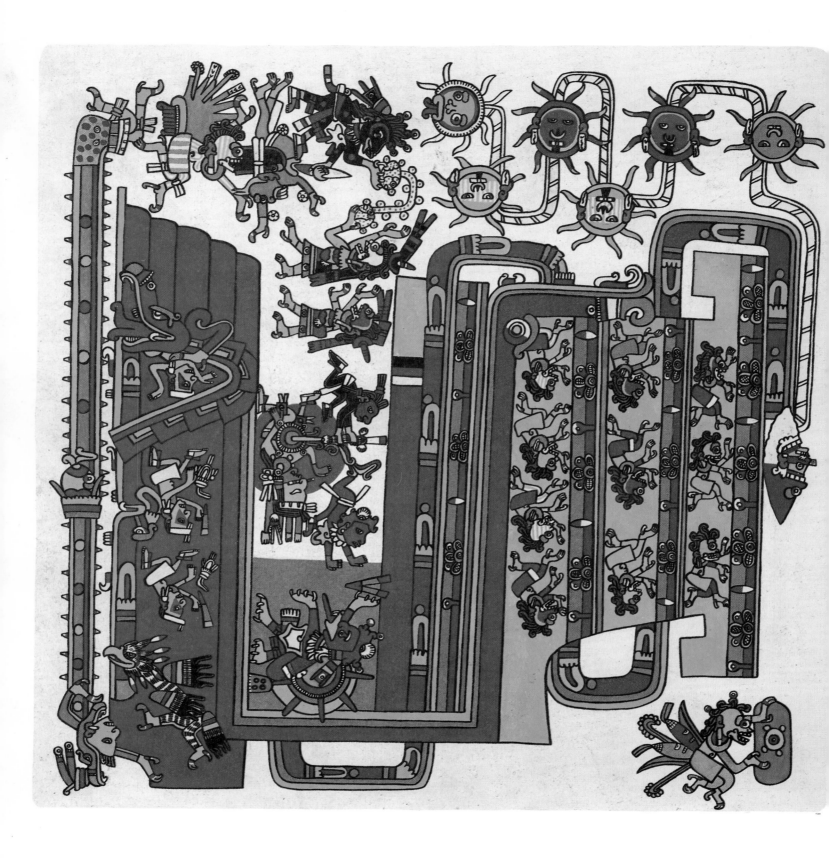

PLATE 34: Page 6 of the ritual sequence, the eared-roofed heaven temple

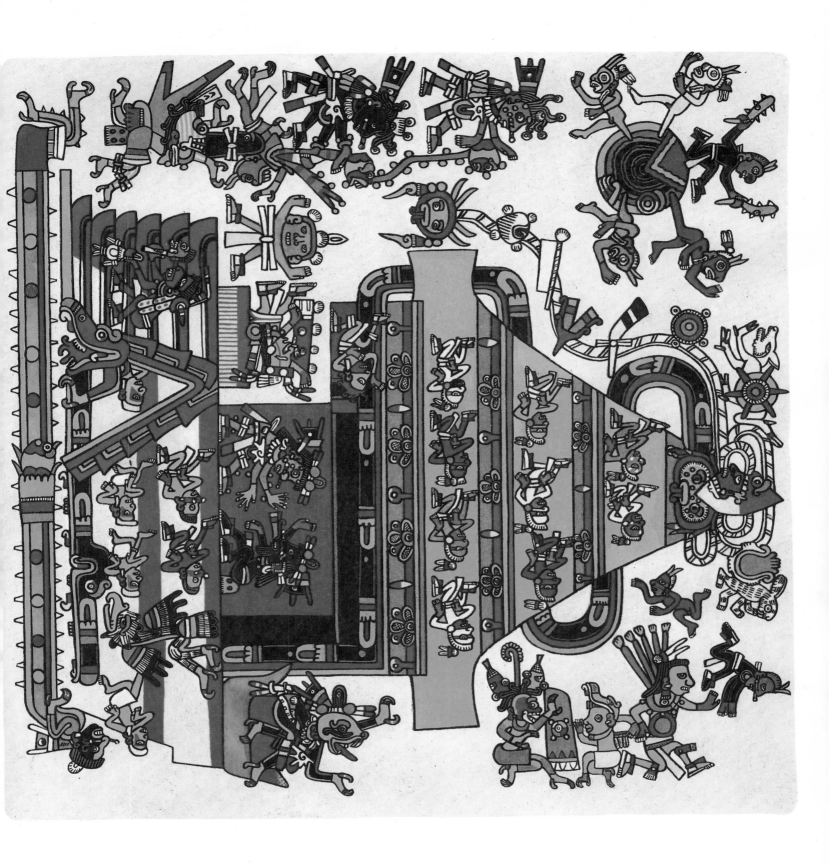

PLATE 33: Page 5 of the ritual sequence, the round heaven temple

45

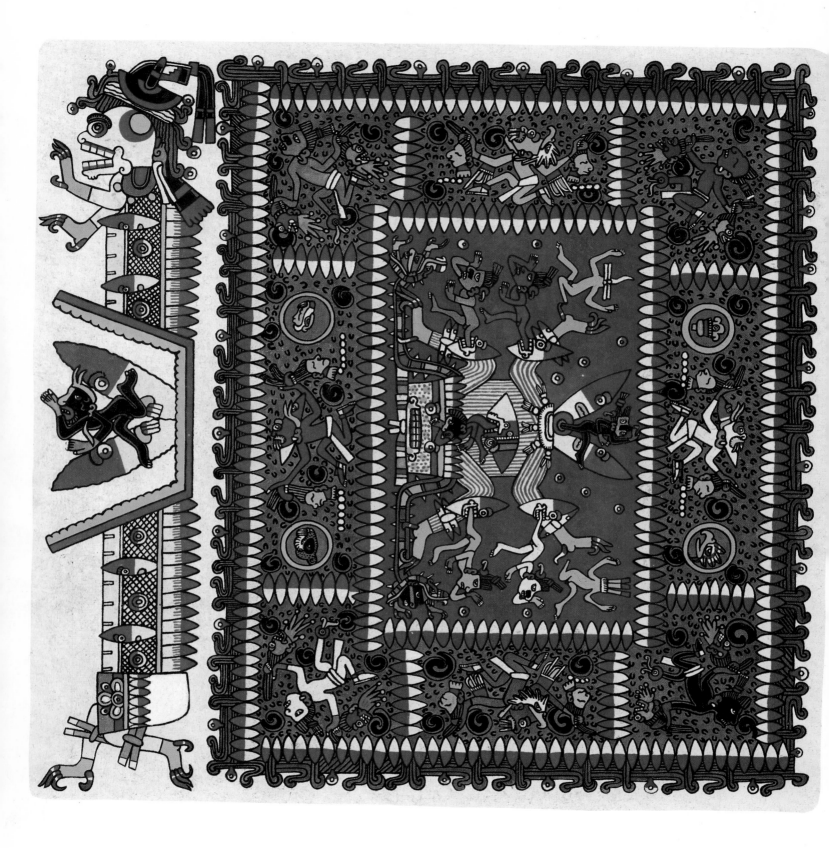

PLATE 32: Page 4 of the ritual sequence, the fifth enclosure

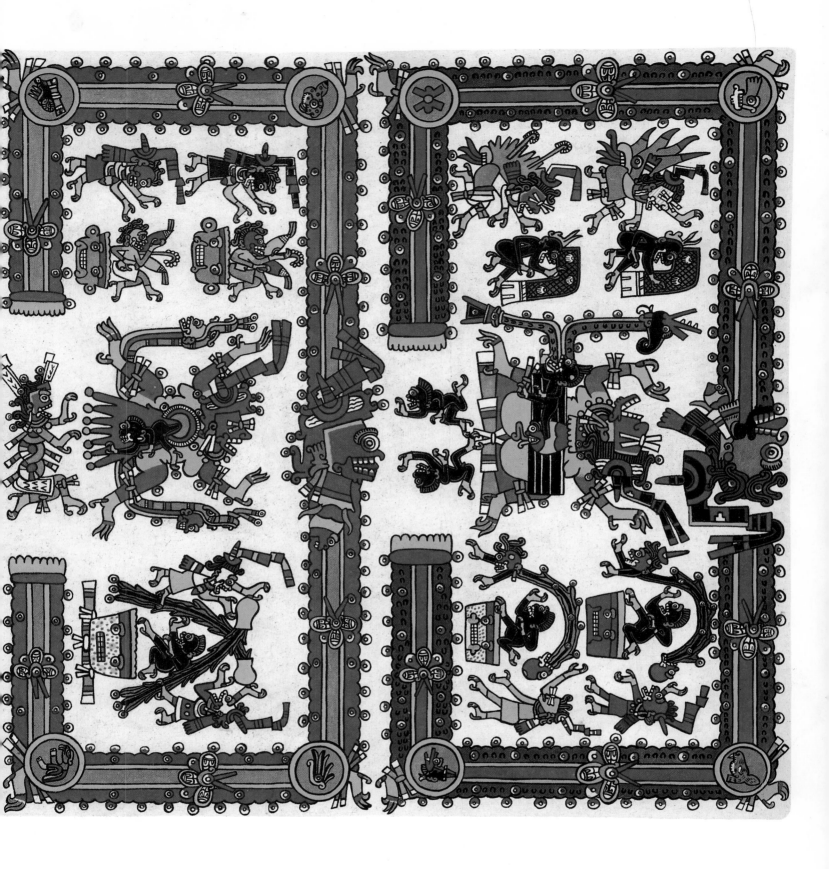

PLATE 31: Page 3 of the ritual sequence, the third and fourth enclosures

47

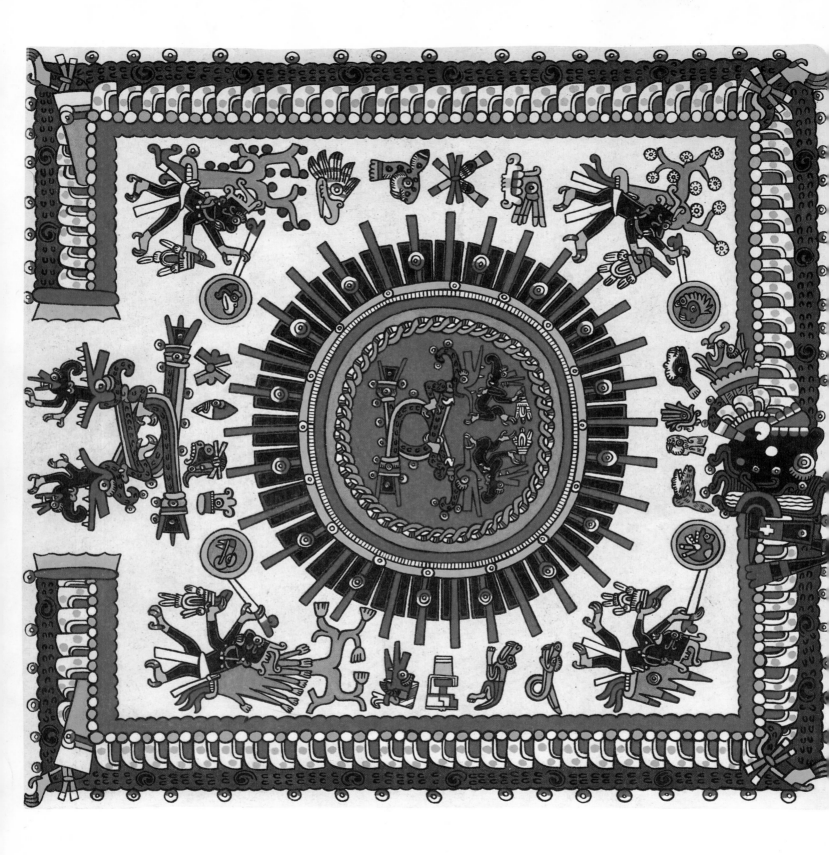

PLATE 30: Page 2 of the ritual sequence, the second enclosure

48

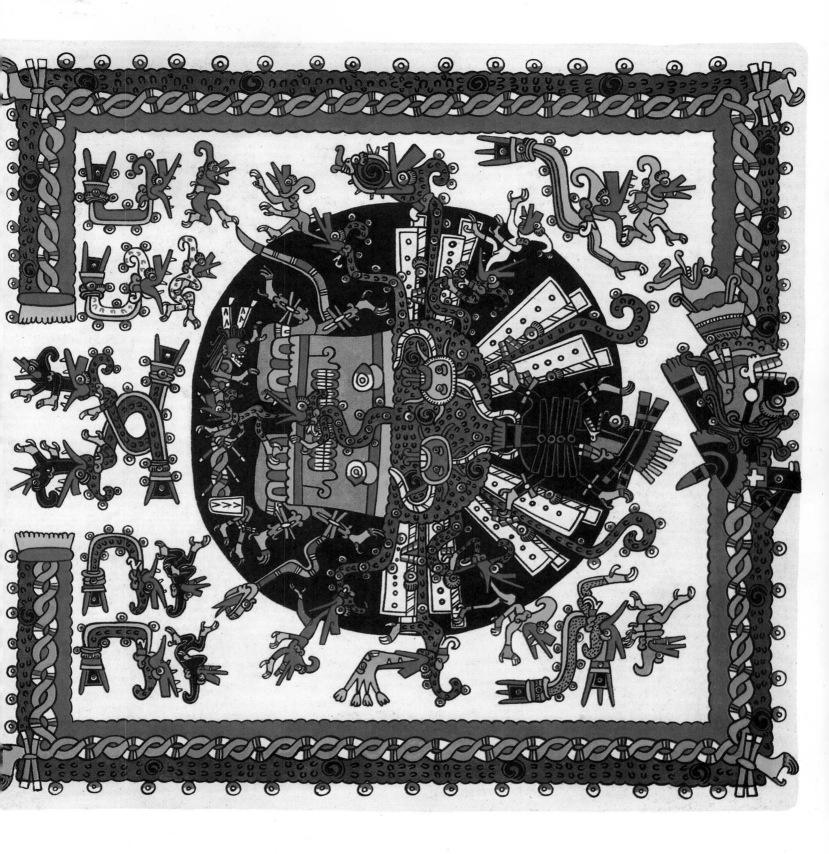

PLATE 29: Page 1 of the ritual sequence, the first enclosure

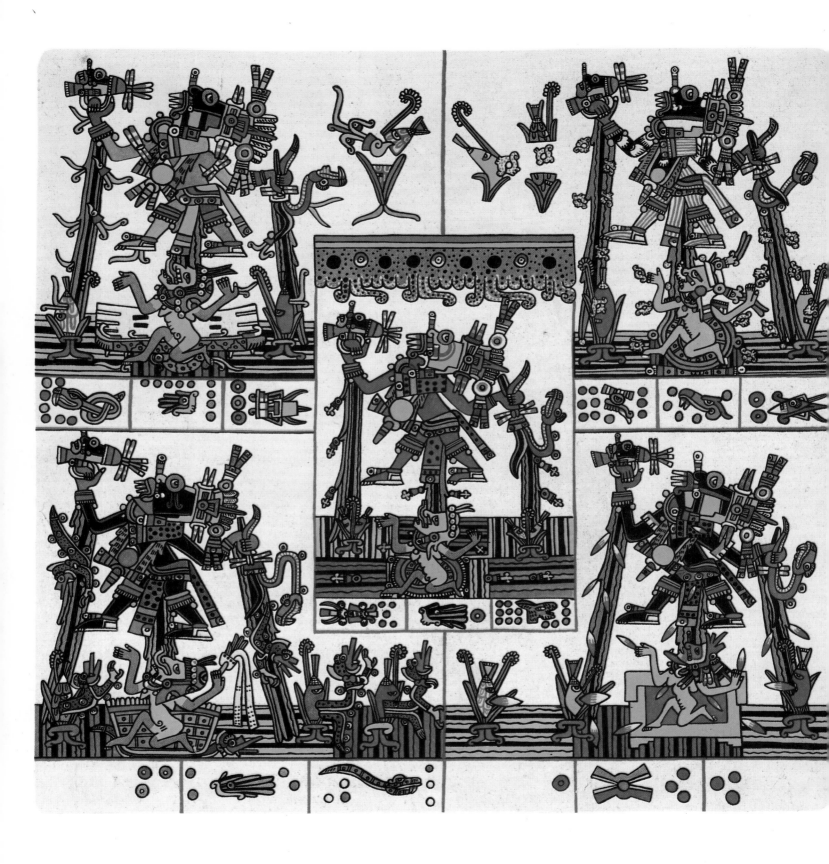

PLATE 28: The five directions with rain deities and the first five years of a 52-year calendar cycle

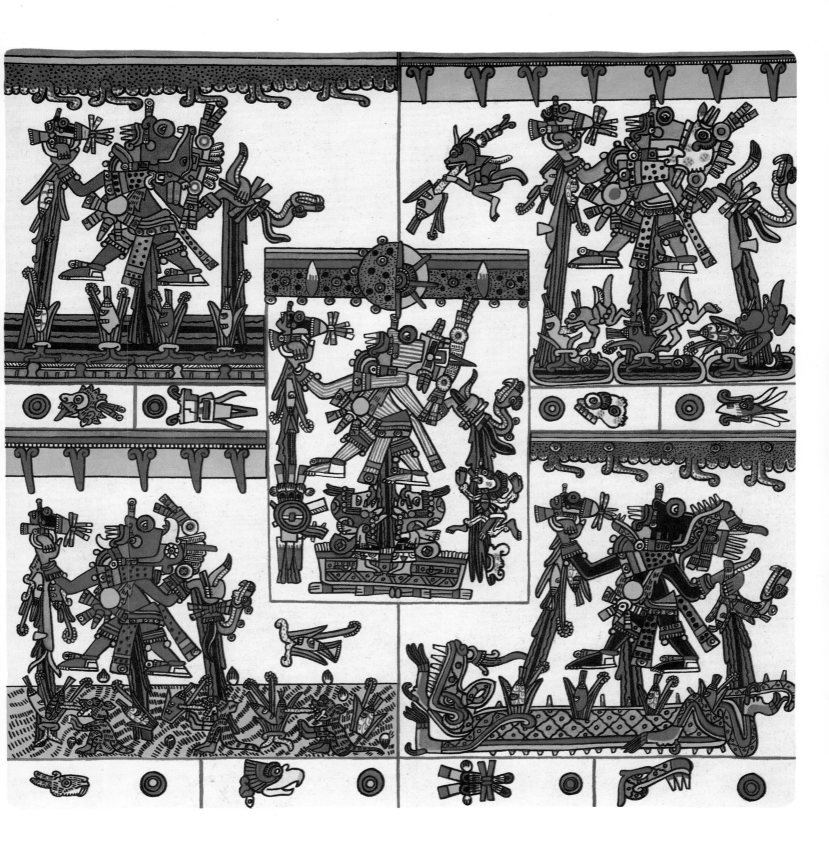

PLATE 27: The five directions with rain deities and four quarters of a 52-year calendar cycle

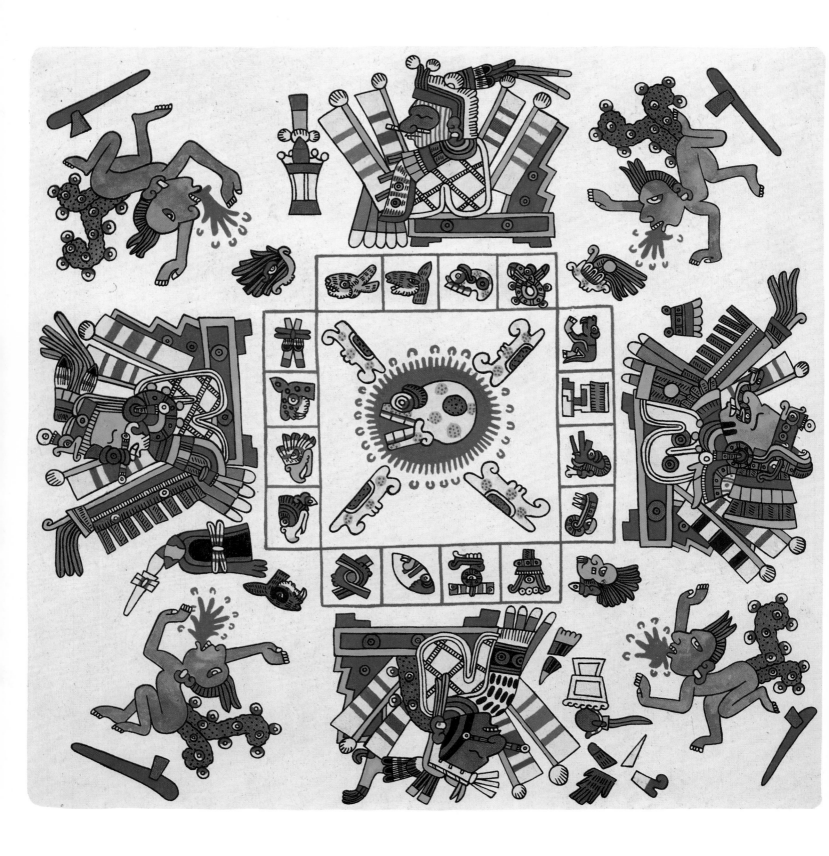

PLATE 26: The five directions with deities and 20 day signs in the underworld

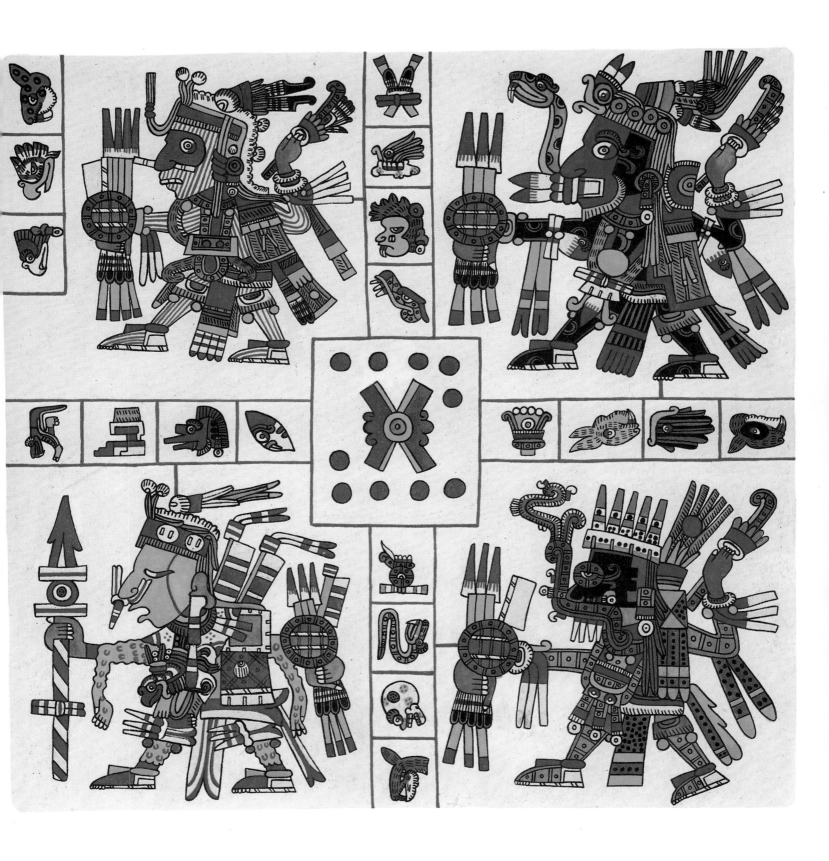

PLATE 25: The five directions with deities and 20 day signs

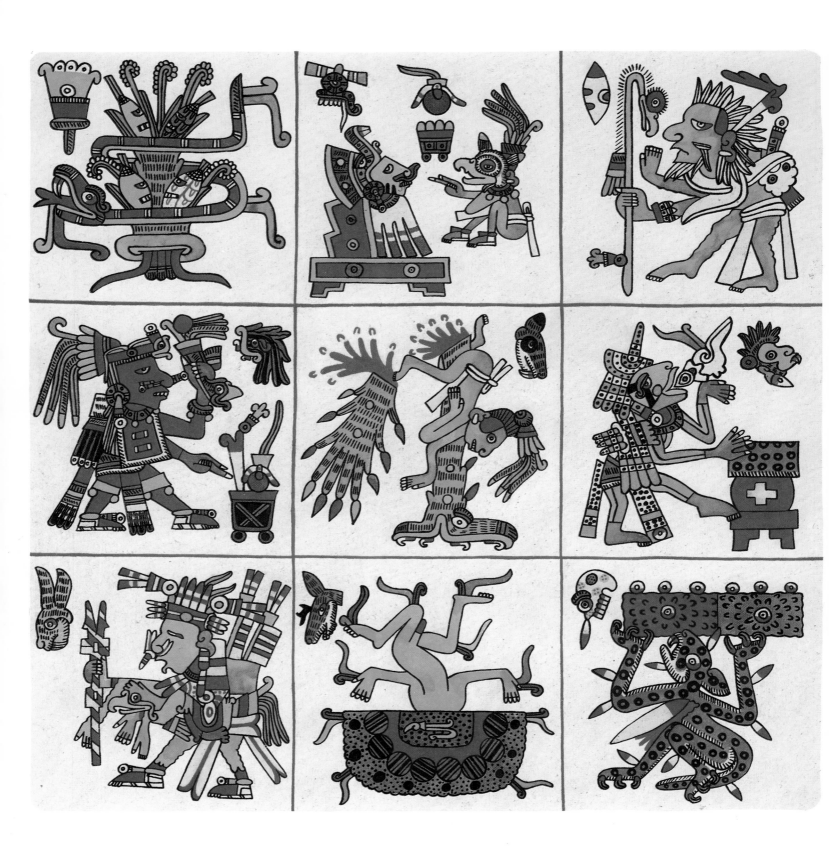

PLATE 24: Page 3 of 20 supernaturals associated with the 20 day signs

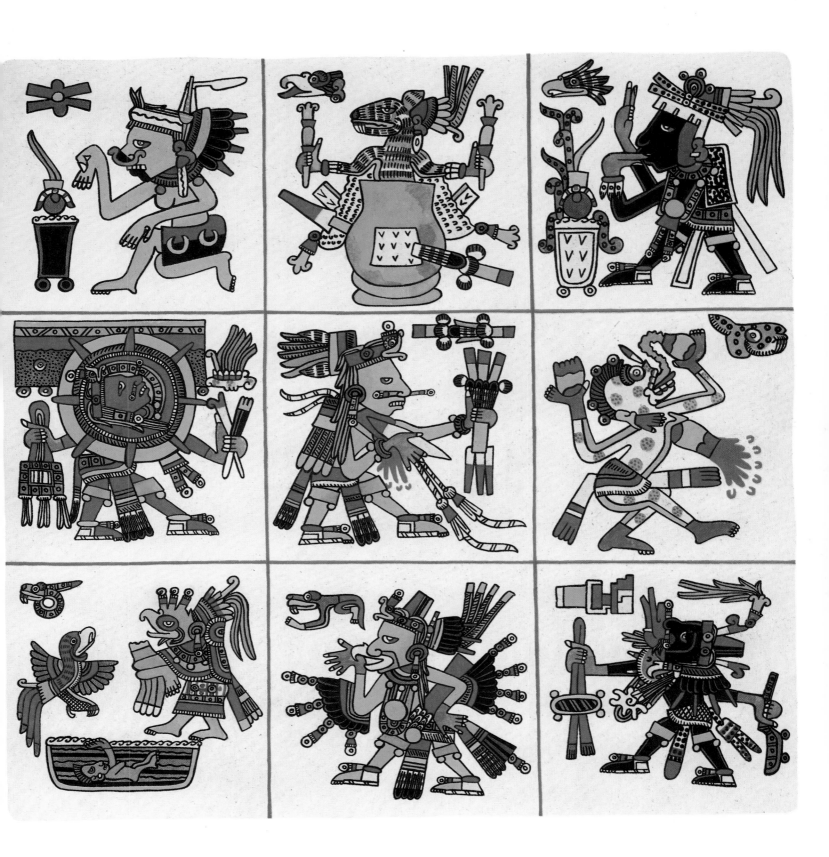

PLATE 23: Page 2 of 20 supernaturals associated with the 20 day signs

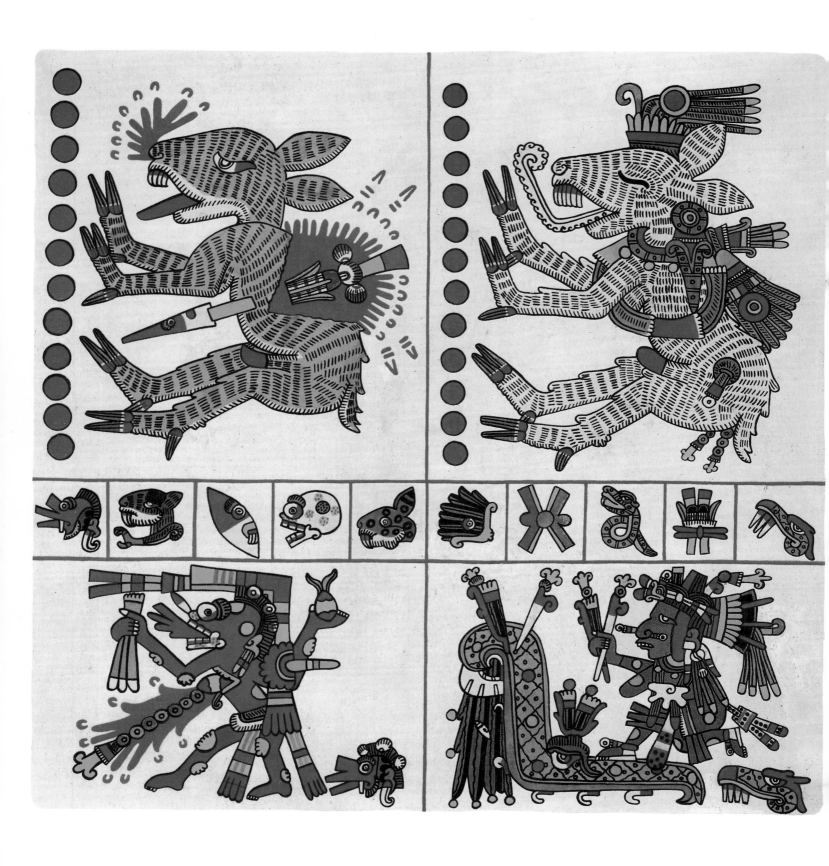

PLATE 22: Two deer with one half of the *tonalpohualli*, and page 1 of 20 supernaturals associated
with the 20 day signs

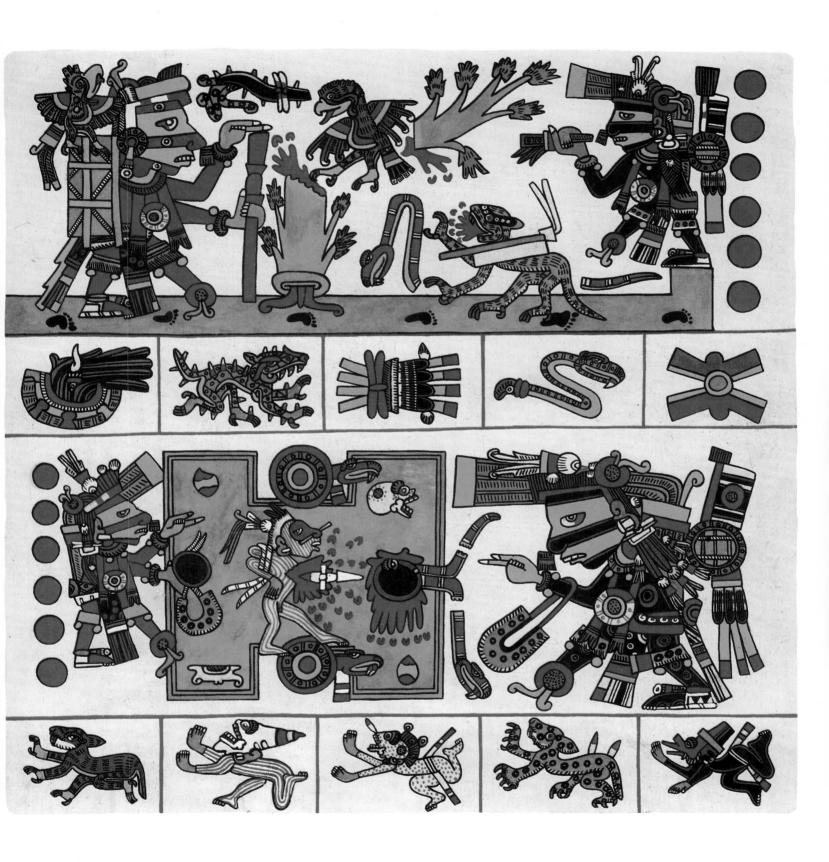

PLATE 21: Page 4 of eight supernatural scenes with calendrical associations

57

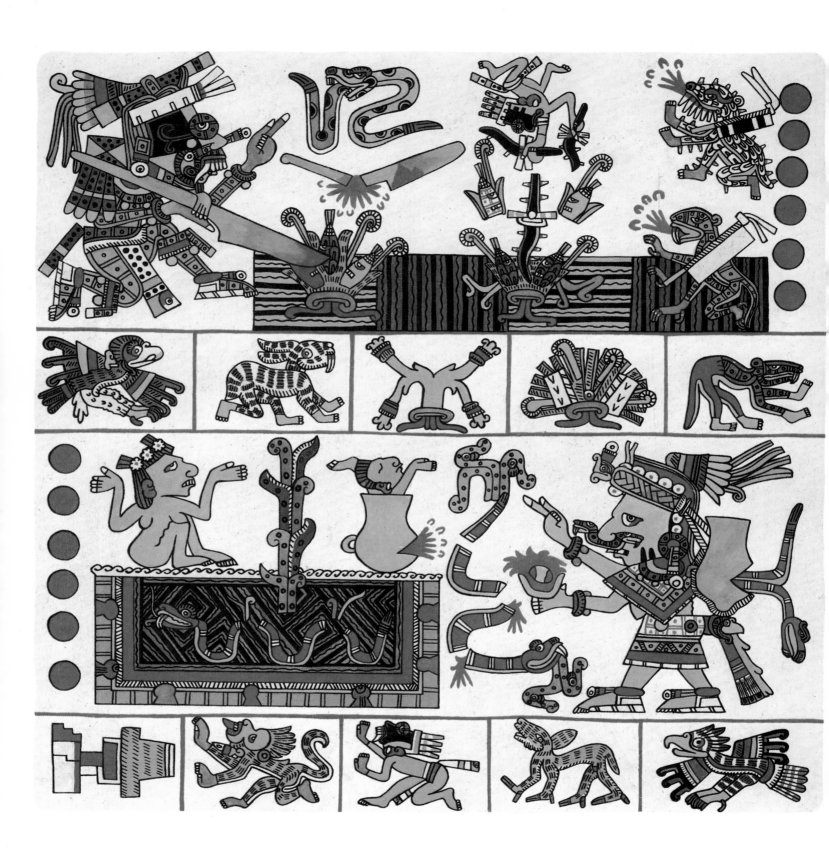

PLATE 20: Page 3 of eight supernatural scenes with calendrical associations

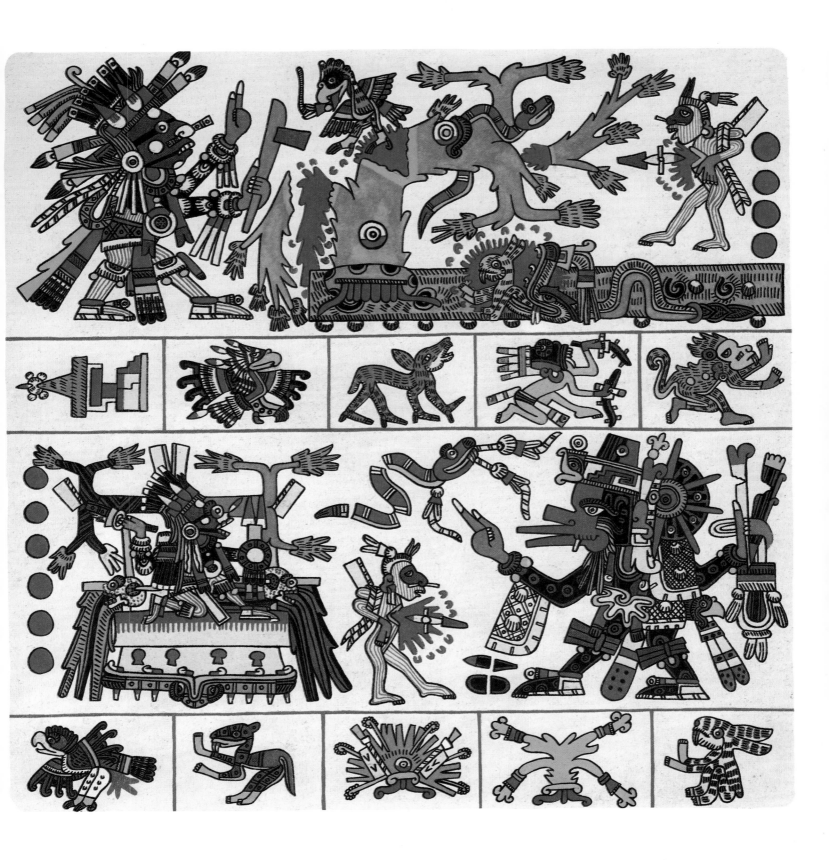

PLATE 19: Page 2 of eight supernatural scenes with calendrical associations

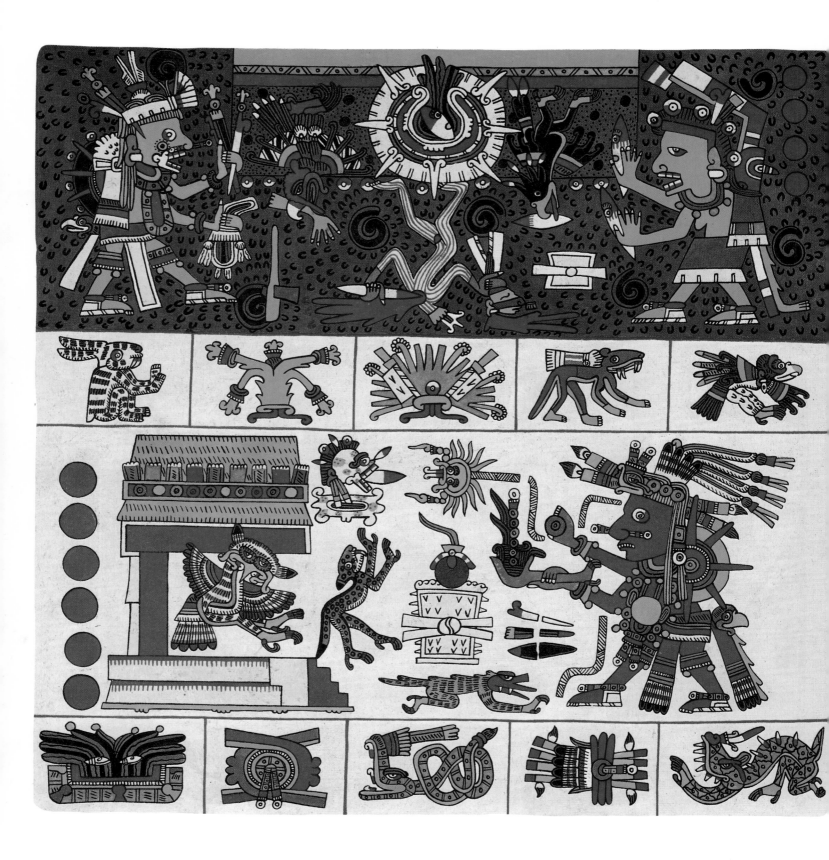

PLATE 18: Page 1 of eight supernatural scenes with calendrical associations

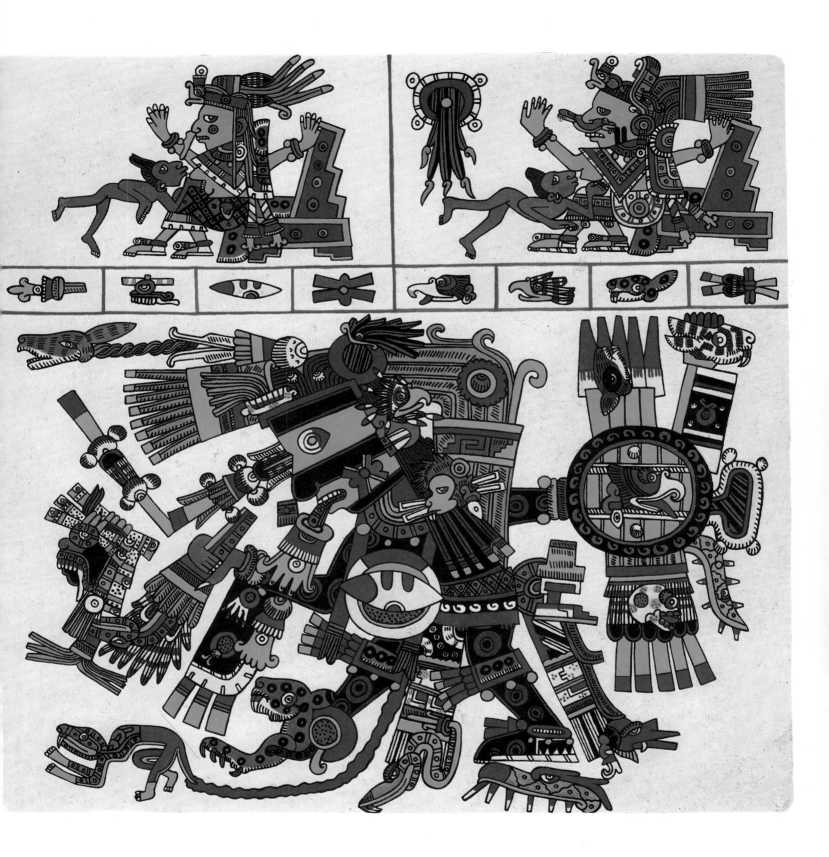

PLATE 17: Page 3 of 20 deities and 80 days, and Yayauhqui Tezcatlipoca with the 20 day signs on his body and costume

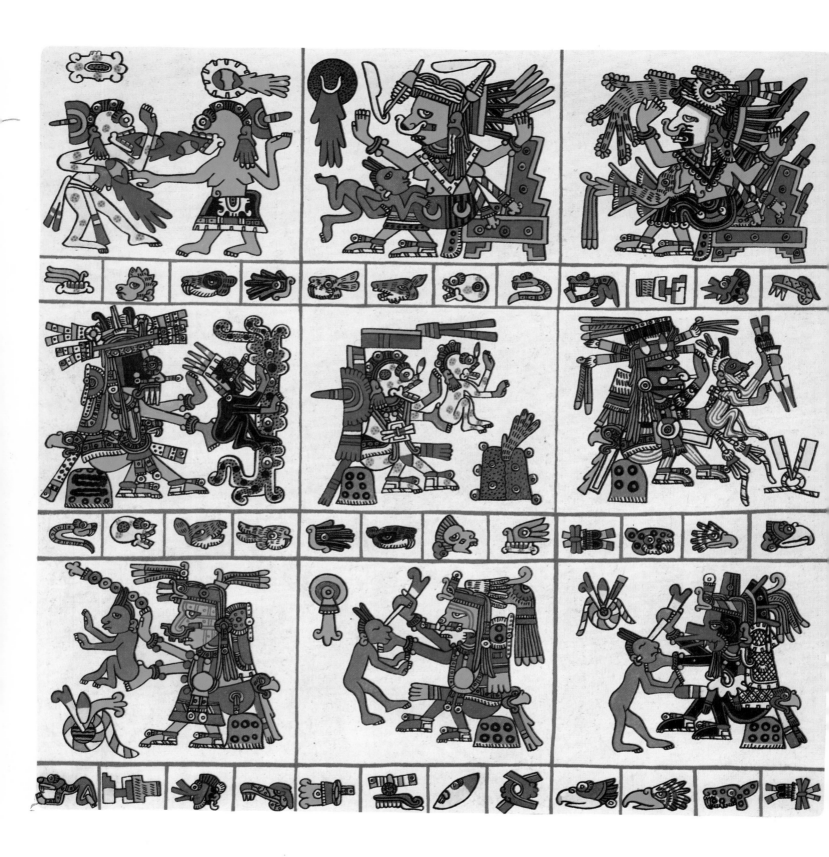

PLATE 16: Page 2 of 20 deities and 80 days

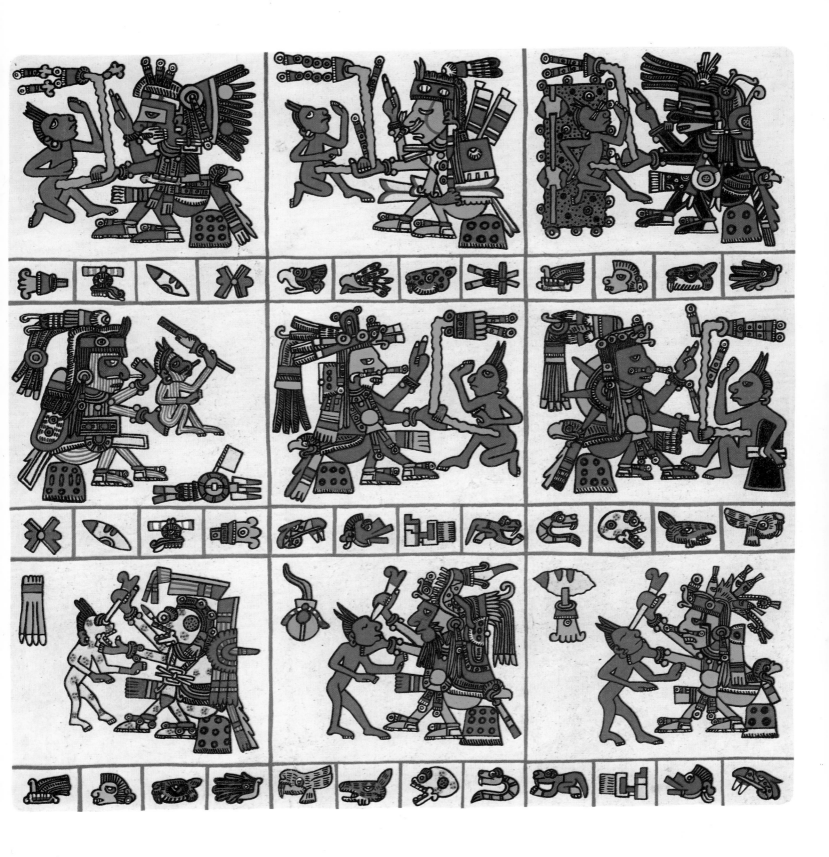

PLATE 15: Page 1 of 20 deities and 80 days

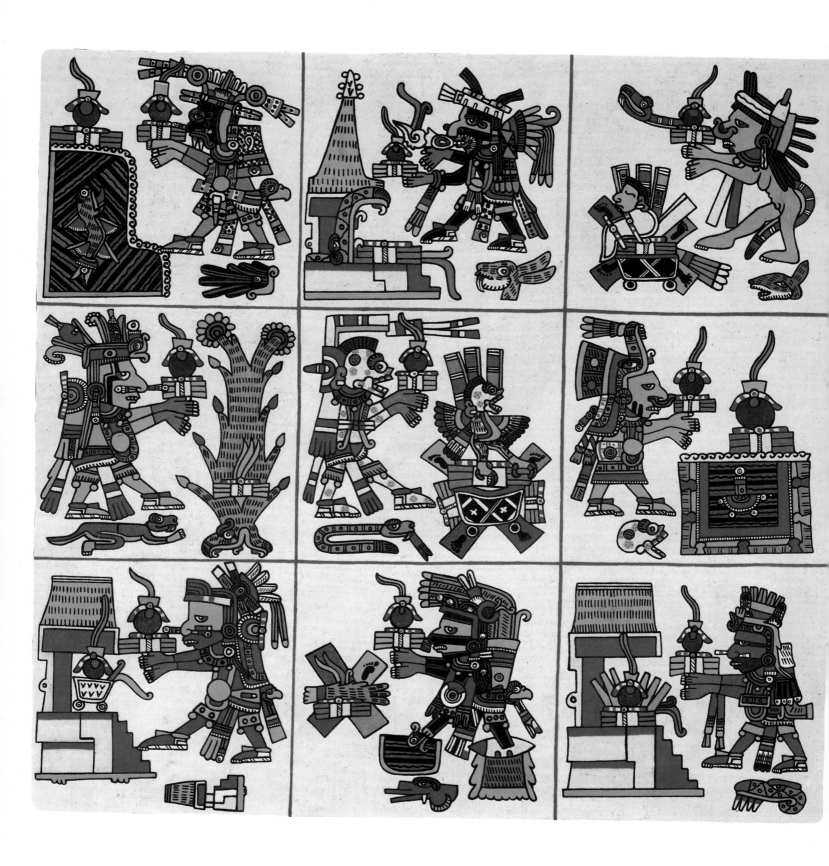

PLATE 14: The nine deities of the night

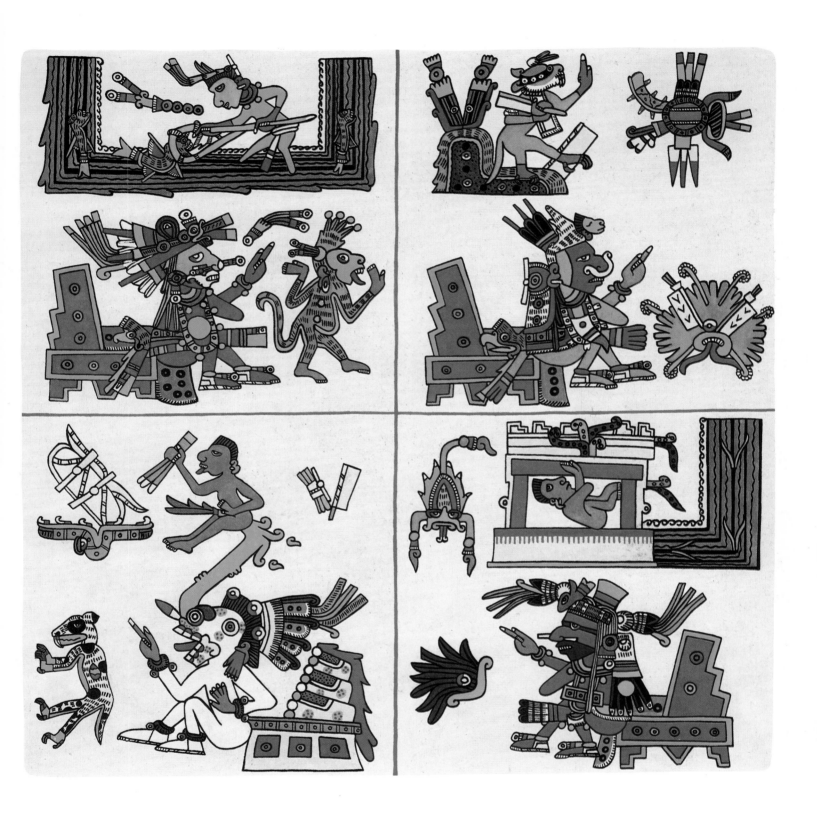

PLATE 13: Page 5 of the deities of the 20 day signs

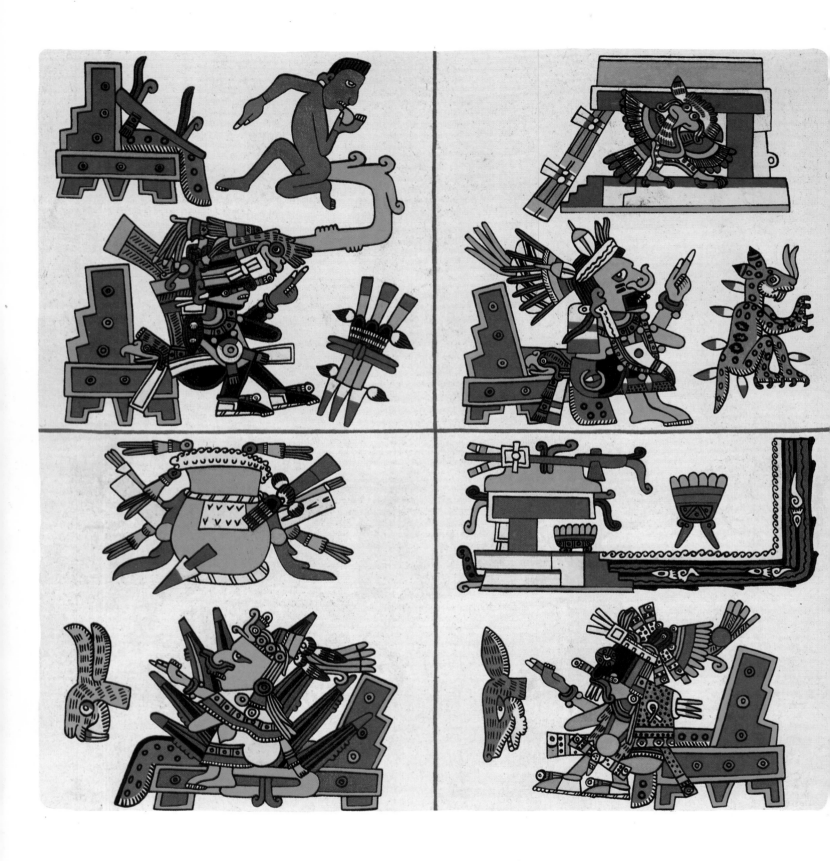

PLATE 12: Page 4 of the deities of the 20 day signs

66

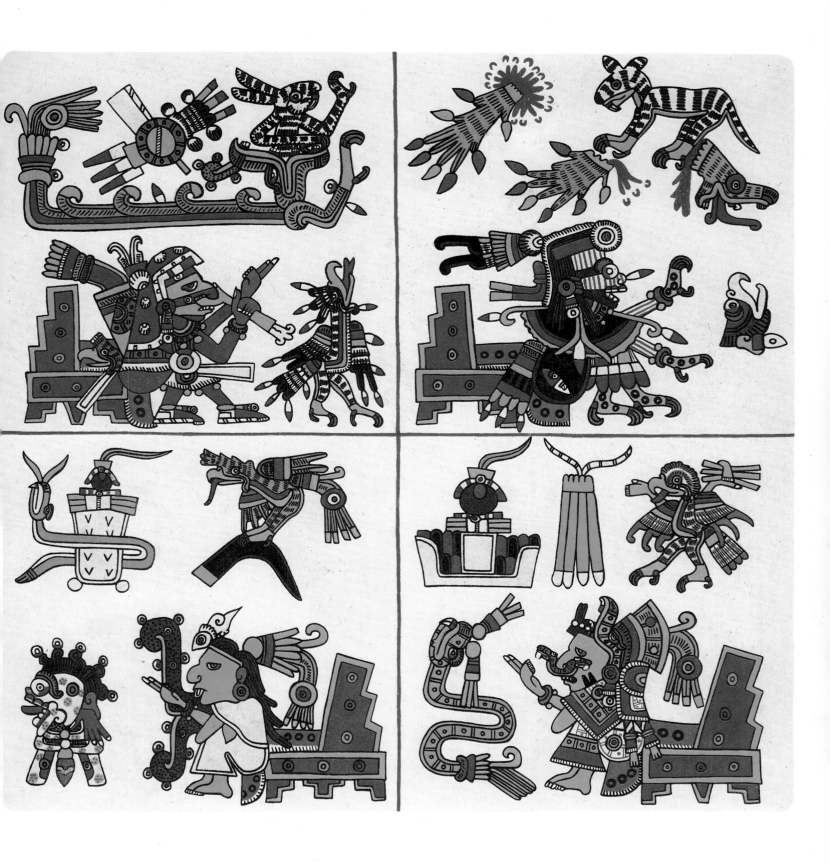

PLATE 11: Page 3 of the deities of the 20 day signs

67

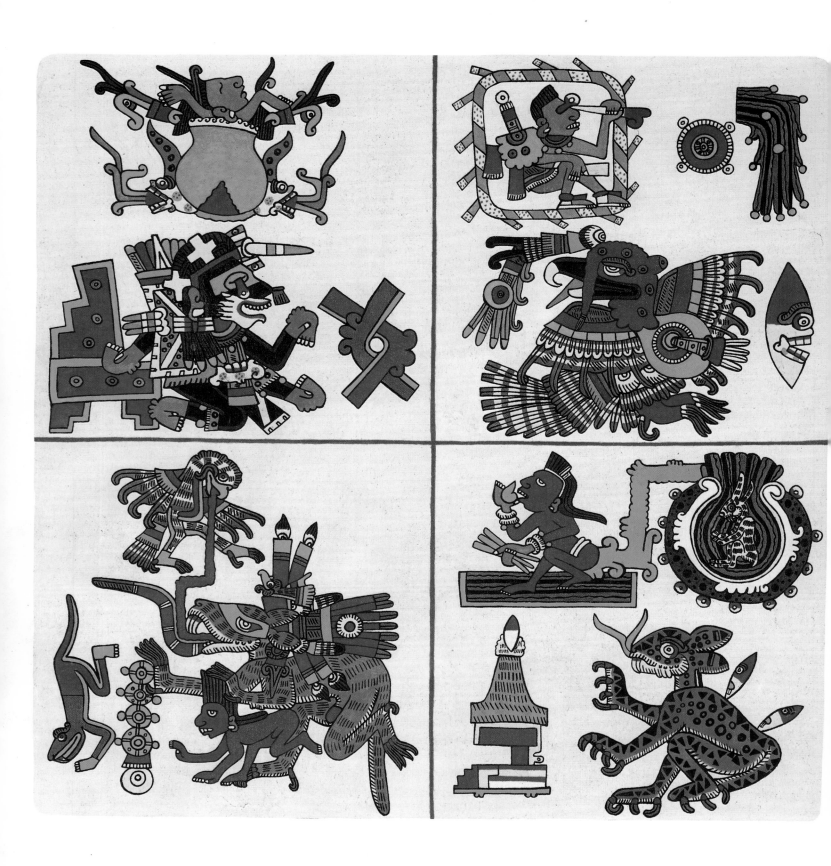

PLATE 10: Page 2 of the deities of the 20 day signs

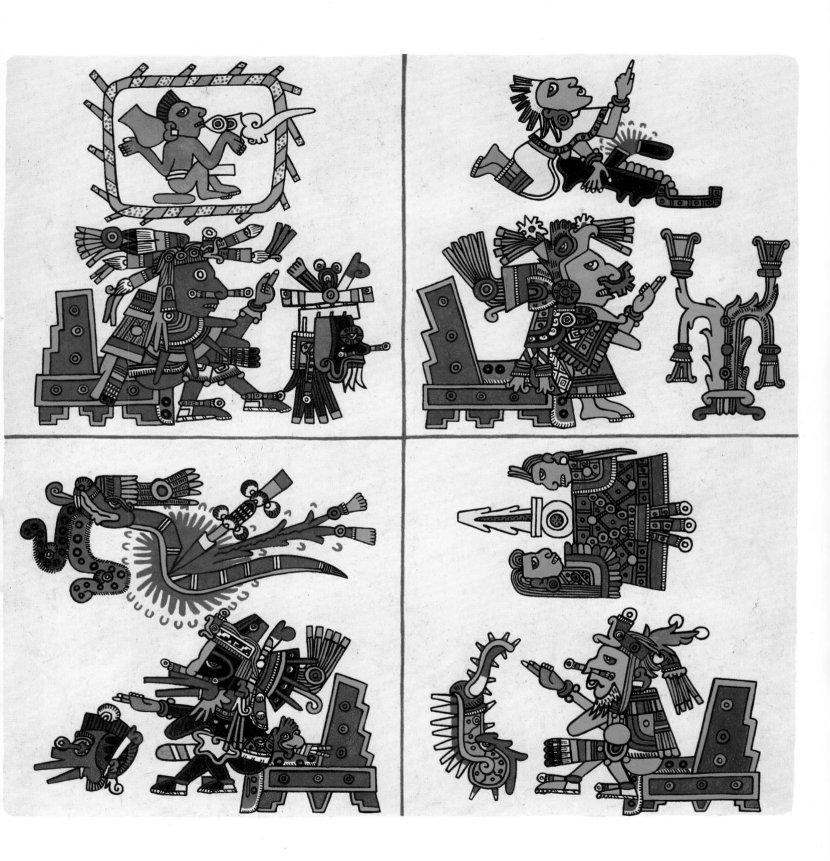

PLATE 9: Page 1 of the deities of the 20 day signs

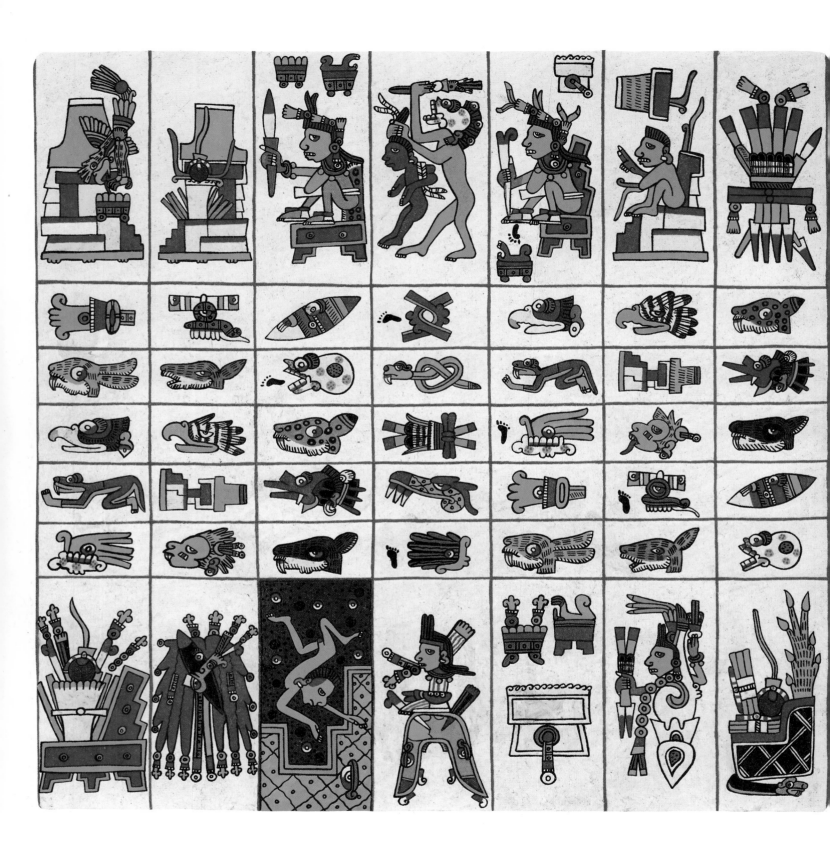

PLATE 8: Page 8 of the *tonalpohualli* arranged in five rows of 52 members

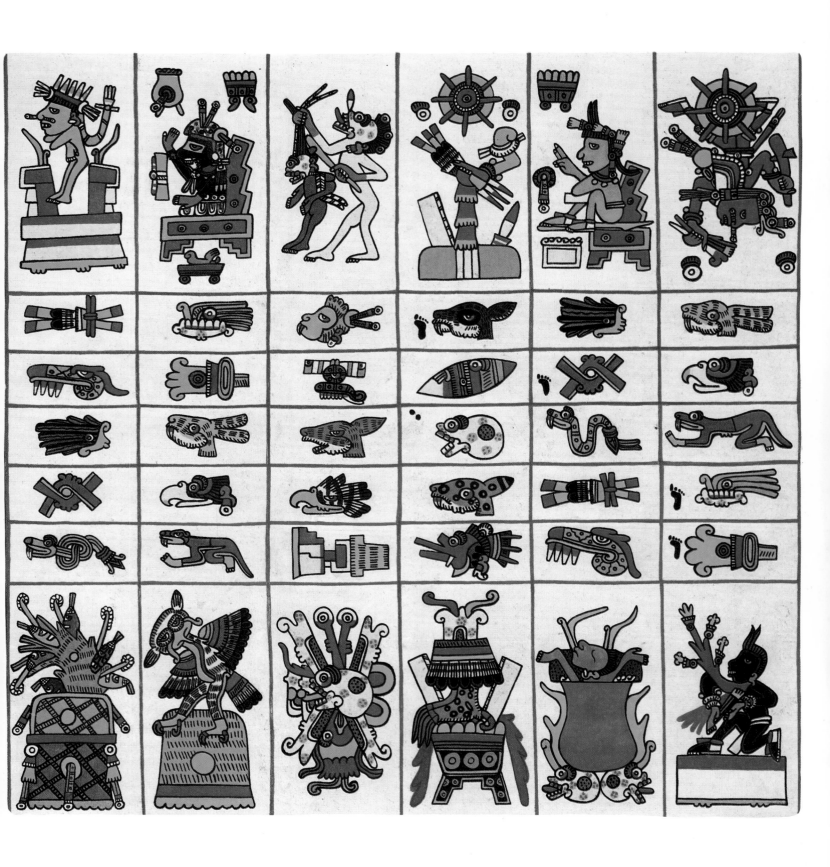

PLATE 7: Page 7 of the *tonalpohualli* arranged in five rows of 52 members

71

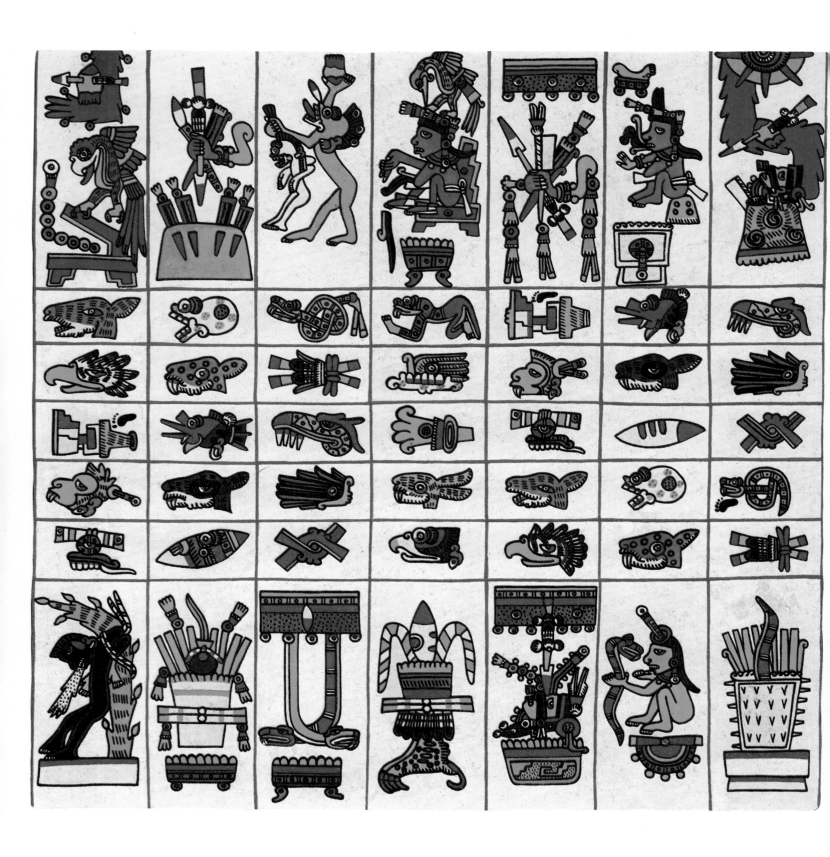

PLATE 6: Page 6 of the *tonalpohualli* arranged in five rows of 52 members

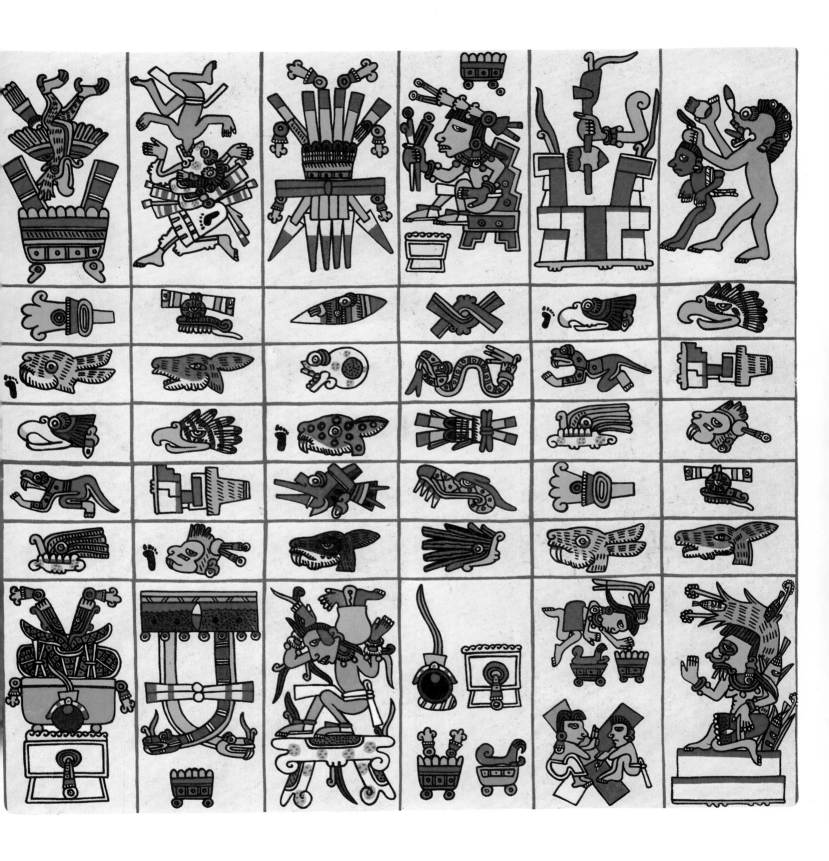

PLATE 5: Page 5 of the *tonalpohualli* arranged in five rows of 52 members

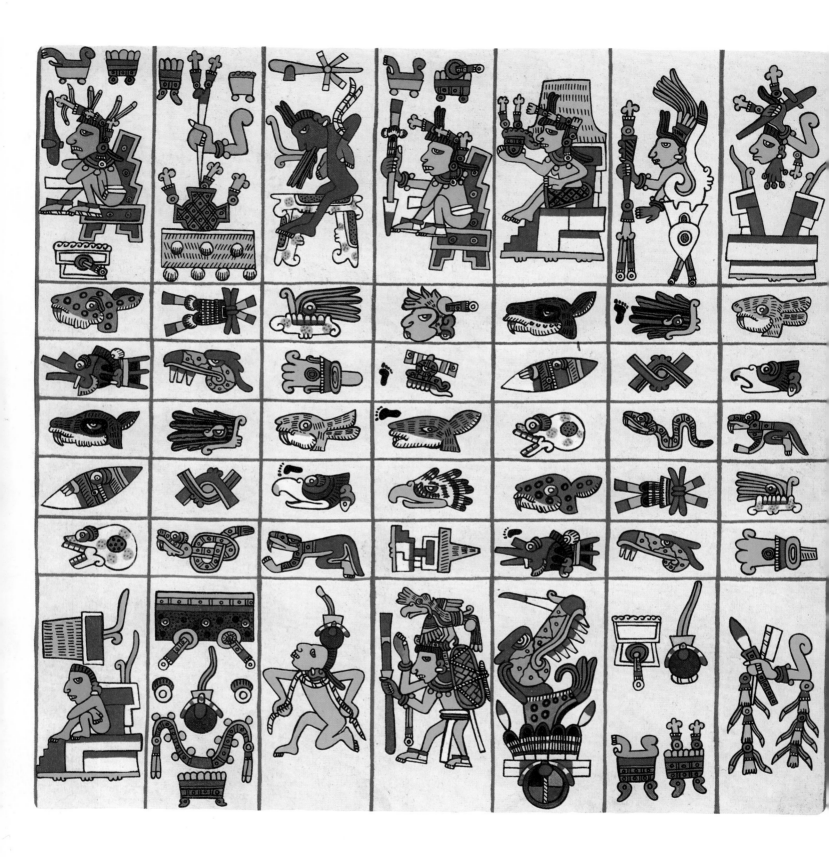

PLATE 4: Page 4 of the *tonalpohualli* arranged in five rows of 52 members

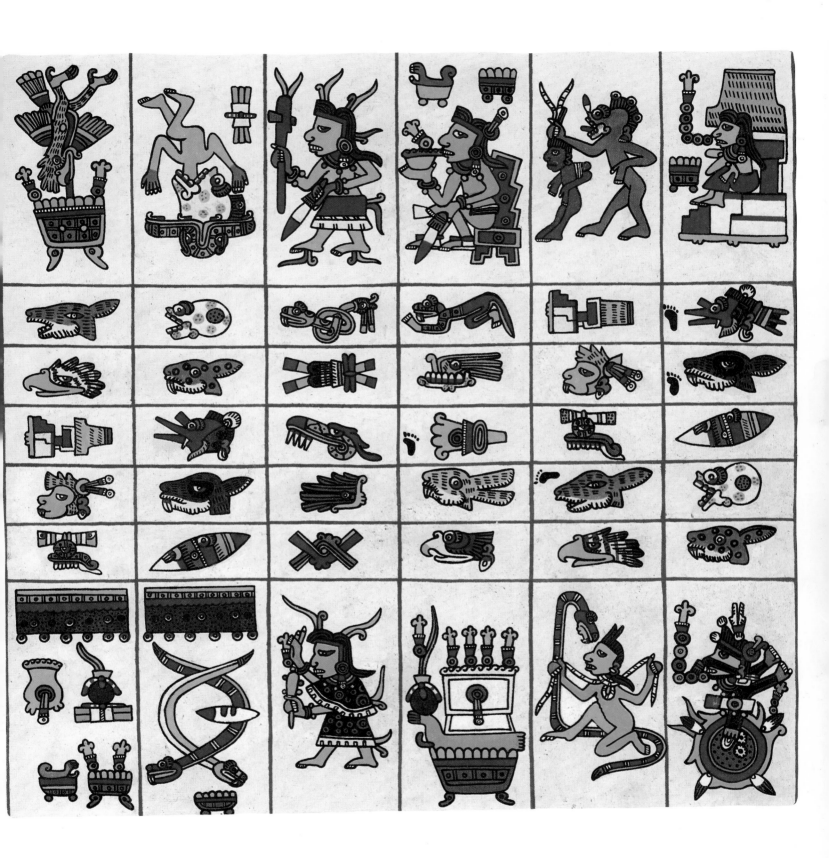

PLATE 3: Page 3 of the *tonalpohualli* arranged in five rows of 52 members

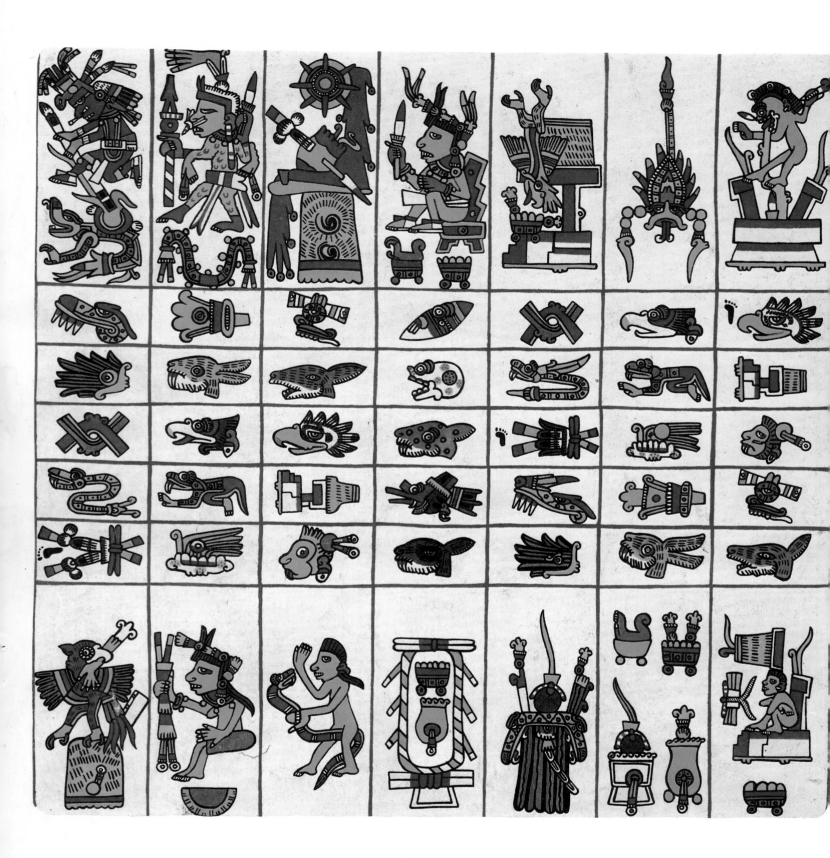

PLATE 2: Page 2 of the *tonalpohualli* arranged in five rows of 52 members

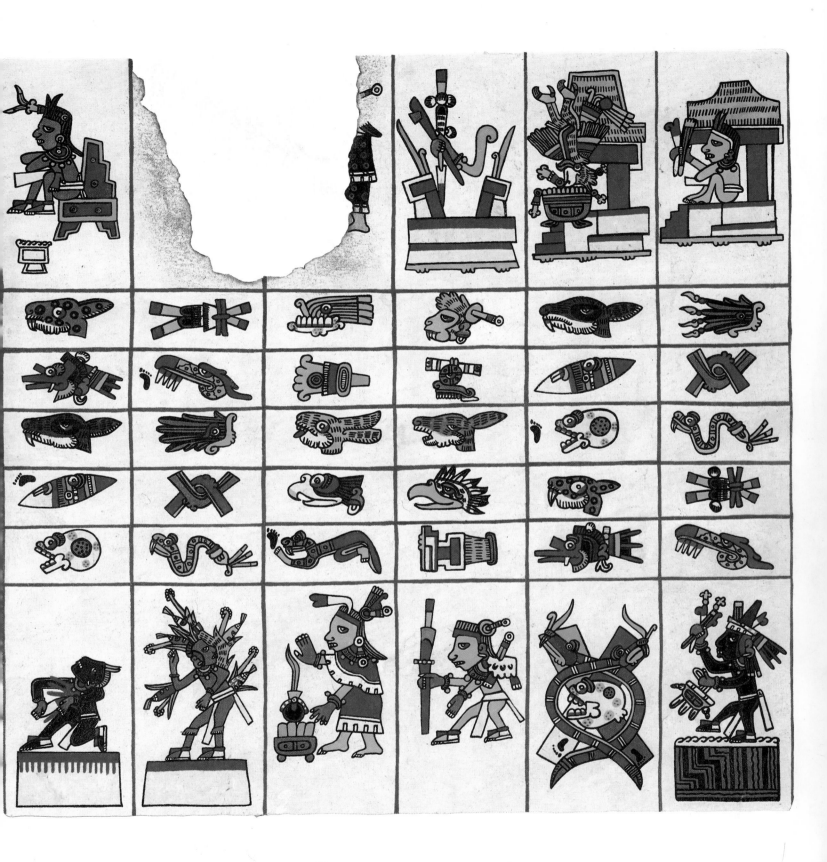

PLATE 1: Page 1 of the *tonalpohualli* (260-day ritual calendar) arranged in five rows of 52 members